onetree

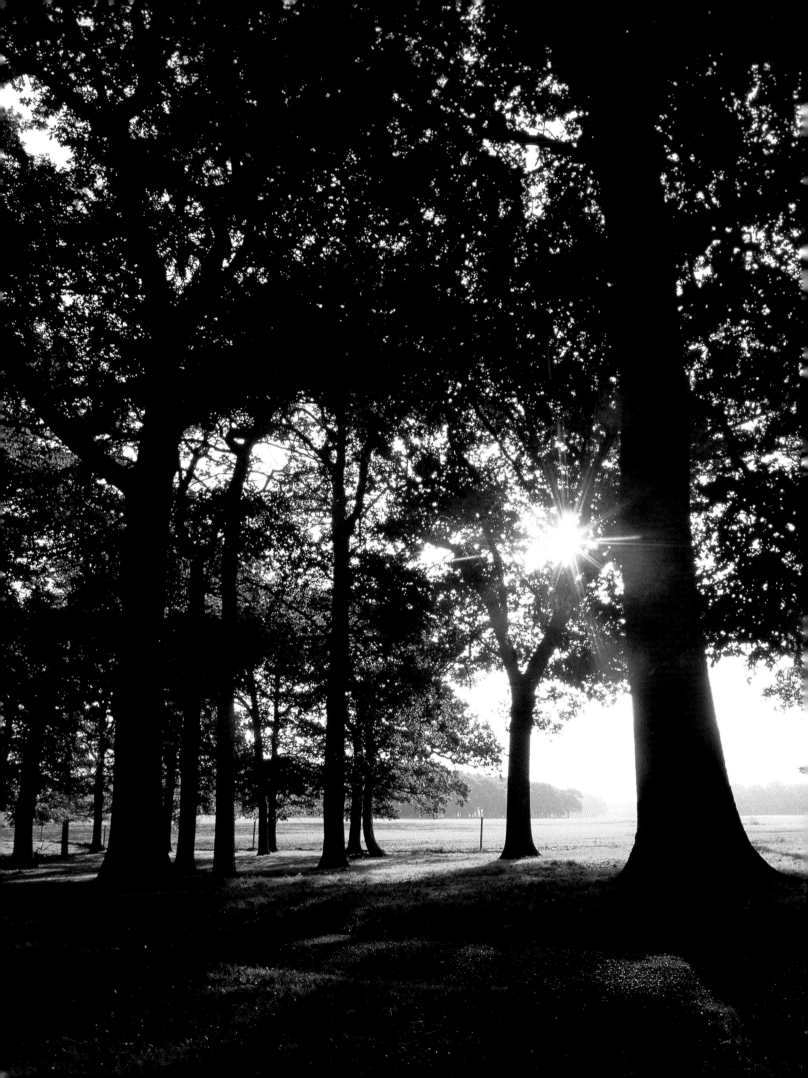

onetree

GARRY OLSON AND PETER TOAIG

FOREWORD BY HRH THE PRINCE OF WALES

PHOTOGRAPHY BY ROBERT WALKER

MERRELL

To Tim Stead, Karen, Amanda and Susan

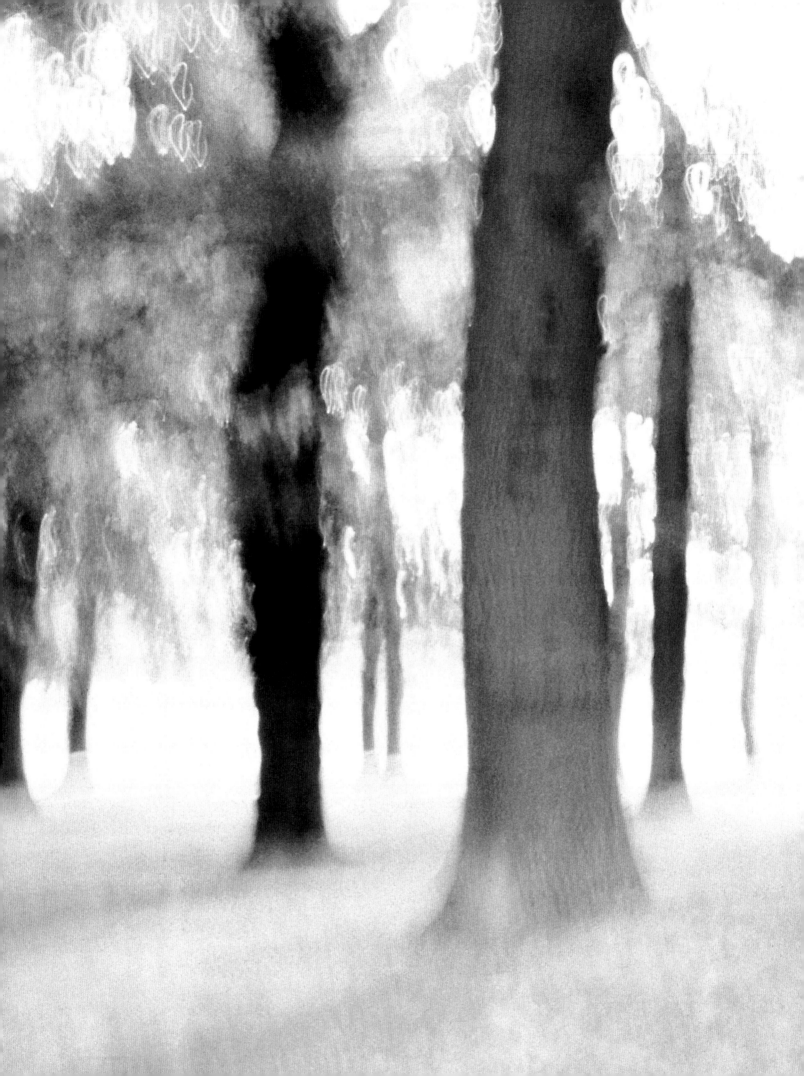

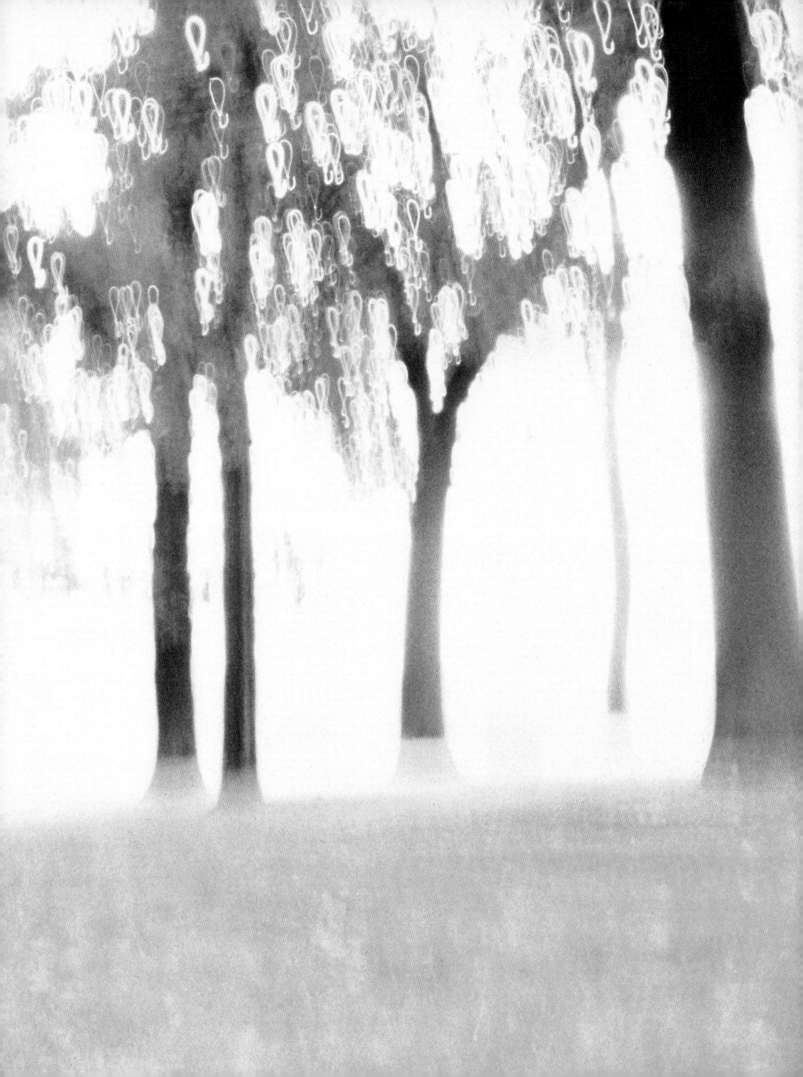

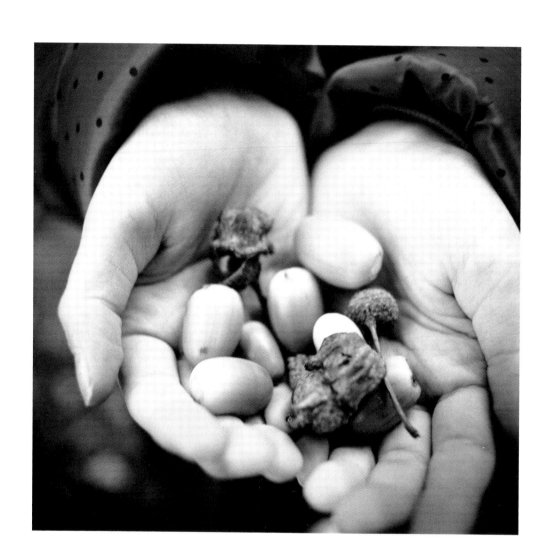

ST. JAMES'S PALACE

The oak is a quintessentially British tree, but its cultural and economic importance has diminished during the twentieth century. So I am delighted that this project, 'onetree', seeks to raise awareness of this remarkable tree, and its place in our heritage.

At a time when environmental awareness is higher than ever before, with issues such as global warming, air pollution, overfishing and many others all receiving detailed attention, it is particularly important to recognize the links between actions and their consequences. As consumers, our individual choices can make a real difference to our impacts on the environment. 'onetree' provides a beautiful illustration of the chain that connects end products to their source material.

There has been a rapid decline in the nation's ancient woodlands over the last fifty years, in parallel with changes in patterns of work and levels of rural employment. Traditional timber-based crafts and industries have not escaped this decline, yet as a nation we still consume large quantities of wood. Much of this is now imported, and only a small proportion is independently certified as coming from sustainable sources.

I am particularly keen to see the beauty and versatility of our native timber given even greater recognition. Properly managed woodlands, especially when operated under a 'continuous cover' system, are infinitely sustainable and by using more of the whole tree we can add value to the harvest and leave less waste. Well-managed woodlands are also places of rare beauty and tranquillity in an increasingly frantic world, and provide a whole range of rich wildlife habitats.

'onetree' is raising awareness of all these possibilities by exhibiting the diverse uses to which oak can be put. At the same time the project is celebrating the creativity of some of the highly skilled artists and craftsmen who share that vision. I hope that this book will not only be a source of enjoyment and inspiration, but also an encouragement to its readers to ask searching questions about the source of any wood they buy.

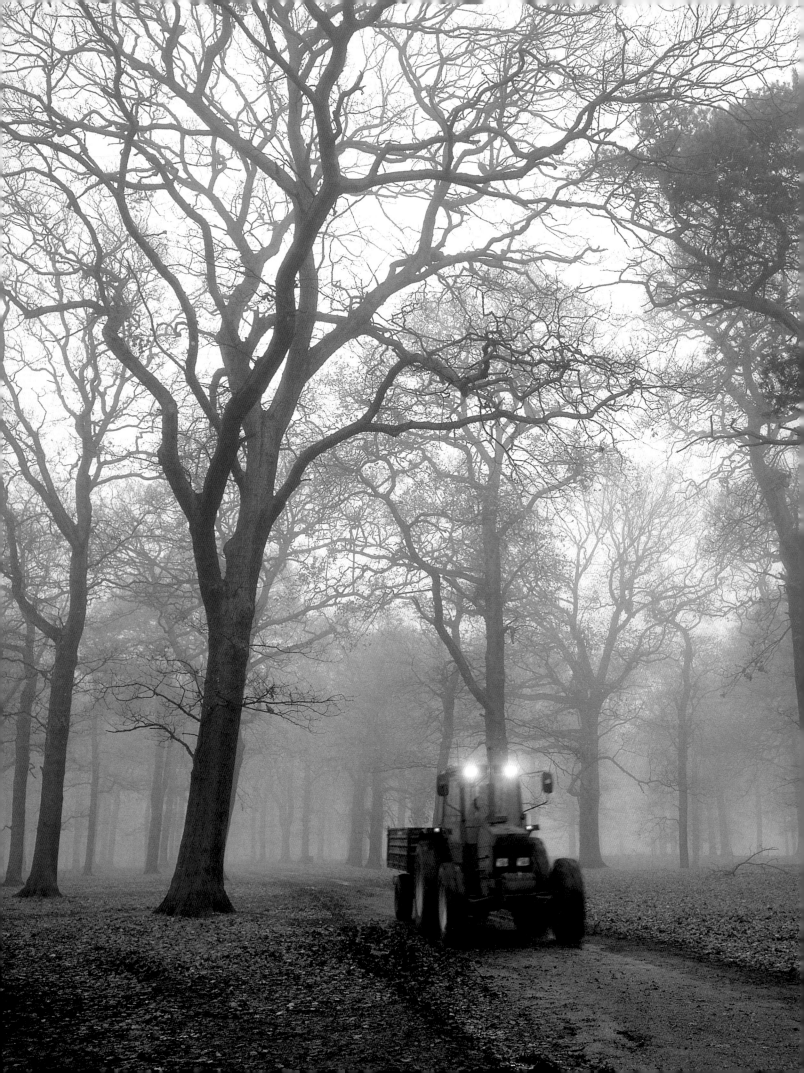

INTRODUCTION GARRY OLSON AND PETER TOAIG

Just after midday, on Friday 27 November 1998, a 170-year-old oak tree was cut down. As the watching crowd felt the thud passing through the ground, a round of polite applause broke out. This event was the launch of the onetree project.

By telling the full story of a single tree in this book we hope to impress upon its readers the extraordinary value of trees to our society, the unique beauty and versatility of wood as a material and the creative talents of over seventy artists and makers whose work is illustrated.

Our tree grew near the edge of Boat House Wood, which overlooks a lake in Tatton Park, Cheshire. The wood is grazed by deer farmed in the park, and the short grass makes a lovely shaded spot for picnickers on hot summer days. The day of the felling was damp and cold. Small groups of people huddled together, patiently waiting for the final cut. Excitement and anticipation were tempered by the seriousness of the act. Everyone knew what was planned for this tree and there was tremendous optimism about what we could achieve. Despite this, there was an underlying sense of guilt at bringing an end to such a long life.

The tree had been stripped of all its upper branches, one by one, throughout the morning. Mark Hatch, the tree surgeon performing the task, held us all spellbound as he climbed around the crown with his chainsaw – engine running – dangling from his belt. This trimming was done to prevent the tree from catching the branches of its near neighbours, and to avoid the impact on limbs driving splits deep into the trunk. What was left of the tree before it finally came to ground did not look very impressive to the onlookers standing around. The massive trunk, at over 6 m (20 ft.) in height, represented less than a third of the tree's previous height, yet there was a shock to the senses as it hit the ground and we could truly appreciate its bulk.

Once the felling was complete, and after soup, sandwiches and some enthusiastic discussion, we all went our separate ways, leaving the tree sprawled over the ground. The next task to be tackled was converting

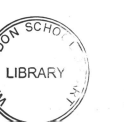

the huge log to more manageable sections of timber. This would also reveal any faults concealed within the trunk. It is quite common for trees to have major splits, areas of rot and other damage covered up by years of growth. Scarring on one of the largest limbs indicated a lightning strike, which might have had a serious effect.

Before the felling we had mentioned the idea of onetree to many people. One of them was Lucinda Nimmo, a sales representative from Whitmore's Timber, doing her rounds. She suggested we contact her Managing Director, Paul Magoris, to ask if they could help by milling our tree. In Paul we could not have had more willing or enthusiastic support. He recognized the relevance of our aims to his industry and offered his milling facility for free. Lucinda represented the company at the felling event, and three weeks later the massive trunk and the largest limb were being hosed down, tested for metal and swung along the gantry towards the giant bandsaw in their mill in Leicestershire.

Before slicing the tree into boards we had to cut it twice across its almost 1 m (39 in.) diameter. The first chainsaw cut divided the length into more manageable sections, 4 m and 2 m (13 ft. 2 in. and 6 ft. 7 in.) long. The second provided a 10 cm (4 in.) thick slab from the base of the trunk. This cross-section was later flattened and polished to display clearly the growth rings, which were studied by Jonathan Lageard for his analysis of the tree's life (p. 29).

The mill was a noisy, busy place with a team of men supporting the saw by preparing logs and stacking planks for seasoning. Our main log weighed several tons, but the turning arms flipped it lightly on the carriage that clamped it in place during each cut. The scream and awesome power of the saw were overshadowed by the accuracy of the whole process and the well-ordered efficiency.

We had decided in advance that we would saw the main trunk into planks from 18 to 50 mm (3/4 to 2 in.) thick. Later, some applicants to the project were disappointed that we didn't have thicker material, but it would have taken too long to dry.

Planning each saw cut was of crucial importance, and we had to bear in mind what would be made from each section. For example, the

Alan Peters

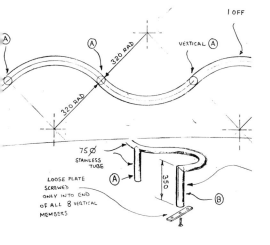

Andrew Varah

thinnest materials would probably be used in fine furniture, so they needed to be the most stable (the least likely to warp or shrink). This quality is found in boards that come from near the radius of the trunk, at right angles to the growth rings. Quarter-sawn boards, as they are called, also have the advantage of showing the attractive figure of the medullary rays. Particularly prominent in oak, these vessels carry stored nutrients between the growing outer layer of the tree and the heartwood. When exposed the rays produce wonderful silvery streaks in the surface of the wood, as can be seen in Alan Peters's Romanian-inspired chest (pp. 124–25).

We wanted to have at least one board from the largest section of the trunk kept whole, which would show a cross-section of the tree, giving an impression of its size and shape. This was to be 50 mm (2 in.) thick but still needed to be as stable as possible, so it was cut to one side of the quarter-sawn boards. This board can be seen in Andrew Varah's massive bench (pp. 166–67).

G.O.: *The milling was full of tension for me. I had never done this before and here I was directing sawyer John Coulton, knowing that you get only one chance. The saw was stopped after each cut for me to decide on the next one. Sawmill manager Barrie Hardy was on hand to give advice, but he was scarcely needed as it soon became apparent that our tree was a prime specimen. As each plank fell away from that huge blade worries dissolved and the tension turned into excitement and delight. There was great satisfaction in seeing that neat stack of perfect planks at the end of the conveyor belt.*

Three large bags of sawdust were scooped up from beneath the saw. Later these were put to three very diverse uses. Mike Dodd made a wood-ash glaze for his pots (pp. 64–65), David Grimshaw combined the dust with resin to make a table top (pp. 76–77), and John Ward at The Cheshire Smokehouse took a bag to smoke a ham (pp. 50–51).

It was inevitable that, no matter how the tree was sawn, there would be certain products and processes that would be excluded. For example, a traditional use of oak is the construction of beer casks by a cooper, who takes advantage of the same tannic-acid properties as

does the tanner or the food smoker. To make a cask, however, one needs a whole, round section of a perfect trunk. It is a wasteful process, and we couldn't afford to lose any length on those valuable planks, so a cask doesn't feature in our exhibition. It's a great pity, as we would love to have served a onetree brew to guests on the opening night of the *onetree* exhibition.

Another area of under-represented work is heavy construction. Here the project is guilty of imbalance, as most oak still goes into the building industry. Because of its renowned strength and durability, oak has traditionally been the first choice in Britain for timber-framed buildings, flooring, fence posts, bridges, canals, wagons and ships. However, we had only one tree. The 1:3-scale crown-post truss by Treasure & Son (pp. 162–63) is a proud example of the responsible use of oak as a building material today.

The sawn timber stayed with Whitmore's, who left it undisturbed in their open yard for a year and a half. The boards were separated with sticks to allow for even air flow around all surfaces. This period of 'air drying', or seasoning, was very important for the future stability and working qualities of the wood but hardly long enough for many purposes. The aim is to allow the water held in the fibres of the wood to leave very slowly until the moisture content of the plank has reached an equilibrium with the relative humidity of the surrounding atmosphere. We knew that makers would have to continue the process once they took possession, right up to the deadline for finishing work.

While the slow process of drying out the wood progressed, we were working hard to confirm uses for all of it. We knew lots of furniture makers and had already asked a handful if they thought the idea could work. A core group was formed from makers with long experience and good reputations. With these people behind the project we knew we had a platform for success and we could start to fill the huge gaps in the range of work. By word of mouth and by placing small notices in a number of publications we began to attract interest. A deadline for applications was set, and day by day they arrived. An astonishing variety of ideas came in, from down-to-earth practical ideas to wildly

Stacks of seasoning timber

imaginative art projects. The enthusiasm and goodwill we were receiving was overwhelming, and it was becoming clear we could fill any exhibition space we could find.

We could not have achieved as much as we have without the help of experts at various stages of the project. Lesley Jackson worked for onetree for only a few weeks but had a dramatic impact. Her professional approach turned the project upside-down but left it with a realistic budget, an achievable timetable and the basis of the final body of work represented here. The results of the project would be poorer without her influence. Selecting makers and potential exhibits from the applications received was a difficult job completed by us, Lesley and arts journalist Lynne Walker, a long-term friend of the project.

P.T.: *The only occasion that ever caused me to regret starting onetree was the selection meeting. I had thought only of all the exciting work we were going to approve and include. The fact that we rejected around half of the applications was a deep shock. Having been on the other side of this process, I knew the disappointment we were creating. Worse still, I felt myself completely inadequate to judge another person's life's work. I felt physically ill for days after. With hindsight it was a necessary evil. We rejected some very good artists and makers who would have made valuable contributions … but we had to do it.*

Lesley's involvement with onetree ended shortly after selection because she felt she could not commit enough time to the ever-growing project. Without her strong influence the direction changed subtly. The collection of work made from onetree is not an exhibition moulded by a curator. We gave almost complete freedom to the artists and makers we had selected, and the result is a collection of work of extraordinary variety.

Having selected artists, makers, designers and manufacturers from across Britain, we now had to get materials to them. Onetree has always been short of funds, perhaps because it does not fit easily into the categories of grant-giving bodies. The cost of transporting timber was a major problem, and without the help of County Car and Van Hire, of Stockport, we would not have been able to reach the furthest

corners of the country with massive lumps of timber. They never refused our requests for a van or a truck, and whatever we needed was provided without charge.

In the spring and summer of 2000 we visited Whitmore's many times, to load a truck or to meet makers who wanted to collect their allocation. These trips were a wonderful experience, not least because we were usually met by enthusiastic people who had taken the project to heart. Getting to know the marvellous mix of personalities involved in onetree was ample reward for the long hours we worked.

We will never forget the day we delivered a large branch to Richard La Trobe-Bateman in deepest Somerset. This was very early in the project, as Richard wanted to work the wood while it was still wet, or 'green'. His technique is to rive the wood along the radial lines. This is a very low-tech process as it uses hand tools only, but because it follows the fibres of the wood it maximizes its inherent strength. The resulting distinctive texture can be seen in Richard's chair (pp. 98–99). We loaded the branch at Tatton, and after several hours hit serious traffic in Bristol, followed by the congestion of the Glastonbury Festival. We arrived late, exhausted and deflated. Richard was the perfect medicine. His eager chatter and boyish zeal, not to mention his creative brilliance, lifted us enormously. The drive home was no hardship at all.

There was great contrast in the places to which we delivered. The designer Robin Day sought the help of his old acquaintance Floris van den Broecke, who is now the director of design at Ercol Furniture. Ercol are based in the famous furniture-making town of High Wycombe and have a factory employing four hundred people. It was a treat to be given a guided tour. They agreed to make a set of four of Robin's chairs (pp. 60–61) in their prototype shop, and thanks are due to Quinton Harwood for making a fine job of them. At the other extreme, Neil Taylor works in the corner of a field in rural Gloucestershire. We arrived well after dark and Neil had understandably gone home. We dropped his timber over the fence and left a note on the gatepost, hoping that in the pitch black we had found the right field.

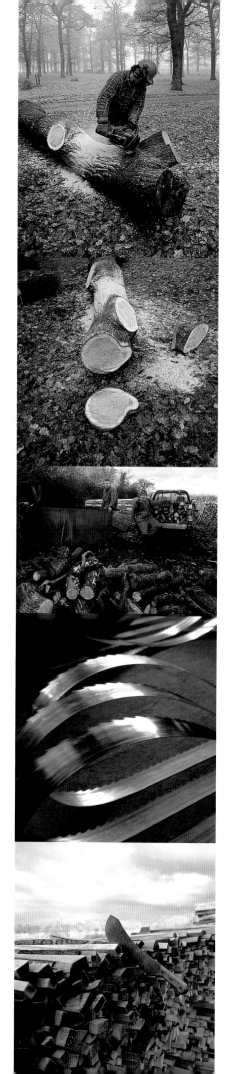

More than once, finding a workshop or studio was a real challenge. John Coleman hides in a maze of narrow lanes and one-way streets in central London, while ELAM Joinery is based on a very isolated farm in the picturesque hills of mid-Wales. Both locations have geographical benefits as well as problems, but are as different as traffic lights and cattle-grids.

As well as storing sawn timber at Whitmore's we had a huge quantity of branches stacked at Tatton Park, ranging from mighty limbs, half a metre thick, to tiny twigs. Normally this pile would not have had any commercial value beyond firewood, but our aim was to use the whole tree and open people's eyes to the potential. It was stored away from the visitor areas and protected from the deer herd, which would have stripped the bark if given a chance.

One artist authorized to strip the bark was Helen Knowles, who also used deer hides provided by Tatton Park. The high tannic-acid content of oak bark has led to its use in tanning leather for centuries, although modern practices use more predictable industrial chemicals. Helen's work (pp. 96–97) represented an experiment in tanning carried out while she was artist-in-residence at Jodrell Bank, home to the Lovell Telescope, less than ten miles from the park.

G.O.: *Many participants made the trip to Tatton to select branches from that pile. I met them all and enjoyed the process. It was fascinating to watch people select exactly what they wished or decide what they wanted to make, based on what was available. The park became very familiar. I felt that our patch was a private oasis and that, in a small way, I belonged.*

Slowly the pile dwindled. Photographs were taken of the largest limbs so that some participants could select from a distance. Two giant branches were trucked to Alison Crowther in Hampshire and two more to David Mach in London. One was sent to Philip A. Cheshire Ltd in London to be sliced into veneers. By slicing the log with a huge and super-sharp blade, they produced an amazing number of uniform sheets around 1 mm (1/16 in.) thick. These were used in brilliantly diverse ways by Max Cooper (pp. 56–57), Michael Leigh (pp. 100–01) and De Stockton (pp. 148–49).

Jane Whitaker, print taken from a rough-sawn plank (see pp. 176–77)

When all the selected participants had satisfied their needs, charcoal burner Carl Cooper filled his truck with a ton of wood. This was a kiln load for Carl, and his work demonstrates that a woodland activity (p. 160–61) that many people assume to be a thing of the past is still relevant and valuable. More branches remain, and it has been suggested that the final use should be a bonfire as a symbol of mankind's greatest debt to trees – fuel.

The geographical spread of those makers selected for onetree is wide and varied, with only a couple of disappointing bare patches on the map of mainland Britain. Most areas of England are represented, with a sprinkling of participants from Scotland and Wales. The heaviest concentration is in the North West of England. The tree came from this region and the project received a great deal of local publicity. Since one of our aims is to promote native woodland as a local resource, this bias seems appropriate. Cheshire County Council, which administers Tatton Park, adopted onetree as a project to support and its Arts Services provided some publicity and funding, as did North West Arts Board and Macclesfield Borough Council.

De Stockton

Cheshire County Council sponsored residencies by two artists in Tatton Park during 2000. The first, in early March, featured chain-saw sculptor Giles Kent, who transformed the root ball (pp. 90–91) that had been dug up several months before. Giles had to work in appalling weather, which restricted visitors at the time, but his sculpture has been on show in the park ever since and has gained much admiration. During that week poet Joan Poulson held a creative-writing workshop for local school children who were following the project. Joan has been dedicated to onetree from the start and has visited many of the artists involved as well as spending many hours in the park. She has produced a very significant body of work as part of the onetree legacy.

G.O.: *Before the root ball was ready for Giles to carve, several tons of compacted clay and stones had to be removed from it. First attempts, with pressure hoses, were tearing off the fine network of roots that had once supported the tree, so the job had to be done with hand tools over three weekends of patient work. Thanks to family and friends who helped.*

The second residency was an opportunity for environmental artists Trudi Entwistle and Lorna Green to combine their efforts in making a sculpture from onetree branches (pp. 74–75). They held centre stage on Cheshire County Council's stand at the Royal Horticultural Society's show in July 2000. In total contrast to Giles they had bright, hot sunshine and thousands of curious visitors to inform and entertain.

It was planned that all the work would be completed during the year 2000, but once the materials had been delivered the project was relying on the energy and dedication of individuals to complete their tasks. Most had received their part of the tree in the first half of the year, but there were a thousand reasons for putting off the job. Most of those reasons were very good ones, such as the need for the timber to dry further in centrally heated conditions. The biggest problem that most faced was the need to make a living. Orders for other work had to be won or completed and customers had to be satisfied. When under commercial pressure it is easy to put aside speculative work like onetree. Consequently the deadline of 31 December 2000 loomed quickly, and people worked long hours in the final weeks to complete on time.

Some had their own deadlines. Ceramicist Robin Welch sent his grand pot with wood-ash glaze (pp. 174–75) in November before heading overseas for four months. Several were impressively organized and delivered with weeks to spare. One of these was Maggy Stead, who took responsibility for completing work on wood delivered to her husband Tim Stead, who sadly died in April 2000. *Homage*, a magnificent three-dimensional jigsaw (pp. 146–47), had been sensitively made by David Lightly, who now runs Tim's workshop. It was a great source of fun and a privilege to receive.

As the deadline approached it was clear that many were going to miss it, with all sorts of extraneous problems being allowed for: flooded studios, illness, broken-down vehicles and heavy snow inhibiting travel between Christmas and New Year. Maybe it was unwise to set such a deadline at this time of year. A major national carrier, to everyone's distress and anguish, lost a parcel from toymaker Robert

Race. Fortunately, Robert's work doesn't use large quantities of wood. We sent him more and to his great credit he duplicated his enchanting automata (pp. 132–33) within a fortnight.

Throughout January 2001 products rolled in, and as they arrived they were ferried to Robert Walker's photographic studio in central Manchester, where they were shot in preparation for this publication. The last week was put aside for the largest items to be photographed in a separate ground-floor space. Many of the biggest sections of wood had returned no smaller than when they left. The heaviest items took at least four strong people to lift, and Robert kept repeating "don't mark that white floor …".

When it was all over there was great satisfaction, not just because a difficult job was done but because a significant stage in the project had been reached. Through the creative talents of over seventy committed people onetree was living again.

The work produced was now waiting for the year-long tour that had been formulated by exhibition organizers John Williams and Gaby Porter. Opening at the Royal Botanic Garden Edinburgh, the collection would then move on to four venues across England.

"It is very sad when a tree is felled, but trees are not immortal and it is better that they are felled before they fall. If the timber is usable, then the tree has achieved its maximum potential."
Tim Stead

P.T.: *During the five years I shared Garry's Wilmslow workshop, lunchtimes were always a time for deep discussion. Making one-off pieces of furniture calls for long periods of concentration and equally long periods of noisy and repetitive work. With the ear protectors off, thoughts that had been stewing would flow and bounce between us. Onetree was such a simple idea, I just slipped it into the conversation. Soon, though, it began to take hold. The possibilities came thick and fast. It was obviously a powerful concept; why wasn't somebody doing it? Back to work and the idea was put on a back burner. There it stayed, with occasional stirring, for many months.*

I had a three-month spell away from the workshop and was reassessing where I wanted to take my career when Garry rekindled the onetree fire. It was exactly the kind of challenge I was after, but it looked too big for one person. I asked Garry if he would help, and foolishly he agreed. If we had known then how much work would be involved we would have talked ourselves out of it. This naïvety has been the hallmark of our approach ever since.

A woman once came into our furniture workshop and was admiring a finely finished piece. She then noticed a stack of rough-sawn timber, with the bark still attached, in the corner of the room. Astonished, she asked, "You don't really start with that, do you?"

For many of us environmental responsibility means little more than an occasional visit to the bottle bank. Yet all the time we are making decisions that have an impact on our environment, locally and globally. If we don't know where the products we buy come from, how can we know what effects our purchases are having?

Scientists have finally agreed that the earth is getting warmer, and most agree that carbon dioxide released by the burning of fossil fuels is a factor in this. It is also well known that the effect trees have on the environment is to reduce carbon dioxide in the atmosphere. As a result many companies are claiming to have a 'carbon-neutral policy' by planting trees to offset the carbon dioxide they produce. The carbon locked away in the cells of the tree is released only when the

wood rots, is eaten or is burnt. Every piece of wood shown in this book contains carbon extracted from the atmosphere over the 170 years of our tree's life.

Since the sixteenth century non-native wood has been fashionable in Britain. The fine texture and colour of walnut, mahogany and satin-wood seemed so much more refined to the people who could afford them. The effects of this world trade in timber were truly dramatic. The mahogany bought today is completely different from that used by Chippendale. Cuban and Honduran mahogany is no longer available because it was felled into virtual extinction. Sustainable production of timber in managed forests has recently been introduced to many areas across the world, but replacing the destroyed rain-forests with plantations does not reinstate the ecosystem that previously existed.

British woodlands do not contain the variety of life seen in the rainforests of South America and other areas of the world. Our climate is not as favourable, our woodland is not as old and we have manipulated the ecosystem to our own ends for thousands of years. This does not mean we shouldn't safeguard what we have. The pockets of wild places we have left should be protected and, where possible, allowed to expand. The artificial environments that have been created also have their place and support sometimes unique ecosystems, particularly where the practices that have created these environments have been carried on for many generations. The production of timber itself can be seen as a superb example of organic farming. The saplings that are planted in place of our tree will hopefully provide materials for artisans in centuries to come. In the meantime they will form part of a beautiful landscape and be enjoyed by generations of visitors to Tatton Park.

Although the responsible use of native timber is undoubtedly beneficial, a lot of the waste produced is not effectively recycled. The valuable part of an oak tree is the main trunk, from just above ground level to just below the first major branching. In a managed woodland careful pruning and thinning of surrounding trees forces this section to grow tall and straight, which is why our tree looks very different

from oaks standing alone in fields. Often the larger branches are sawn for fencing posts but the huge number of smaller ones are burnt or left to rot. One of our aims for onetree was to see if we could find a use for all this material and also the waste products from the milling and making processes.

If scientific predictions of a hotter world climate hold true, then the distribution of trees will change and species may disappear from Britain. Nature is, however, very resilient. Ten thousand years ago there were no trees in Britain at all. As the grip of the Ice Age relaxed and the glaciers retreated, plant life spread north, crossing the land bridge that then existed to continental Europe. Pioneer species prepared the ground for the wealth of biodiversity that followed. Finally the dominant plant species became established and a stable pattern emerged. The mix of flora and fauna in each area was determined in part by the species that dominated the area. The oak held this pivotal position across large areas of Britain.

Part of the northward flow of life was humanity. Our history and the natural history of Britain have been intertwined ever since. Mankind has always exploited trees as a source of fuel and construction materials. This does not mean that they were treated without respect. Ancient Britons worshipped and revered trees, the oak above all. This respect, though, did not halt the relentless erosion of the forested area as the population increased and farming practices developed. Times of war led to more rapid deforestation as oaks, in particular, were required for shipbuilding.

What we have left in Britain today is an environment shaped by our own activity. Beautiful as it is, the British countryside is not natural. Tatton Park is a perfect example. Although many records have been lost it is clear that the trees in the park were planted partly to create the landscape that is visible today, but also to provide a source of a valuable material.

When we first started looking for a tree we wrote to the National Trust and to a number of estates near our Wilmslow workshop. Tatton was one of these, but, in fact, we were first offered several

trees by another National Trust property. A small area was due to be cleared of large trees to increase airspace for the second runway at Manchester Airport. Although it would have been sensible to make good use of these trees in some way, we decided that our message would become very confused. It was a good choice as, a few months later, environmentalists took up residence in protest. (We deeply sympathize with protesters who try to stop trees from being demolished for road building and such projects as the airport runway. Clearing a whole area of woodland and covering it with tarmac is a brutal thing to do. Somehow, society has to weigh up how highly it values these amenities in comparison with what is being lost. Hopefully this project will add a few votes for the trees.)

The foresters at Tatton Park had recently won an award for their woodland management, and when we visited them to talk about the project we could see why. Regular visitors to the park would barely notice the work of Brian Goulden and his team as they manage the estate. The woods through which the public walk seem a permanent part of the landscape, as they are. Individual trees, however, are regularly felled. Local furniture makers and joiners can buy timber from the estate, sawn from these trees. We were convinced that this was the ideal model of timber production, so we asked the park if they could provide us with both a tree and an exhibition venue. They enthusiastically agreed.

The choice of the tree was made very carefully. Brian wanted to fell trees selectively in Boat House Wood, which is formed mostly of large oaks. The deer that graze the woodland floor, making it so attractive to visitors, also eat any saplings that are seeded naturally. New trees have to be carefully introduced in deer-proof cages to ensure a future for the wood. In order for the trees to thrive sunlight has to be allowed through the canopy, hence the need to fell trees. Signs of dieback had been seen in some of the trees, and these would be the best ones to fell. We had to wait until they were in full leaf before a decision could be reached. From our point of view, we wanted to show how much could be achieved with a typical oak tree of commercial value. We also wanted a tree without major faults: damage to

the timber would severely restrict the range of work we could show. The choice was finally made in the summer of 1998 and the felling date set.

In the autumn of the same year we were hoping to collect a good crop of acorns to pass on the tree's DNA. We had visions of a thousand, healthy, two-year-old saplings potted for sale at our first exhibition. This was not unrealistic as a mature oak produces up to 90,000 acorns in a good year. Owing to a combination of unusual circumstances, however, 1998 had the worst possible crop of acorns throughout the country. First there was poor weather; then there was an invasion from Eastern Europe of wasps that hatch their larvae inside acorns. Heavy rain knocked off flowers, and, to make matters worse, the damp weather at the end of summer encouraged the growth of a mildew-like fungus, which spoiled millions of acorns.

Bexton County Primary School, near Tatton Park, was keen to involve a group of its pupils in onetree. We met teacher Yvonne Seymour and a dozen children under the tree two months before it was due to be felled. The children didn't realize how many acorns there should have been. They ran around excitedly collecting what they could. After three visits they had twenty-four acorns and were pleased. Of the twenty-four most were suffering from insect and fungal attack, but they were all put in pots and given their chance. In the following spring, to everyone's joy, two germinated and they have been nervously tended by Yvonne ever since.

P.T.: *At the time of going to press we haven't decided what will become of the two saplings. I hope that at least one of them will be planted in a managed woodland. I look forward to the time, around my two-hundredth birthday, when I can go to see the exhibition of work made from onetree – the second generation.*

In felling and taking onetree and planting new trees in its place we are part of a chain of custody of the landscape. This landscape will not persist without active management. We owe it to our ancestors, who planted the tree around 170 years ago, to share their foresight. Equally, we owe it to our descendants who will see the collected acorns reach maturity sometime next century.

WHAT IS A TREE RING?

Oak trees in the British Isles generally grow in response to seasonal weather patterns. Most of us know that in every calendar year trees produce a tree ring, and if we chance upon a felled tree we can count its rings and determine the tree's age. A tree ring does not, however, represent growth throughout the whole year, as trees 'shut down' in autumn and winter. Wood that forms the tree ring is generated in a layer under the bark called the cambium, and cambial activity in oak trees has been recorded from April through to September. An oak-tree ring reflects this growing season, and its structure has two distinct phases: the early wood (spring growth) and late wood (summer growth). The distinctive structure of an oak-tree ring is shown below.

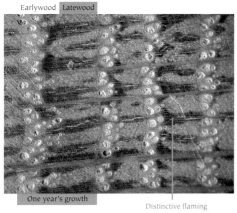

Earlywood Latewood

One year's growth

Distinctive flaming
pattern of oak-tree rings

The combined records of oak trees in one geographical area (calculated using average ring-widths) are known to be a good reflection of regional weather conditions. The tree-ring record of individual trees, however, may also reflect other tree-specific factors, such as defoliation by insects or the loss of a branch. As a result, it is often difficult to demonstrate the direct influence of factors such as temperature or rainfall on the ring-width record of a single tree. Land and/or woodland management may also be important influences on tree growth, particularly in parkland settings such as Tatton.

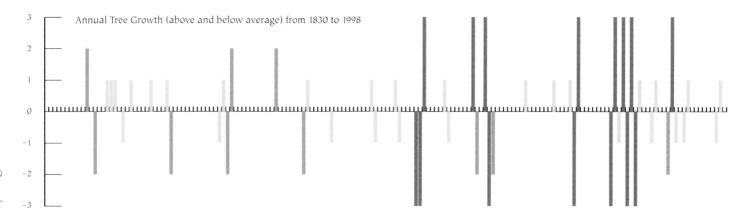

Annual Tree Growth (above and below average) from 1830 to 1998

THE HISTORY OF ONETREE: BOAT HOUSE WOOD, TATTON PARK JONATHAN LAGEARD

Onetree: oak tree (*Quercus robur*), felled on 27 November 1998 in Boat House Wood, Tatton Park

1830
Germination.

?1830–40
One of several saplings planted in Boat House Wood.

1842
Poor growth year: recurrent April drought 1839–42; insufficient access to water.

1875
Poor growth year: recurrent April drought 1873–75.

1887
Good growth year.

1892
Local historical records document a harsh winter. Onetree showed little ring-width response (spring most important period for oak growth); benefited from sheltered location within wood.

1922–23
Poor growth years: low rainfall May 1922 and June 1923.

1936
Start of a period of growth release (wider rings), possibly due to felling of surrounding trees or a change in local management practices, such as removal of grazing animals.

1939
Good growth year: recovery after drought in April 1938.

c. 1960
Loss of woodland-management records in a fire at Tatton Park.

1967
Deer, sheep and cattle allowed to graze within Boat House Wood – previously excluded. Possible negative effects could include reduced chance of seedling establishment and soil compaction (puddling), leading to root damage. Conversely, reduced competition from grass and added nutrients from dung could be beneficial to tree growth.

1970
Poor growth year: low rainfall May 1970.

1973
Good growth year.

1974
Poor growth year: joint-lowest April rainfall (4 mm) for nearly 200 years.

1976
Gale on 2 January: Mature trees, notably beeches, uprooted in Tatton Park. Poor growth year. Summer drought affecting most of Britain reflected in the Manchester Ringway temperature record.

1984–85
Winter: selective felling of ten oak trees from Boat House Wood and their sale for veneers and high-quality planking. Removal of competition (for sunlight and nutrients) from neighbouring trees may be reflected in the significantly wide ring for 1985.

1988–89
Winter: selective felling of twenty oak trees from Boat House Wood and their sale for veneers and high-quality planking. Similar but less dramatic effect on ring width to 1984–85.

1990–98
Decline and die-back of some mature oak trees in Boat House Wood and elsewhere in Tatton Park – trees studied by researchers from the Forestry Commission. Disease thought to be primarily the result of drought (increasing incidence since mid-1970s) exacerbated by other stresses such as defoliation by insects or oak mildew. Similar symptoms were first noted in north Lincolnshire in 1989.

1998
Summer: onetree selected for felling – showed signs of die-back (sparse leaf cover making the crown appear open – leaves in clumps and some yellow and malformed).
Felled 27 November.

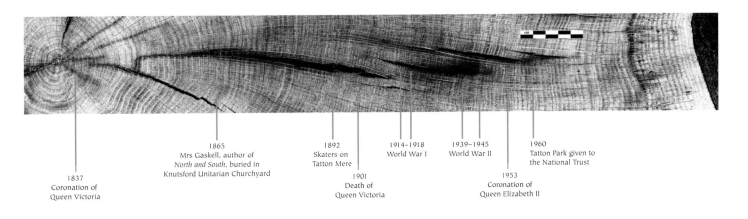

1837
Coronation of
Queen Victoria

1865
Mrs Gaskell, author of
North and South, buried in
Knutsford Unitarian Churchyard

1892
Skaters on
Tatton Mere

1901
Death of
Queen Victoria

1914–1918
World War I

1939–1945
World War II

1953
Coronation of
Queen Elizabeth II

1960
Tatton Park given to
the National Trust

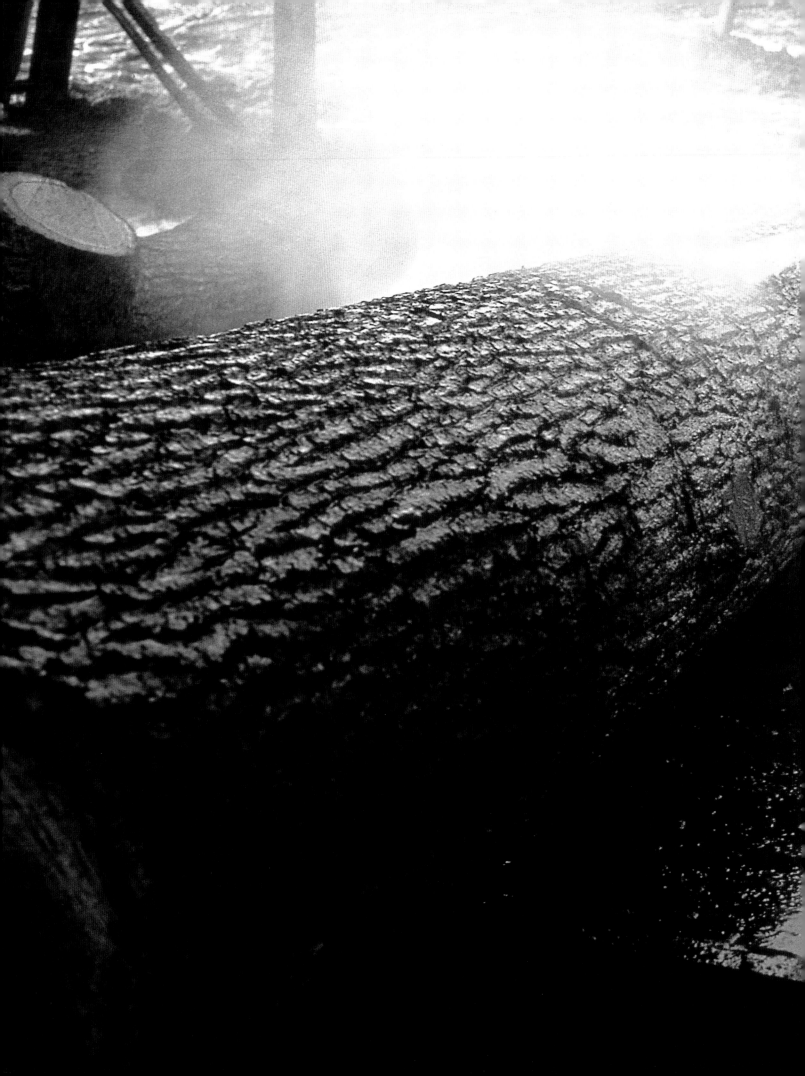

PROJECT PHOTOGRAPHER ROBERT WALKER

"I have always had a keen interest in crafts and contemporary design. Over recent years I have been involved with the photography for several shows held at the Artizana Gallery in Prestbury, Cheshire, including their major exhibition showcasing the work of the late Tim Stead. Through Artizana, I met Garry Olson and heard about the concept for onetree. From the start I felt this was an important project and was keen to be part of it.

I should like to thank the following people who have made significant contributions to the photography and, through this, to onetree as a whole. They are: Richard Scholey; Martin Manning of Fuji Film; Norman Dutson of R.S. Colour Processing; Ann Mulqueeny of G.B.M. Digital Services; Susan Walker for black-and-white prints; and my assistants Paul Moffat, Hugo Wilkinson, Karl Taylor and Mark Winkley." *Robert Walker*

Robert Walker was born in Manchester in 1960. He set up his first studio in 1981, specializing in advertising photography. Both his commercial and personal work have been widely exhibited at venues including the Barbican Centre, London; the Royal College of Art, London; the Dean Clough Design Gallery; the Association of Photographers Gallery; Viewpoint Photographic Gallery; and the Design Innovation Centre.

Robert's commercial work has won numerous prestigious awards from such organizations as the Creative Circle, the Association of Photographers, Campaign, Epica, Roses, D&AD, the Art Directors' Guild (New York) and the London International Advertising Awards. His commercial clients include Adidas, Arthur Andersen, Co-operative Bank, Ellesse, Esso, Goretex, ICI, Mercedes-Benz, National Westminster Bank, Olympus Cameras, Peugeot, RCA Records, Reebok, Sharp and Weetabix.

In his personal work, Robert's main interest has always been portraiture. He has completed a series of portraits of British boxers, including Prince Naseem and Lennox Lewis. Other well-known subjects include Vivienne Westwood, Quentin Crisp, Robbie Williams and George Melly.

ARCHITECTURE

ASH-GLAZED CERAMICS

AUTOMATA

BASKETS

BOOKS

BOXES

DRAWINGS

ROOTS SMOKED FOOD

TRUNK FURNITURE

BRANCHES JEWELLERY

BARK JOINERY

TWIGS MEDICAL INSTRUMENTS

LEAVES PAPER

ACORNS POETRY

SHAVINGS SCULPTURE

SAWDUST TABLEWARE

COMPOST TOYS

CHARCOAL VESSELS

onetree seventy-four artists WOOD SMOKE WOODCARVINGS

STEPHEN BAILEY

NICK BARBERTON

JOHN BELL

LEE BREWSTER

ANTHONY BRYANT

MATTHEW BURT

ROB CADE

THE CHESHIRE SMOKEHOUSE
 – JOHN WARD

VALERIE CLARKE

JOHN COLEMAN

MAX COOPER

ALISON CROWTHER

ROBIN DAY

JANE DILLON AND TOM GRIEVES

MIKE DODD

GILIAN DYE AND
 DERRICK EARNSHAW

SIMON EASTON

ELAM JOINERY
 – HYWEL EVANS

LORNA GREEN

LORNA GREEN AND
 TRUDI ENTWISTLE

DAVID GRIMSHAW

THOMAS HAWSON

MARK HUMPHREYS

ROBERT INGHAM

HELEN JOHNSON

OWEN JONES

MIYUKI KASAHARA

GILES KENT

RAY KEY

ROBERT KILVINGTON

HELEN KNOWLES

RICHARD LA TROBE-BATEMAN

MICHAEL LEIGH

PETER LLOYD

DAVID MACH

JOHN MAINWARING

GUY MARTIN WITH CHRIS FOGG

PAULA MCNAMARA

JULIE MILES

JO MILLS

ROBIN NOTT

GARRY OLSON

TRACY OWEN

CATH PEARSON

ALAN PETERS OBE

JOAN POULSON

PRUDEN &
 SMITH SILVERSMITHS

ROBERT RACE

MALCA SCHOTTEN

IAN SIMPSON ARCHITECTS

ANDREW SKELTON

MICHAEL SLANEY

JEFF SOAN

PETTER SOUTHALL

THE WORKSHOP OF TIM STEAD
 – DAVID LIGHTLY

DE STOCKTON

ELIZABETH STUART SMITH

GUY TAPLIN

BRIAN TAYLOR

NEIL TAYLOR

PETER TOAIG

THE TRADITIONAL CHARCOAL CO.
 – CARL COOPER

TREASURE & SON LTD

SYANN VAN NIFTRIK

ANDREW VARAH

WALES & WALES

KATIE WALKER

LOIS WALPOLE

ROBIN WELCH

JANE WHITAKER

JULIENNE DOLPHIN WILDING

GILL WILSON

DAVID WOODROFFE

WES WOTRUBA

STEPHEN BAILEY

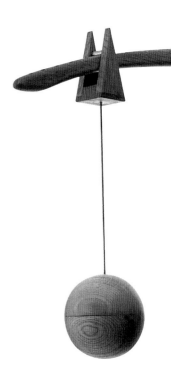

"When I heard about the onetree project I had been working on a series of globes, a project that had arisen out of a fascination with some lines of poetry:

For of Meridians, and Parallels
Man hath weav'd out a net,
and this net throwne
Upon the Heavens, and now
they are his owne.

John Donne, 'An Anatomie of the World' (1611)

Much of our success as a species results from our ability to understand and explain the world around us. The ability to describe, to make the world conform to a pattern of our devising, seemingly leads to a sense of dominion, a feeling of superiority; this in turn gives licence to turn the landscape into a man-made vista. In my piece, the globe of meridians and parallels is balanced on a knife-edge. Adding water or nutrients to the mulch requires the counterbalance to be adjusted to maintain equilibrium. Similarly, changes that occur over time without intervention, as moisture evaporates, material decomposes and the oak seedling grows, will also require adjustment.

Trees have provided the air we breathe, fire, tools, ships for those early explorers tracing the parallels and meridians, buildings to shelter us, fruits to feed us and medicines to heal us. There is nothing benign in this relationship: nature is indifferent to the survival of any particular species, and unless we maintain the balance, we could make life untenable for ourselves. Life will continue, but not necessarily for man." *Stephen Bailey*

Stephen Bailey was born in 1951 in Witham, Essex. He studied architecture (briefly) at the University of Sheffield, followed by a foundation course at Salisbury College of Art (1972–73) and a degree in 3-D design at Leeds Polytechnic (1973–76). More recently he took an MA in fine art at Leeds Metropolitan University (1998–2000).

Bailey originally practised as an interior designer, running his own consultancy for a number of years in London. His clients included IBM and Hatchard's; his publications included *Offices: A Briefing and Design Guide* (Butterworth Architecture, 1990). He moved to the Yorkshire Dales in 1988, where he now lives with his family, and teaches interior design part-time at the University of Teesside while developing his new vocation as an artist.

Stephen's work has been shown in exhibitions including *Lost and Found* at Leeds Metropolitan University Gallery (2000) and *2Day* at Keighley Arts Factory (2000–01). Published work includes a monograph on Anthony Gormley's sculpture *Angel of the North* (2000).

Balance
Oak, sawdust, leaves, twigs,
shavings, brass rod and wire, oak seedling
112 x 72 x 72 cm (44 x 28 x 28 in.)

NICK BARBERTON

"Lesley Jackson met me at the Chelsea Crafts Fair and asked me if I would be interested in joining the onetree project. I mumbled something about logistics and Manchester being a long way away and that there were lots of fallen trees locally, but information about onetree was sent to me and the excitement of the project started to sink in.

I wanted to carve one of my long vessels from a big branch section so that the sides of the bowl would follow the medullary rays and the figure would be visible. I explained my needs to Peter Toaig and Garry Olson, and they turned up at my door surprisingly quickly with my selected log on the back of their pick-up. Because time does not tiptoe when there is work to be done, I soon cut a lot of the waste away with the bandsaw and the small circular saw so that I would not have to dry too much waste. I put the roughed-out bowl in a plastic bag in my attic, where the heat would pump out some of the moisture. Once Chelsea was over I got carving. It would have been simpler to carve a curved vessel from a straight piece of wood because the chips jump out more easily. A much larger log would have given me a more distinct figure, but this is not a perfect world. This is the biggest long vessel that I have carved to date. It is going beyond the parameters of domestic use that I had previously placed on these designs. This vessel is vibrant, exciting and fun and comes from one tree." *Nick Barberton*

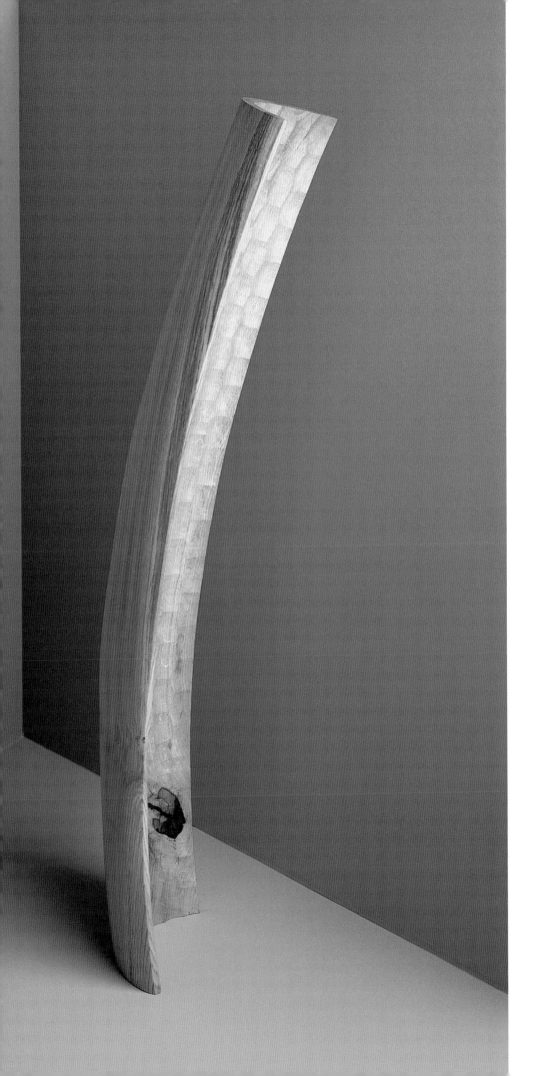

Nick Barberton was born near Cape Town, South Africa, in 1946. After school and military service in the South African navy, he went to Johannesburg College of Art, where he gained a diploma in industrial design.

Nick started work as a designer and draughtsman for a firm making wireware and point-of-sale display items, but he soon started working for himself making wooden furniture. In 1976 Nick moved with his wife and daughter to France and then to The Netherlands, where he built traditional Dutch sailing barges. In 1978 he moved to Christchurch, Dorset, to build yachts. Following a period of temporary or part-time work in various fields between 1979 and 1987, he started working full-time as a self-employed woodworker, making furniture and carvings to commission, and turning wooden bowls for craft shops and galleries.

Nick's work can be seen in several churches, mainly in Hampshire, including Winchester Cathedral. Other commissions include a garden seat at Goodwood, West Sussex, and the gates at Artsway Gallery, Sway, in the New Forest, Hampshire. He took part in the Chelsea Crafts Fair, London, in 1999 and 2000, exhibiting long, carved vessels. He was selected for the Crafts Council Index of Selected Makers in 1999.

Nick Barberton's wife, Syann van Niftrik, is also included in the onetree project (see pp. 164–65). The chips produced while carving this vessel are featured in her work.

Carved vessel
Oak
When lying down: 12 x 112 x 23 cm
(5 x 44 x 9 in.)

JOHN BELL

"I first became aware of the onetree project in an article in the *Liverpool Daily Post* on 3 March 1999. I wrote off for more information and was sent the outline plan: a large oak was being cut down at Tatton Park, the whole of which was to be used by a wide range of artists and makers.

Initially I was inspired by the project, but then thought, 'Sacrifice a great oak for art?' So I wrote back to Garry Olson to voice my concern. He reassured me that the oak needed felling and that Tatton Park had a generous replanting programme. I therefore declared my wholehearted interest in becoming involved in the project. I sent a drawing of my proposal, and this was accepted as a concept. Garry Olson brought me some fairly slim oak branches, as requested, from onetree.

I had previously produced an 'econstruction' entitled *Door I*, using an actual door with the panels removed. I inserted pieces of rough wood of various kinds into the door base, drilling into it and rebating the pieces of rough wood into the door itself. Considering that the *Door* idea had developed from the millennium (with its evocation of exits and entrances), I felt there was a strong follow-through from *Door I* to *Door II* and onetree. I constructed shuttering based on the dimensions of *Door I* and produced *Door II* without panels, with just the oak branches forming a very earthy door shape." *John Bell*

John Bell was born in 1943 in Bangor, north Wales. He studied painting at Liverpool College of Art (1961–66) and then gained an art teacher's diploma from Liverpool University in 1967. On leaving university he taught in secondary schools on Merseyside for twenty-five years, continuing with his own work throughout. In 1970 he had his first solo show at the Bluecoat Gallery, Liverpool.

In 1982 John was seconded to Goldsmiths College, London, to pursue his own work. He continued teaching and working and in 1991 became artist-in-residence on Hilbre Island, at the mouth of the Dee estuary, spending two days a week there over a period of four months.

In 1992 John took early retirement from teaching in order to concentrate fully on his work. Since then he has been invited to complete an 'Artist at Work' weekend placement at the Walker Art Gallery, Liverpool (1995), and has made a site-specific installation on Morpeth Dock, Birkenhead, for the Brouhaha International *Invisible Cities* exhibition (1996).

John's work has been exhibited in numerous solo and group shows, including, most recently, *RE-INVENTING Nature* (group exhibition), Woodlands Gallery, London (1996); *DEAD SOUND* (group exhibition of Liverpool artists), Café/Gallery, New York (1996); solo exhibitions at The View Gallery, Liverpool (1997), and Doncaster Art Gallery (1998); group exhibition, Royal National Eisteddfod of Wales (1999); and Sefton Open, Atkinson Gallery, Southport (2000).

Door II (onetree)
Oak branchwood, screws, PVA, acrylic
202 x 80 cm (79½ x 31½ in.)

LEE BREWSTER

"It doesn't matter how you look at it, you're not going to be able to climb up this tree. The frustration of putting your foot on the first rung and slipping off every time!

What a good thing it is to be part of a vision. Onetree has, over the past couple of years, come to make us feel part of a team that has a common goal. It has been like a long-distance game of chess with a friend you have never met." *Lee Brewster*

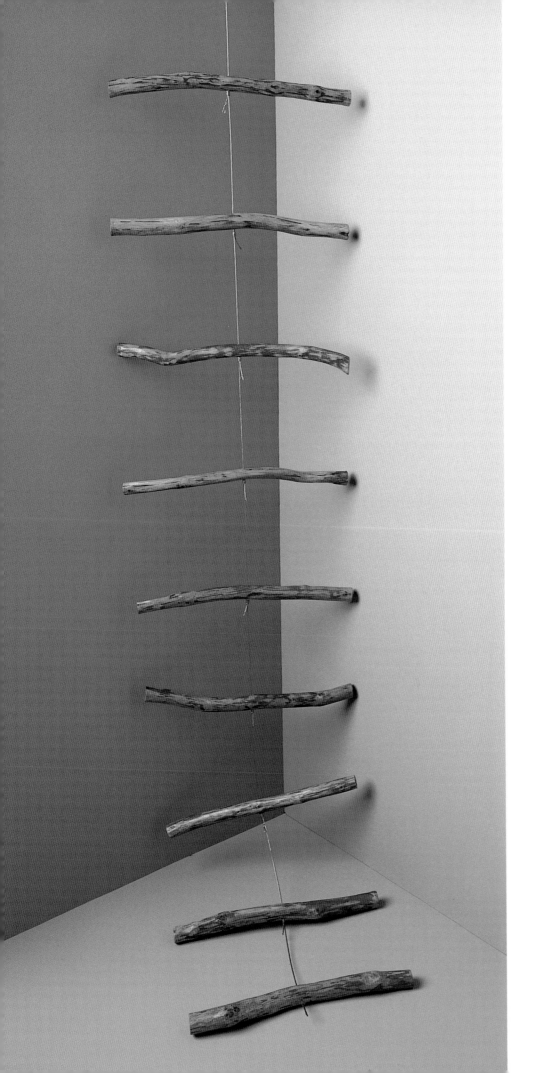

Lee Brewster was born in Essex in 1967, and studied 3-D design, specializing in furniture, at Loughborough College of Art and Design from 1988 to 1991.

Lee started his own business the year he left college, making and supplying interior products, lighting and furniture to a number of design shops in London and across the UK. Although he had some success, he found it frustrating to produce batches of small objects. He started working with a traditional timber-frame specialist in Shropshire, constructing houses and barns from green oak. With a new set of skills Lee moved to the North East and set up a small design business with his partner, Jill Cadman. Since 1984 they have worked all over the UK, producing sculpture and outdoor furniture for public places. Much of this work is community-based. Lee also teaches part-time at Northallerton College in North Yorkshire.

Tree-house Ladder
Green oak and wire
215 x 44 cm (85 x 17 in.)

ANTHONY BRYANT

"My first response was to get on the phone immediately and demand a piece as I need to work with dripping-wet wood in order to get the maximum movement out of a piece. Consequently a week later a lorry arrived which was too large to fit down my lane, and the unbelievably heavy plank was roped to my van roof for the last half mile. I turned the thin piece first and waited expectantly for it to move into an exaggerated 'U' shape. Quite surprisingly for fresh oak, it moved very little, and to be honest I was very disappointed as I had predicted it would warp into a wonderful floppy-hat shape. Part of my job is to be careful to cut up trees in such a way that I know in which direction the final piece will warp successfully. Anyway I put this large piece to one side in my workshop to dry and stored the remaining piece of oak away in my barn awaiting further instructions from onetree. Many months later Garry told me to hurry up and make another piece perhaps showing the contrast between the earlier 'wet' turned one and now something from a much drier material. I was a little concerned as I really dislike making work from predictable, dry, hard oak. However, the end result is, for me, quite satisfying since, having removed the conventional base, the piece has (with some encouragement from sitting on a hot boiler) moved considerably into an interesting form." *Anthony Bryant*

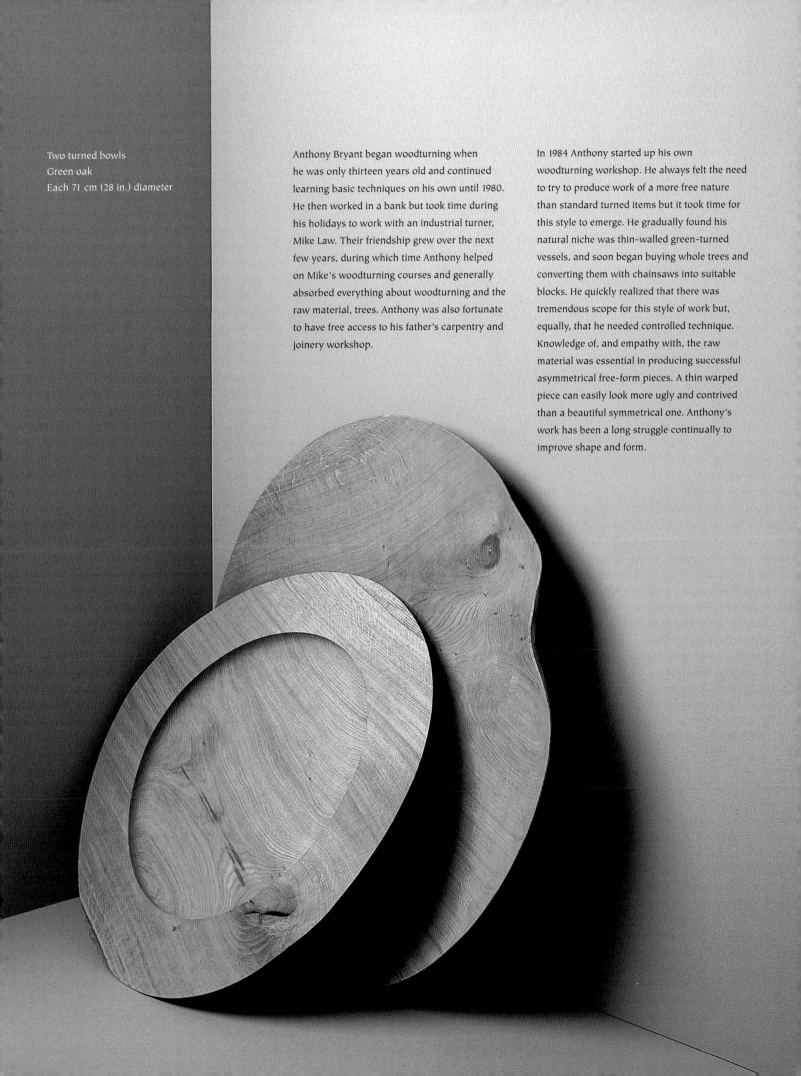

Two turned bowls
Green oak
Each 71 cm (28 in.) diameter

Anthony Bryant began woodturning when he was only thirteen years old and continued learning basic techniques on his own until 1980. He then worked in a bank but took time during his holidays to work with an industrial turner, Mike Law. Their friendship grew over the next few years, during which time Anthony helped on Mike's woodturning courses and generally absorbed everything about woodturning and the raw material, trees. Anthony was also fortunate to have free access to his father's carpentry and joinery workshop.

In 1984 Anthony started up his own woodturning workshop. He always felt the need to try to produce work of a more free nature than standard turned items but it took time for this style to emerge. He gradually found his natural niche was thin-walled green-turned vessels, and soon began buying whole trees and converting them with chainsaws into suitable blocks. He quickly realized that there was tremendous scope for this style of work but, equally, that he needed controlled technique. Knowledge of, and empathy with, the raw material was essential in producing successful asymmetrical free-form pieces. A thin warped piece can easily look more ugly and contrived than a beautiful symmetrical one. Anthony's work has been a long struggle continually to improve shape and form.

MATTHEW BURT

"I was exhibiting at a show where readers of a well-known style magazine were being given a free tour. The magazine had published articles on new trends, and furniture from 'recycled' materials had featured prominently. The readers continually breezed past my pitch with an airy 'Oh, this isn't recycled'. After half an hour of this I was stung into action, and in response declared, 'This is the ultimate recycled material. It is recycled sunshine and rainwater requiring only nurture and confidence in the future to become the most generous material available to us … it is wood.'

Congratulations to onetree for reminding us and our ingenuity of wood's timeless merits.

The piece that I've made for onetree is a seemingly simple cantilevered table, relying on the intrinsic strength of the oak to span a long unsupported surface. That surface has been 'v-grooved' to communicate the sensual and tactile delights of wood. Each facet is different and equally beautiful." *Matthew Burt*

Matthew Burt was born in Wiltshire in 1951. He graduated in zoology from Reading University in 1972 before turning to furniture-making and attending Rycotewood College, Thame, Oxfordshire, from 1973 to 1974. He served an apprenticeship under Richard Fyson until 1976.

Since setting up his workshop in 1978, Matthew has gained enormous experience as an independent designer–maker, working for both private and corporate clients. He displays and sells his work – interior and exterior pieces – at the Splinter Group showroom, Hindon, Wiltshire.

Matthew has exhibited widely throughout the UK, most recently in *Furniture for the 21st Century* (1999) at the Banqueting House, Whitehall, London; the *Celebration of Craftsmanship* exhibition (1990, 1995–2001) in Cheltenham; *Art in Action* (1996–98, 2000) at Waterperry House, near Oxford; and the Chelsea Crafts Fair (1996, 2000), London.

Matthew has been awarded Craft Guild Marks from the Worshipful Company of Furniture Makers and received design development grants from Southern Arts. He is represented on the Crafts Council Index of Selected Makers, and in 2000 he was elected a Fellow of the Royal Society of Arts and a member of the Society of Designer Craftsmen. He is furniture adviser to Southern Arts and a visiting tutor to the Letterfrack College of Fine Furniture Making in Ireland.

Recent major commissions include library furniture for Stanton Guild House, near Broadway, Worcestershire, and café furniture for the Russell-Cotes Art Gallery and Museum in Bournemouth.

Matthew's work has featured regularly in publications, including *Furniture and Cabinetmaking* magazine and *Furniture for the 21st Century* by Betty Norbury (1999).

Cantilevered table
Oak
81 x 224 x 32 cm (32 x 88 x 12½ in.)

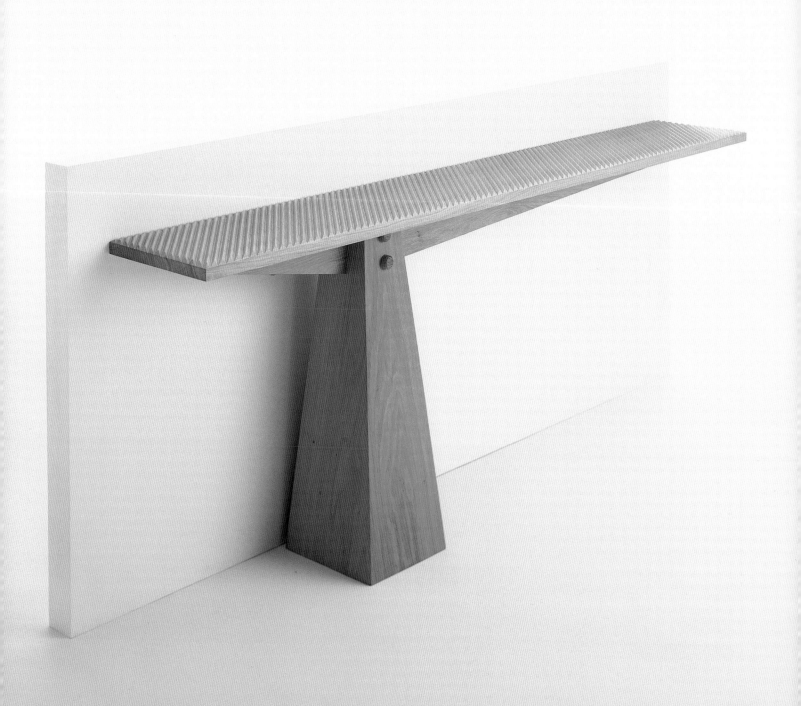

ROB CADE

"I'm interested in any project that reminds us of the importance of trees in their native environments, and I see the onetree project as a good example of this. Solid wood is a fine material, and I'm always keen to find applications where it's at least as good (and affordable) as the alternatives. I'd like to think that people will use the objects I make.

Foetal stethoscopes are made for midwives and doctors, and are used to check the foetal position and heartbeat in the later stages of pregnancy. The (Pinnard) design is a traditional one, and wood was the original material, though they're now made in metal and plastic. So why wood? It's a good conductor of sound, it's warm to the touch, and it's beautiful. Because the stethoscope is made by hand, I can ensure that the earpiece is dished for better contact with the ear, that the edges of the bell are softened and that the whole thing is a smooth, wipeable shape. It's finished with walnut oil rubbed into the grain, so it will develop a pleasing patina after a few years of use." *Rob Cade*

Rob Cade was born in Leicester in 1954. He attended Birmingham University, graduating in mathematics in 1976 and completing a teaching qualification in 1978.

Rob was introduced to woodturning by his father in 1978. He began to sell work professionally in 1980, and since then has sold and exhibited in galleries throughout the Midlands, including the Bristol Guild, Birmingham Museums and Art Gallery, Warwick Gallery, Ridware Arts Centre and Torquil Gallery in Henley-in-Arden. In 1988 his work was selected for the first Craftspace West Midlands Open Touring Exhibition.

Rob has written several articles on turning for *The Woodworker* magazine, some of which were republished in *The Woodworker Book of Turning* in 1990.

For the past fifteen years Rob has worked exclusively in European timbers, concentrating largely on the production of functional objects, such as architectural turning and turning for antique restoration.

Since 1995 Rob has been actively involved in a European Union-sponsored project to produce decorative structural materials from laminated recycled paper, and in November 2000 he exhibited pieces turned from these materials at the Ikon Gallery in Birmingham.

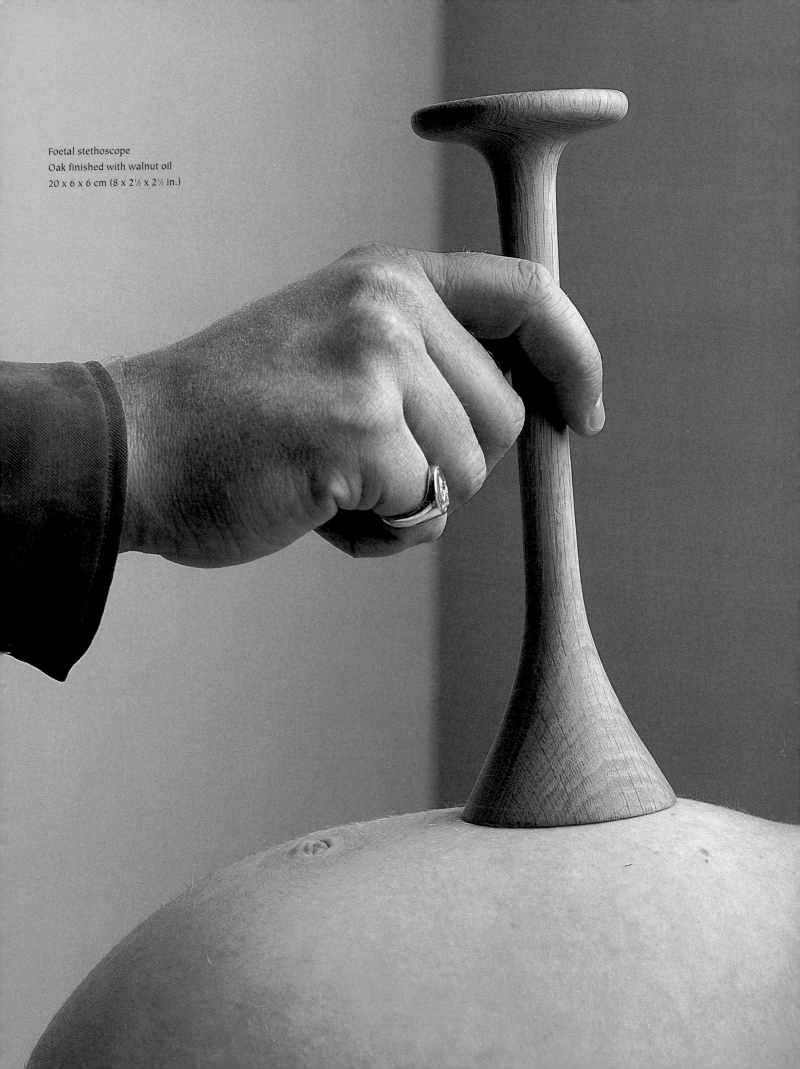

Foetal stethoscope
Oak finished with walnut oil
20 x 6 x 6 cm (8 x 2½ x 2½ in.)

"I was delighted to be asked to take part in the onetree project; in a way, it seems to sum up so well what we're all striving for.

Although our part in the project – using the oak chippings to smoke and smoulder beneath our traditionally cured bacon, ham and salmon – may seem rather minor and rather an afterthought, this sawdust product lies at the very heart of what we do. Without chippings of the finest seasoned woods (oak, maple, hickory and so on), great flavours can never be imparted to the finished product. However good the cure may be in which our finest-quality meat or fish is marinaded, without the right smoking process or materials the end result will be a big disappointment. If you think about it, it's not even the oak itself that permits this flavour, but the combination, the transformation of wood through fire, that gives that perfect finish. There is surely something magical, even ethereal, about this transformation – a time-honoured process that lies somewhere between dying and the giving of life.

We love natural things and processes. Our whole approach to the manufacture of fine foods for a modern, technological world lies in a combination of traditional taste and modern methods. While using ancient recipes, we have to comply with the latest Health and Safety regulations, where hygiene and traceability are of paramount importance. Even sawdust is a highly regulated product: the precautionary procedures for its use in the food-processing business seem tighter than those imposed on any logging company.

So we thoroughly applaud the close observation and attention to detail that have characterized the onetree project. We've been pleased to follow the development of the onetree story in our customer newsletter, and feel that anything that serves to draw people's attention to the slow and complete processes of the natural world is, in turn, particularly deserving of our attention. Our business, too, is about slowness, quality and organic growth: if the project makes people realize more about where good things come from, it will have been as valuable as it has proved fascinating." *John Ward*

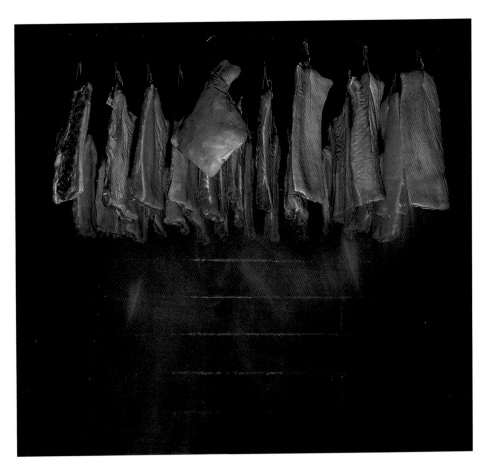

The Cheshire Smokehouse – John Ward
Smoking food at The Cheshire Smokehouse

John Ward was born in Stretford, Greater Manchester. Educated at Buxton College (then a grammar school), he had a short career in farming before, in 1953, joining the family smoking business, which had originated in Cheetham Hill, Manchester, in 1907.

When John joined the business, it was involved in importing bacon from The Netherlands, Denmark and Ireland. He quickly became dispirited at the increasing trend for 'quick cures' and 'chemical smoking', which were intended to speed up the smoking process but had the effect of reducing taste and rendering the product inferior.

In 1980 he rented some farm buildings at Mellor, high in the Derbyshire hills with glorious views of Kinder Scout.

John's son Darren joined him and together they developed an ever-growing following of discerning clients who relished traditionally smoked foods. They outgrew the farm and moved down to the Cheshire plain, to the more temperate climate of Morley Green, Wilmslow, where, with lots of family help, they converted a disused abattoir into a replica of the Old Smokehouse in Manchester.

A retail shop followed, then a café/restaurant, then a wine department and sundry additions and extensions. Recognition for all the hard work duly followed, with numerous accolades and articles in the press: the award in 1998 for Best Ham and Bacon in Britain in the *Food Lover's Guide* by food writer and broadcaster Henrietta Green was followed in 1999–2000 by the coveted Best Speciality Shop in the UK in the BBC Good Food Awards.

VALERIE CLARKE

"I am interested in the relationship between the landscape and the body, and the changes that surfaces undergo when affected by time, growth, decay or the processes that the materials pass through.

When I read about the onetree project I was interested in making a sculpture that would use the materials discarded by the processes employed by the other makers. I am also interested in the written word, and as trees are the source of the materials that allow the exchange of ideas through the printed page, I wanted to reflect this in the sculpture. The making of the sculpture was governed by the materials, and my original ideas changed slightly to accommodate the textures of the shavings I received.

The decision to merge the figure into the oak is a reference to the fact that when reading we cease to be conscious of our physical body as we become engrossed in the fictional world of the text.

Many wooden objects are sanded smooth to enhance the beauty of the wood, but I wanted to keep the roughness of the surface. This roughness is also contrary to the aesthetic expectations of skin and gives an extra dimension to the figure, because although the figure is female she cannot easily be sexualized; she is a generic figure engaging in a cognitive act.

I like to think of my reading woman, integrated into nature and lost in fiction, as being undisturbed by the gaze of the viewers." *Valerie Clarke*

Valerie Clarke was born in 1952 in Manchester. She studied English and visual studies at Manchester Metropolitan University from 1994 to 1997. She then trained in adult and further education, and is now a lecturer in communication, English and creative writing at South Trafford College.

Valerie facilitates workshops for community groups, and is an active member of The Art House, an organization that ensures that disabled and non-disabled artists have equal access to facilities

and opportunities in the visual arts. Exhibitions of her own work – usually produced using natural materials – have been held at All Saints, Manchester; Art on the Street, Alsager; Henshaws' Arts and Crafts Centre, Knaresborough; Mount Grace Priory (English Heritage), Yorkshire; The Cooper Gallery, Barnsley; and the Crossley Gallery, Dean Clough, Halifax.

In 2000 Valerie was artist-in-residence at Pickering Castle, North Yorkshire, where she produced a 'Heritage Tower' created from soil,

wood and PVA in response to the site and to images of culture and heritage received via the Internet.

Valerie is also a writer, and her stories have been published in collections including *Relative to Me* (1990) and *No Limits* (1994).

Untitled
Oak, shavings, PVA, wire, paper
40 x 232 x 92 cm (16 x 91 x 36 in.)

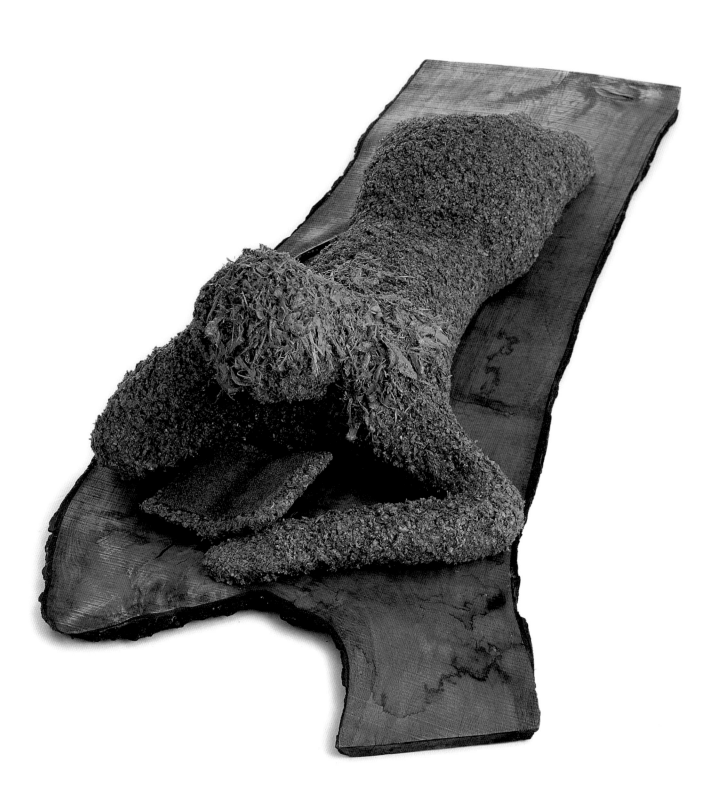

JOHN COLEMAN

"I've always been interested in environmental and ecological issues and in making things grow. If I hadn't been a furniture designer I could easily have been a forester.

In all my work I strive to find innovative solutions to challenges and to use materials and resources economically and responsibly. So the idea behind onetree – to use all parts of a tree in a range of imaginative ways – caught my imagination. It also helped me resolve an idea for a new chair that had been brewing for some time. The chair, which became the Obi, draws on Japanese imagery. Its simplicity, clean lines and use of exposed timber mean there is no place to hide; each component must be perfectly made.

Despite my interest in ecology, my designs tend to be influenced by the architectural, rectilinear patterns found in man-made structures rather than by the organic world; and I found the tension between this natural and the 'craft' elements of the project an interesting one to explore.

The experience has thus been a doubly rewarding one: I found it stimulating in design terms; and the Obi is now in production with Design Division Ltd. I'm very grateful to onetree for helping to focus my ideas and inspire its design." *John Coleman*

John Coleman was born in 1953 in London. He studied furniture design from 1972 to 1979 at Kingston Polytechnic and then at the Royal College of Art, London.

After graduating from the RCA, John worked initially for leading furniture designer David Field. He established his own studio in 1981, and his work was selected for the Crafts Council Index of Selected Makers soon afterwards. He has been featured in numerous publications and has exhibited widely, most recently at *Spectrum* (Royal College of Art, London, 1996, 1997, 1998; Commonwealth Institute, London, 1999, 2000) and *100% Design* (Duke of York's Headquarters, Chelsea, London, 1995, 1996, 1997; Earls Court, London, 1999).

John's work was purchased for the Crafts Council Collection in 1986. Major projects since then have included furniture for the office of the Secretary of State for Culture, Media and Sport, London; the Avenue and Circus restaurants, London; and Oxford University.

After many years as a successful designer–maker working to private commission and for corporate clients, John is now focusing on design consultancy and has established fruitful partnerships with a number of leading furniture companies. He continues to work on one-off projects that capture his imagination.

4 Obi chairs
Oak, upholstered in Alcantara
Each 76.5 x 52 x 50 cm
(30 x 20 x 19½ in.)

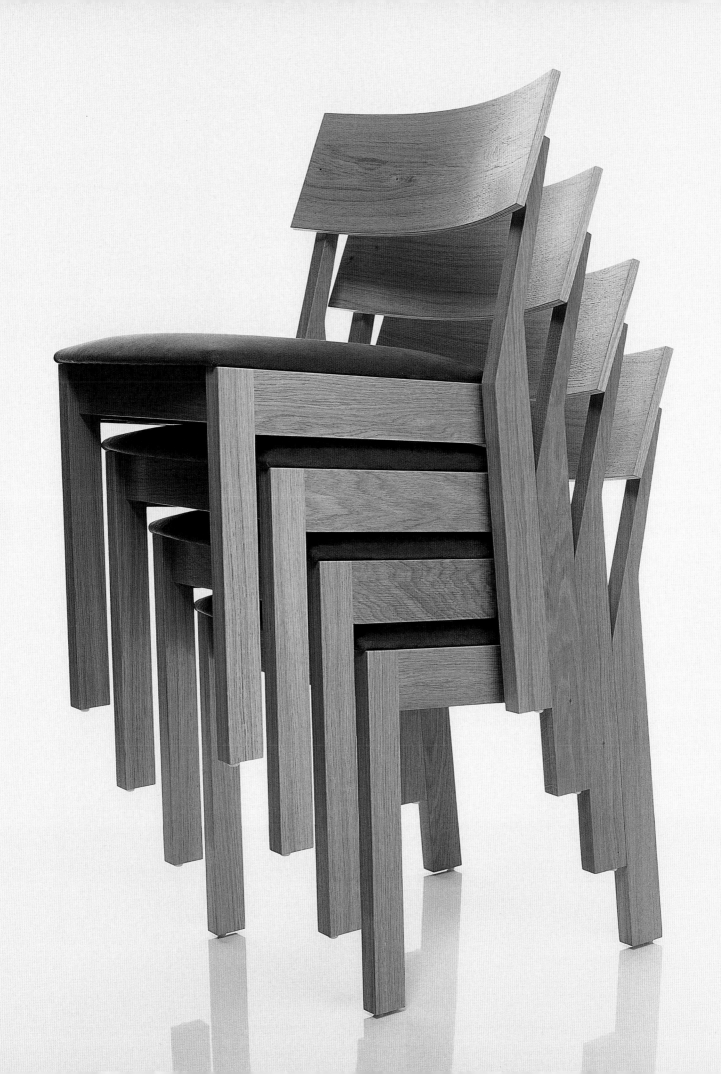

MAX COOPER

"The brief I was given by the organizers of onetree was to produce an item of furniture from the wood of an English oak. I have met the challenge to create a unique piece of furniture that transcends the boundaries and expectations usually found in items made from oak. Being a timber of durability and strength, oak is usually chosen for items that require these qualities. However, the wood also has many different facets in its figure and texture and in the light-reflective qualities of the grain; I have endeavoured to emphasize all these facets in my cabinet. This approach, together with the way I have used the interplay of grain direction in the marquetry, contrasts with the traditional view of oak furniture.

Although the base carcass is made from laminate, all the wood you see is oak. To obtain the full benefit from this quintessential English tree and to enhance the aesthetics, I have used sixteenth-century burr oak (taken from floorboards), which has darkened naturally with age, and bog oak (at least two thousand years old) to contrast with the lighter 'modern' wood of the Tatton tree. These elements also symbolize the longevity of this remarkable wood.

The other browns and greens within the marquetry are long- and end-grain veneers cut from the solid timber of onetree. These I artificially dyed, while the white parts of the ribbon are the natural sap wood.

By utilizing natural variations in the colour of the Tatton Park oak over the whole cabinet, I have shown the great variations and beauty of this versatile material." *Max Cooper*

Max Cooper was born in 1955 in Newton, near Rugeley, Staffordshire. He worked as an apprentice to the well-known local craftsman Bernard Jack, and from 1974 was periodically taught marquetry techniques by Andrew Oliver until the latter's death in 1979.

In 1975 Max started to make furniture in his own small workshop in Rugeley, using marquetry to embellish each piece, usually in late seventeenth-century or early eighteenth-century styles.

Max's moved his workshop in 1988 to renovated farm buildings at Yarnfield, near Stone, Staffordshire. The business combines specialist restoration work with fine furniture-making.

Over the past decade Max has taken part in exhibitions in Cheltenham, Gloucestershire, and Wilmslow, Cheshire. He has been featured in a number of magazines and books, including *The Illustrated London News*, *House & Garden*, *The Field*, *British Craftmanship in Wood* by Betty Norbury (1990), *The Book of Boxes* by Andrew Crawford (1993) and *The Buyer's Guide to British Furniture Craftsmen* by Melvyn Earle (1993).

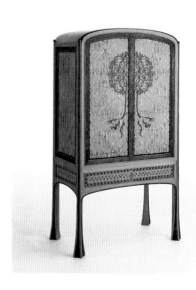

Drinks cabinet
Oak, oak veneer, bog oak, reclaimed oak
184 x 107 x 64 cm (72 x 42 x 25 in.)

ALISON CROWTHER

"I returned from Austria early in 2000 to find two huge boughs that had been delivered for my onetree project. They were each about 11 feet long and 8 inches in diameter. They curved and snaked over the workshop floor, almost as if they were alive. Being more accustomed to enormous butt-ends of oak to work with, where lots of energy is expended on the removal of material, I realized that I needed to consider how to approach them carefully, because if I hacked straight into them I could quite easily end up with very little left! I found myself looking at them from all sorts of angles, sitting down on them, and wondering what to do with them. After sitting on them for some time, I was reminded of going for walks in the countryside, where you may come across fallen oak trees, and would welcome a perch and a rest on a bough. And it was this image that inspired me to play on the idea with the design of the pieces. Hence the two boughs work in conjunction with each other for you to sit, perch, put your feet up, sit on one bough and put your feet on the other, in a variety of ways! The hand prints are an indication of where you naturally put your hands out to steady yourself as you sit down on a tree trunk." *Alison Crowther*

Alison Crowther was born in 1965 in
Keighley, West Yorkshire. She took a
foundation course in art and design at
Bradford and Ilkley Community College,
Bradford (1981–82). She then gained a BA in
3-D design at Buckinghamshire College of
Higher Education, High Wycombe (1982–87),
followed by an MA in furniture design at
the Royal College of Art, London (1987–89).

After graduating from the RCA in 1989,
Alison worked in Buckinghamshire as a
designer–maker. In 1993 she began teaching
in Bedales School's highly respected craft and
design department. After three years' full-time
teaching she decided to combine her work
with the development of her own practice,
producing one-off and commissioned pieces.
In 1998 she was able to return to full-time
making and designing. Her workshop is based
near Petersfield, Hampshire.

Alison retains her interest in teaching with
occasional tutoring and lecturing at Kingston
University. A research bursary awarded by
the university involved her participation in
an international sculpture symposium at
Großsteinbach, Austria, in 2000.

Recent projects have included a group
exhibition in London, a commission for
Chatsworth Park in Derbyshire, a public
commission for a nature reserve near
Newbury, Berkshire, and private
commissions on Nantucket Island and
Martha's Vineyard, USA.

Resting Limbs
Oak, carved and charred in places,
with a linseed oil and wax finish
60 x 340 x 100 cm (24 x 132 x 40 in.)

"I wished to support the onetree project for all the well-documented reasons of trees' importance in protecting the planet. A more selfish reason is my own great enjoyment of the visual aspect of trees. This is a great gift to mankind. Their infinite variety and ever-changing appearance are magical and a source of constant pleasure. They are taken for granted, although their miraculous structure would amaze a stranger to our planet. I spend a lot of time just looking at trees in their diversity of form, colour, movement and dramatic changes through the seasons.

As a designer, I also greatly enjoy working in timber. Unlike synthetic materials, it has unpredictability, an infinite variety of texture and pattern, smells good when worked and is sympathetic to the touch – it has soul.

The little chair I have designed is an attempt to make something that can be made in quantity using machine production. I have tried to imbue it with 'woodenness' and the stoicism of oak. The vertical turned legs echo the form of the stems of trees.

We still have a rich inheritance of trees, and this great wealth must be maintained and developed." *Robin Day*

Robin Day was born in High Wycombe, Buckinghamshire, in 1915. He won a scholarship to a local art school, and after a period working for a furniture factory he won a further scholarship to the Royal College of Art, London, which he attended from 1934 to 1939. There followed periods of part-time teaching in Croydon and at Regent Polytechnic School of Architecture, London, and freelance practice in graphic design and exhibition design, including producing exhibitions and posters for the Ministry of Information. In 1949, in partnership with Clive Latimer, Robin won first prize in a New York Museum of Modern Art international competition to design low-cost furniture. In 1951 he designed a section of the Festival of

Britain exhibition, and in the same year he designed the furniture for the new Royal Festival Hall in London.

Over the following decades awards came frequently and recognition grew. In 1983 Robin was awarded an OBE; in 1991 he was appointed senior fellow of the Royal College of Art; and in 1997 he was made honorary fellow of the Royal Institute of British Architects.

Although best known as a furniture designer, Robin has worked in many fields of design, including graphics, exhibition and interior design, the radio and television receiver industries, the carpet and vinyl flooring industries and in aircraft interior design, notably for the Super VC10. He is

probably most famous for his pioneering development of injection-moulded-plastic one-piece chairs, of which tens of millions have now been made worldwide.

From 1962 to 1987 Robin was design consultant to the John Lewis Partnership. He has served on the juries of numerous national and international design competitions.

A major retrospective exhibition of Robin Day's work, together with that of his wife, the fabric designer Lucienne Day, was held at the Barbican Art Gallery, London, in 2001.

Four chairs
Oak
72 x 52 x 50 cm (28½ x 20½ x 20 in.)

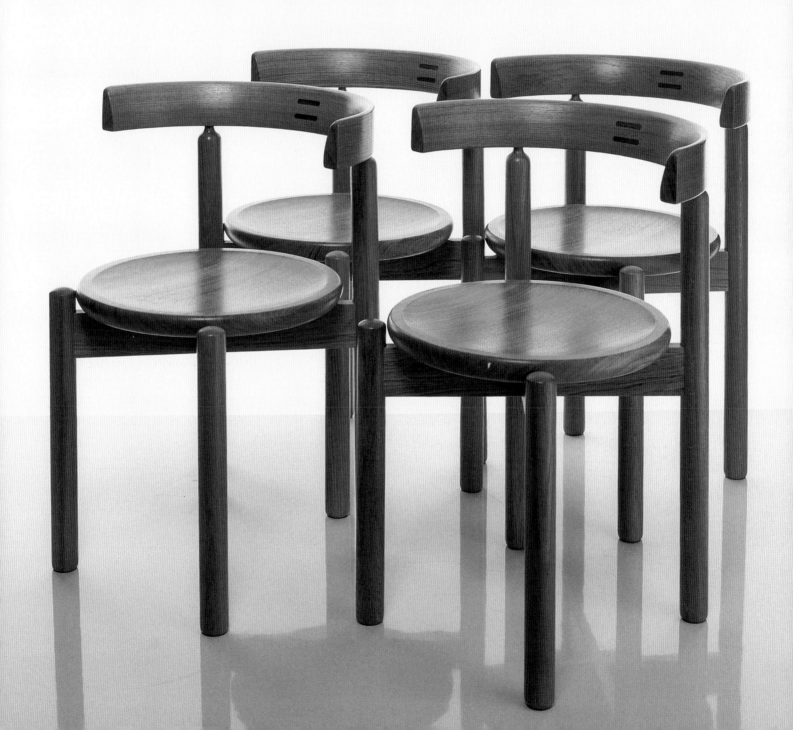

JANE DILLON AND TOM GRIEVES

"To be asked to contribute to such a worthwhile project as onetree was something very special for us. We are not craftspeople and don't really fit into the designer/artist-craftsman category either, but if you see 'design' as the core ingredient to the understanding of the manipulation of materials and processes then you will understand where we fit.

Our piece is a celebration of the use of an invention made in 1922 by an Austrian scientist to compress solid timber. The technology involves changing the wood's cell structure so that it is compressed transversely, thus allowing it to be bent three-dimensionally. The wood is not plasticized in any way, and is compressed by 10–15% in its longitudinal section during the process. Once the component is formed into shape it is then kiln-dried.

So our beautiful piece of English oak was put on an aeroplane and sent to Denmark to be compressed. Once it was back in our workshop, with the aid of simple jigs and clamps we started with the idea of making free-flowing hooks to be used to hang anything from a coat and hat to whatever one might want. It is an object much in the vein of the hunter's trophy – like a stuffed moose head and antlers!

We would like to thank Ole Lundby Jensen of Compwood Machines Ltd, Denmark, for his help in making our piece possible. Thanks also to Guy Mallinson Furniture for their work on the project." *Jane Dillon and Tom Grieves*

Coatstand #1
Oak with Danish oil finish
180 x 35 x 10 cm (71 x 14 x 4 in.)

Jane Dillon was born in 1943 in Prestwich, Lancashire. She studied interior design at Manchester Regional College of Art (1961–65) and then attended the Royal College of Art in London (1965–68), where she studied furniture design.

Jane has been an international furniture designer for the past thirty years, producing designs for mass production as well as one-off pieces. After working with Ettore Sottsass at Olivetti in Milan, she set up a studio in London in the early 1970s with her late partner, Charles Dillon, producing work that was to be highly influential. Her method of working has always been studio/workshop-based.

Jane is a tutor in the Design Products Department at the Royal College of Art. Clients have included such well-known names as Herman Miller (USA), Cassina (Italy), Casas (Spain), Thonet (Germany) and Habitat (UK).

Her work has been featured in all major international design journals and in the daily press, as well as in a number of books, including *Women in Design* (1988), *New British Design* (1986), *20th Century Design and Designers* (1993), *The Sixties* (1998), *1000 Chairs* (1997) and *The Modern Chair* (1988).

Jane's work is held in the collections of the Museum of Decorative Arts, Barcelona, and the Science Museum, London (Challenge of Materials Gallery). It has been included in many exhibitions, including the Royal College of Art centenary exhibition, *Design of the Times* (1996), and the Craft Council's centenary travelling exhibition, *Objects of our Time* (1996).

Tom Grieves was born in London in 1973. He took a foundation course at Camberwell College of Art, London, in 1991–92, followed by a degree in furniture design at Loughborough College of Art and Design (1992–95).

Tom joined Jane Dillon's studio in 1996 after completing work experience in Stockholm and a summer course working with green wood in Sweden.

MIKE DODD

"My first response to things is nearly always intuitive; thinking comes later. I work from a deep trust in those feelings and the sense of interconnectedness they engender. It is not a conceptual approach. Consequently, I do not normally respond to invitations to themed exhibitions, as they require me to make something to fit someone else's co-ordinated, but usually limiting, idea. When I heard of the onetree project, I was, as you might expect, slow to respond. Having thought about it for a while, though, the 'idea' gradually took on a vitality I hadn't anticipated. The idea blossomed in my mind as something delightfully open, unlimited and connected.

I asked for a large quantity of sawdust. This was dried and then burnt in a specially constructed fire box so that I wouldn't lose any precious wood ash to the wind. The cooled ash was collected and washed in water to remove the alkaline salts (mostly potassium and sodium), then sieved and dried. A glaze consisting of Tatton oak ash (50%), granite dust, iron oxide and chalk was applied to the pots and fired to approximately 1300°C in a reducing fire. The addition of iron oxide to the glaze gives a rich, deep, tannin-like colour, and I've tried to reflect the broad majesty of the oak in the form of the pots themselves." *Mike Dodd*

Mike Dodd was born in 1943 near Epsom, Surrey. He was educated at Bryanston School in Dorset, where he came under the guidance of Donald Potter (himself a student of Eric Gill for eight years), who taught metalwork, pottery and sculpture. Later Mike studied medicine at Cambridge University (1962–65), but went on to Hammersmith College of Art in London to study pottery. He set up his first workshop in 1968 under the South Downs at Edburton in Sussex. He has had several workshops since, in Sussex, Cornwall, Cumbria and Dorset, and is now establishing a new one in Somerset.

Throughout his career Mike has demonstrated and lectured in Britain and overseas (in the USA, India and Germany), has written many articles and has exhibited widely. Two of his best-known articles are 'In Defence of Tradition' in *Pottery Quarterly* and 'Function and Dysfunction' in *Ceramics: Art and Perception* (1998). Throughout his career he has loved throwing rather than building pots, and he chooses mostly to produce stoneware. He achieves expression through the qualities of the materials he finds and uses and in their transformation by fire.

Three pots with lids
Stoneware
Heights 33 cm (13 in.), 29 cm (11½ in.) and 22 cm (8½ in.)

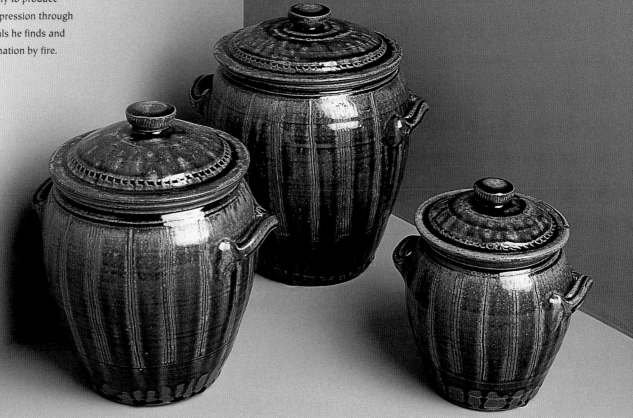

GILIAN DYE AND DERRICK EARNSHAW

"As a lace-maker working with non-traditional materials and exploring interaction with other crafts, I was intrigued by the small notice introducing onetree. One of the joys of lace-making is the pleasure of the bobbins – often miniature masterpieces in wood – so it was natural to talk to Derrick Earnshaw, a woodworker who is always ready to accept a challenge, before asking to be included in the project. We were delighted to be accepted.

From the start we wanted to contrast the polish of turned wood with the roughness of twigs, and some initial ideas were discussed just after the material arrived in May. We then went our separate ways. Two months later Derrick had developed ideas for bobbins and I had decided to use wool and short pieces of twig to create the texture of an acorn cup, contrasting this with a more lacy section enclosing a tree – following through the idea that a tree is hidden within an acorn. The mock-up came as something of a surprise to Derrick, but he was still game to carry on. Two more months and the shape of the finished piece emerged.

Hidden has brought together two completely different crafts – and craftspeople – to reveal a sculpture that satisfies us both. We are proud to be part of the onetree project and have welcomed the opportunity to look at our work in new ways, to work together on this piece and to be part of this exciting challenge." *Gilian Dye*

Gilian Dye was born in 1945 in Stratford-upon-Avon, Warwickshire. She attended Homerton College, Cambridge (1963–66), completing teacher training with biology and textiles as her main subjects. She has since gained City and Guilds qualifications in lace-making.

Gilian is a designer and author of numerous lace-pattern and instructional books. She has twenty years' experience of teaching lace-making, including City and Guilds courses to Part II. She was winner of the miniature class at the 1995 John Bull Trophy competition, and is a member of the Westhope Group, exhibiting in the UK, Belgium and Ireland; her work has also been exhibited in Germany, Spain, Italy and Portugal.

Derrick Earnshaw was born in 1931 in Easington Lane, a mining village in County Durham. He worked as an electrical engineer in several collieries, having spent seven years as an apprentice electrician from the age of fourteen. He started woodcarving in the 1970s, winning the sculpture section of the Coal Industry Social Welfare Organization art competitions seven times between 1980 and 1995, and becoming a full member of the Society of Northumbrian Craftsmen.

Early retirement in 1985 allowed Derrick time to develop woodturning skills and gave him the opportunity to work co-operatively with lace-makers, spinners and other craftspeople.

Hidden
Oak, oak twigs, cashmere, silk, wool, cotton, wire
76 x 30 x 30 cm (30 x 12 x 12 in.)

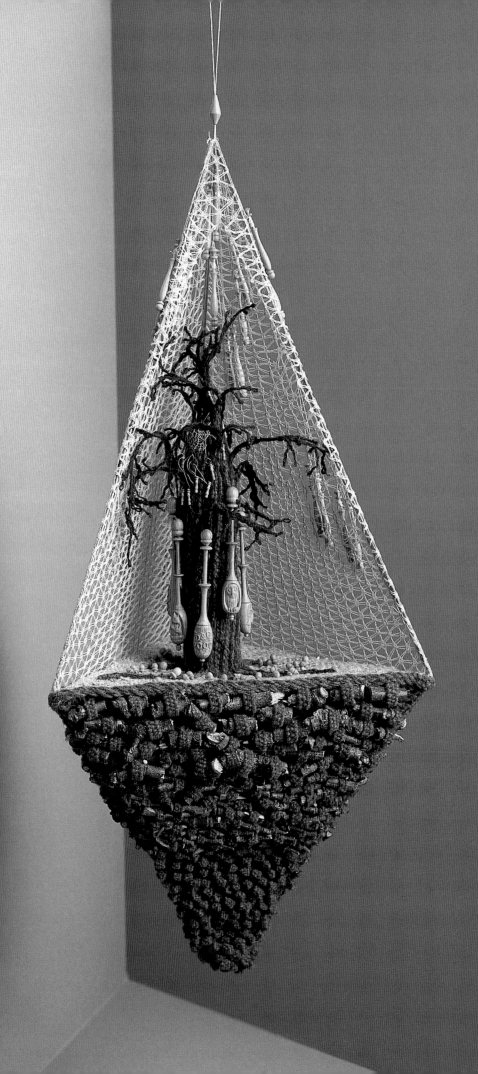

SIMON EASTON

"I enjoy working with a variety of materials and techniques to create simple yet attractive combinations of texture and form. The inspiration for the textural patterns I use comes from examining the world around me in great detail, both through my own photographic studies and the work of others. I also derive many ideas from the microscopic images of scientific exploration. I use texture as a means of giving my works a unique 'personality', which not only increases their visual appeal but also enhances the tactile and sensory experience for the user.

I spent my childhood surrounded by the Wiltshire countryside, and have always appreciated the natural beauty of trees, rocks and the like. Onetree appealed to me because of the honesty and simplicity of its purpose: to promote conservation of our precious resources and demonstrate the scope of use that one tree alone has. The opportunity to participate came at a perfect time, when I was exploring the combination of turned wooden forms and applied texture. The bowl I created is full of contrast. I had never worked with oak before this piece, but the surface qualities it holds are amazing and complement the polished pewter and rosewood patterning. The texturing process itself is long and precise, but always worthwhile owing to the character it creates every time. My wish is that the bowl serves to demonstrate another unique facet of the onetree project, both individually and collectively." *Simon Easton*

Wish, Hope, Dream, Everything
table bowl
Oak, rosewood-dust inlay,
polished spun pewter insert
11 x 19 x 19 cm (4½ x 7½ x 7½ in.)

Simon Easton was born in 1978 in Trowbridge, Wiltshire. He took a foundation course in art and design at Trowbridge College (1996–97) and then a degree in 3-D design at Manchester Metropolitan University (1997–2000).

After considering graphic design as a possible career, Simon chose to study 3-D design because of the scope and freedom it offered to develop a personal philosophy and approach. The nature of the course encouraged individual exploration and expression, and he enjoyed the many experiences it provided.

Simon went on to work successfully in a variety of materials, including pewter, silver, plastics and wood. His pewter napkin-ring set was selected as one of the Manchester Metropolitan University winners of the Pewter Live 1999 competition, and was displayed at Pewterers' Hall in London. He was awarded both a Precious Metals Bursary and a grant from the Worshipful Company of Goldsmiths for a condiment set and double-skinned bowl he produced for his degree show.

As well as being accepted for onetree, Simon has recently exhibited at the *New Designers* exhibition at the Business Design Centre, London, and at *Passing Out: Class of 2000* at Goldsmiths' Hall, London. His work has attracted interest from several galleries and craft outlets.

"We were contacted by the onetree project in 1997 or 1998 and told about the project and the concept. The letters and information were passed to me by Hywel Evans, as he was busy. I thought the project was an excellent idea: any project that attempts to educate the end user is admirable. Timber is one of the most beautiful resources in the world, and once we begin to realize its value both environmentally and as a resource we can further encourage proper management of the world's forests. If we encourage the use and management of the timber we have in Britain we can work towards halting the import of foreign timber, and through good management of our own forests we can set an example to others in the timber industry.

We had almost forgotten about the project as we are a small business and are all very busy, and our company was almost completely destroyed by fire in the summer of 2000. By the autumn of 2000 we were again in contact with Garry Olson. Emma Evans, who was also enthusiastic about the project, and I managed to have a chat with Hywel Evans, and he gave us the go-ahead to get involved. We were supplied with some timber from onetree and will produce a laminated-oak window frame, which is an example of what can be made from small pieces of timber that might otherwise be wasted."

Séamus O'Doherty, for ELAM Joinery

Laminated-oak window frame
Oak (*not from onetree*)

ELAM Joinery has been asked to use onetree offcuts from other makers to produce joinery products including a window frame, which will be similar to the one shown.

Hywel Evans was born in 1951 at Lletty'r-eos, a farm in Powys, where he still lives today. At the age of sixteen he started an apprenticeship as a carpenter–joiner, also attending the Newtown College of Further Education, Powys (1966–67). From here he qualified with distinction in carpentry and joinery. Throughout his career Hywel has been actively involved in the local community, holding positions of responsibility in education and farming organizations. He has been a councillor in his local parish since 1981.

Since his first involvement in the timber industry Hywel has promoted the use of British timber. He was a founder-member and is chair of the Welsh Timber Forum, which was set up to promote the use of Welsh timber products. He is a member of the steering group for the Materials Forum in Wales and a director of Treeline UK Ltd.

In 1996 Hywel set up his own company, ELAM Joinery, which specializes in the lamination of timber. ELAM's product range includes windows, doors, beams, worktops and panels, as well as one-off custom-made items. The process ELAM uses allows a greater yield from trees, which in turn makes forests a more productive and profitable resource. This in turn encourages more well-managed, sustainable and environmentally friendly forestry. Lamination also gives the timber added strength and stability.

LORNA GREEN

"A few years ago I rented a studio in the stable block at Lyme Park in Cheshire. Shortly afterwards a group of students came for a workshop, but there were no chairs for them to sit on while we were discussing their projects. This event became a starting-point for a series of sculptures of chairs – not for sitting on, but as symbols of family groups in various guises, about issues such as pollution and, of course, humour, using the readily available fallen branches within the park. Because these branches were of poor quality, the sculptures, having been exhibited almost constantly both indoors and outdoors since they were made, gradually fell apart.

This was just when onetree was announced. Because I was intrigued by the unique vision of onetree, I wanted to imply some magic in my sculpture, and somehow, looking at the available wood in a huge pile at Tatton Park, a giant rocking-chair emerged in my imagination. *Drink Me!*, alluding to *Alice's Adventures in Wonderland*, seemed an appropriate title, and, with the knowledge that there would be other crafted chairs within the exhibition and that the selected branches were of good quality, I decided that this chair, unlike the others, would be made without screws." *Lorna Green*

Lorna Green was born in Manchester. She took a foundation course and degree in fine art at Manchester Polytechnic in 1979–82. In 1991 she was awarded an MPhil in fine art by the University of Leeds.

She works throughout the UK and overseas on public-art and environmental projects, producing functional earthworks and sculptures and redesigning landfill sites in both urban and rural landscapes, indoors as well as outdoors; her works can be permanent or temporary, large- or small-scale. Her sculpture is site-specific in that it relates to the history, economy, landscape or mythology of the area. Materials utilized include wood, stone, earth, planting, bricks, steel, cement, bronze, water, glass, plastics and even feathers and drink cans.

Major permanent projects in recent years include *Stay, Live and Sit*, Monash University, Melbourne, Australia (1993); *Meet, Sit and Talk*, with Allan Ruff (1995); *Sun Wall/Earth Wall*, Beer-Sheva, Israel (1997); *Power Flower*, Changchun, China (1998); *Warp.Weft*, Rochdale Partnership/Canalside SRB (1999); *Conversation* and *Roof Garden*, with John Micklethwaite-Howe, University of Leeds (1999), both of which won Architecture 2000 commendations from Leeds City Council; and *Old Story – New Story*, Greenfield Valley Trust, Holywell (2000). Major temporary projects in recent years include *Pool*, Bonington Gallery, Nottingham (1992); *Hope* at the *Miss-ing* exhibition, Berlin (1992); *Power Flowers*, Stockport Art Gallery (1998); *Wave: Sculpture by the Sea*, Bondi, Australia (1998); and *15 Christchurch Circles*, Art in the Park 2000, Christchurch, New Zealand (2000).

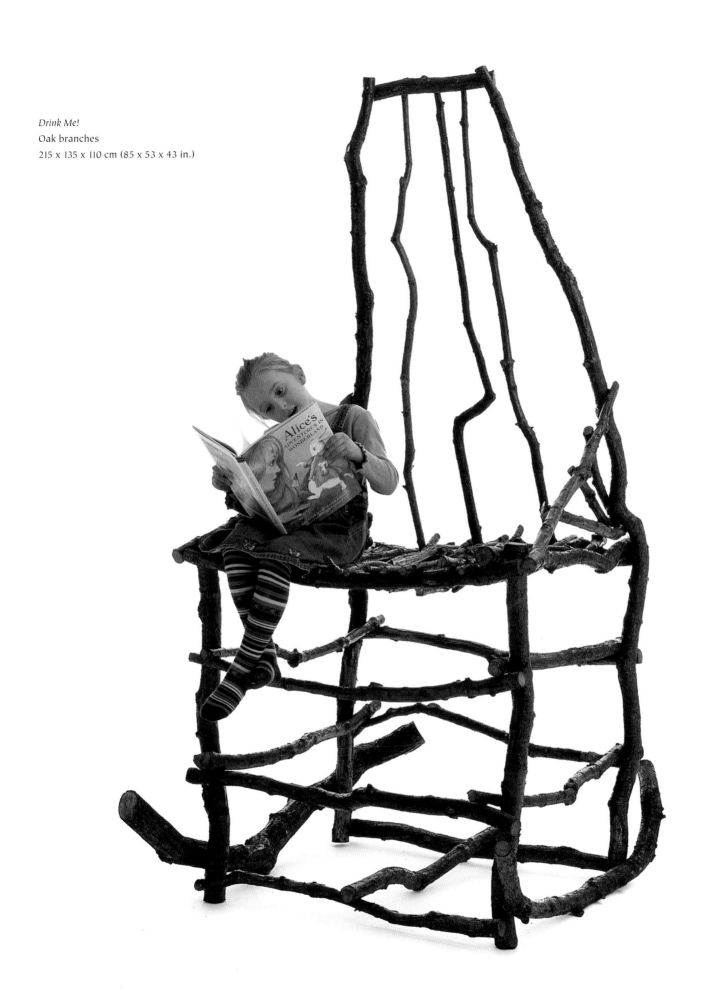

Drink Me!
Oak branches
215 x 135 x 110 cm (85 x 53 x 43 in.)

LORNA GREEN AND TRUDI ENTWISTLE

"We both fell in love with a semi-stripped curvaceous branch, and wanted to highlight the sensuousness of the twisting, turning form of this limb. Determined not to complicate the statement, we created a fragile bed of hundreds of graded sticks for the heavy weather-bleached limb to recline on. Chaise Longue was built in four days using very low-tech methods – bow saws and loppers. Interest was intense, particularly while it was in progress, and on completion it provoked many perceptive comments.

It was different to work on this onetree project, focusing on a material without 'place'. Unusual as it is to find inspiration purely from material alone, we decided to look at the basic form and qualities of the tree from its original configuration.

It has been very exciting to be involved in such a unique project, bringing together many creative individuals to be inspired by one common source, an oak tree." *Lorna Green and Trudi Entwistle*

For information about Lorna Green, see p. 72.

Trudi Entwistle was born in 1969 in Lancashire. She took BA and MA degrees in landscape architecture at Leeds Metropolitan University.

Trudi is a site-specific environmental artist, responding to 'place' and its material, creating sculptural solutions in the landscape that range from earthworks enduring many years to temporary installations lasting only a few days. She has worked with many found materials common to a particular place, including snow, wood, stone, plants and earth, and has worked in a great diversity of landscapes, from the woods of Sweden to the mountains of Japan, from a botanical garden in South Carolina to the exposed east coast of England.

The spatial aspect of Trudi's work is a key element for her to consider and sculpt. Place gives inspiration, meaning and strength to the forms and lines so that the sculpture becomes integrated with its surroundings. Her work does not compete with the landscape, but creates a subtle addition to it. It is not noticeable from a distance: instead, one stumbles upon it, and it becomes a place to linger, serving to highlight qualities that might otherwise have gone unobserved. The transient nature of her work has meant that documentation through photography and video has become an important focus. She also uses these techniques in her lecturing work in landscape architecture at Leeds Metropolitan University.

Trudi's work has been reviewed in the American journals *Landscape Architecture* and *Sculpture*.

In July 2000 Lorna Green and Trudi Entwistle took on a joint residency for onetree, funded by Cheshire County Council, at the Royal Horticultural Show at Tatton Park, Knutsford. They spent many hours prior to the event in front of a pile of branches from the felled oak tree – years of growth now meshed together.

Chaise Longue
Oak branchwood
100 x 500 x 50 cm (39 x 197 x 29 in.)

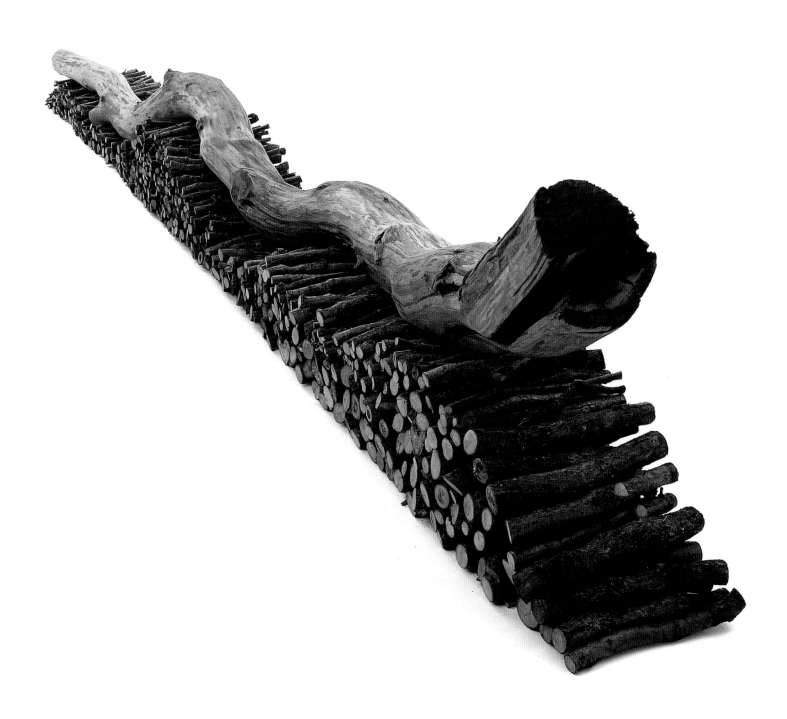

DAVID GRIMSHAW

"When Garry and Peter told me about their plans for onetree I leapt at the chance to be involved. It was such an inspiring project, demonstrating the true value of a natural and sustainable resource. Utilizing the maximum amount of the available material in as many ways as possible would not only show what a versatile resource wood is, but also how it should be valued.

So what could be my reaction to this? As a designer for industry I was interested in seeing how I could use the material within a higher production process, and also to develop a design that would be modern, functional and suitable for further production. I was also interested in seeking to utilize what would normally be seen as the waste products from the processing of the tree, and to find new uses for it.

The concept was to use sawdust in moulding techniques to produce components for a piece of contemporary domestic furniture that would be suitable for batch production. After a series of trials – and errors – the result is the *Dip Table*.

The *Dip Table* has a resin-and-sawdust table top, which is formed over a mould to create an integral bowl. This is then married with a lightweight metal frame to produce a simple, elegant and functional design. The *Dip Table* also demonstrates how a material that is considered waste, such as sawdust, can be transformed into beautiful and desirable pieces of furniture." *David Grimshaw*

David Grimshaw was born in Manchester in 1964. After completing an art foundation course at Bath Academy of Art, he completed an honours degree in 3-D design at Manchester Polytechnic (1986–89).

David established Grimshaw Design Associates after graduating in 1989. The consultancy specializes in developing modern contract furniture for manufacture, embracing a wide range of markets and materials, from low-cost café-bar furniture to corporate-reception upholstery.

David's work is manufactured by such companies as Allermuir, Viaduct, Davison Highley and H.J. Berry, and his clients include Lloyds Bank, British Telecom, Harrods, McDonald's, the BBC, Channel Four, Rank Leisure, Ernst & Young, Ascot Royal Enclosure, Abbey Road Studios and numerous cafés, bars, clubs and restaurants.

David's work has been exhibited around the world, and is regularly featured in trade journals and magazines. It also featured in the *International Design Yearbook 1997*, edited by Philippe Starck, and in the CD-ROM *British Contemporary Furniture Design* (1999).

David has been involved in the promotion of British design as part of trade missions abroad, and as a consultant to the Liverpool and Manchester Design Initiative. He has also been a competition judge at the annual *New Designers* graduate exhibition in London.

In addition to his consultancy work, David is now also employed as a senior lecturer in 3-D design at Manchester Metropolitan University.

Dip Table
Oak-sawdust-and-resin-moulded top, steel frame
35 x 100 x 100 cm (14 x 39 x 39 in.)

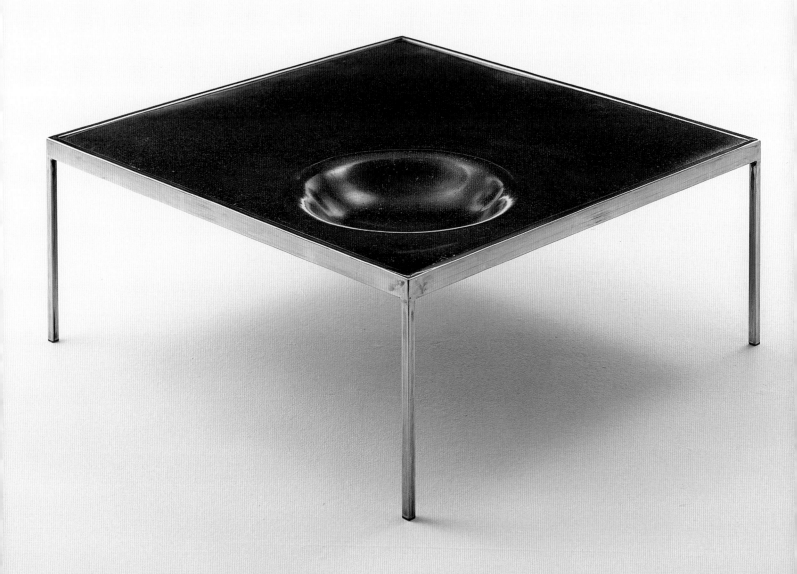

THOMAS HAWSON

"What an excellent idea it is to try to use every element of one tree. It is very wholesome to find a use for everything you take from the environment. It is a perfect celebration of nature. For me it is most important to celebrate the tree and not our products: it is the responsibility we have to the tree that is important. What a fine tree it is, providing me with such strong rungs for my ladder." *Thomas Hawson*

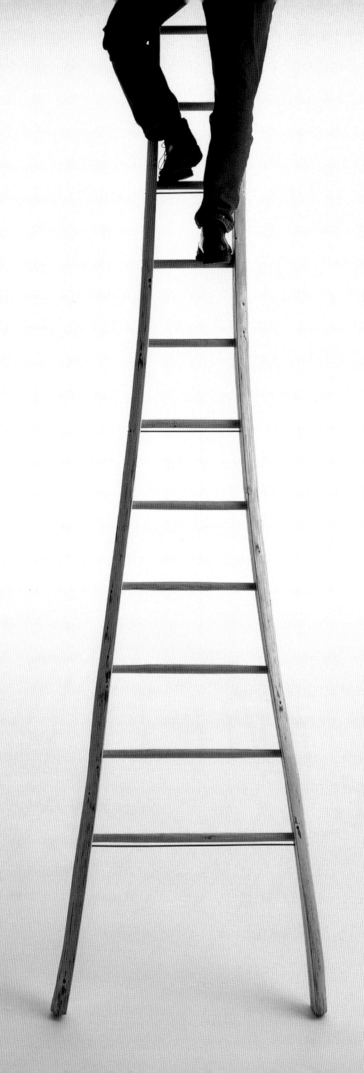

Born in 1973 in Louth, Lincolnshire, Thomas Hawson studied civil engineering first at Lincoln Technical College and then at Edinburgh University. In 1993 he took a foundation course in art and design at Lincoln College of Art and Design and then a degree in furniture design and crafts at Brunel University.

Thomas chose to work with wood because it is the most demanding material to work with, owing to its inconsistent and organic nature.

After leaving Brunel University in June 1997, Thomas set up as a self-employed designer–maker in the Scottish Borders, joining a collective workshop and designing a product range for the Woodschool, set up by Tim Stead and Eion Cox. Recent commissions include a chair for the Speaker of the Icelandic Parliament, handed over in June 2000 by Lord Steel (Speaker of the Scottish Parliament) as a gift from the world's youngest parliament to its oldest.

Thomas received the Morgan Fraser Award at the Visual Arts Scotland annual show at the Royal Scottish Academy, Edinburgh, in 2000. His furniture was shown at the National Museum of Scotland, Edinburgh, as part of the *Twentieth Century Design Collection* exhibition in 1999.

Cherry-picker's ladder
Oak, larch
Height 450 cm (177 in.)

MARK HUMPHREYS

"In woodturning and building yurts, I have always worked with local native timbers using wind-blown and well-managed trees. I have a strong interest in the promotion of British timbers and their sustainability, and have concentrated on ash and oak for building the yurts. When I was asked to take part in the onetree project I was delighted, as it seems to embody the same views as my own. It is also an honour to have my work displayed alongside that of other artists I have admired for many years.

The yurt I have built for the project is 8 feet in diameter, and all the oak used was steam-bent into shape, air-dried in jigs, filmed in ammonia and then oiled. The cover is a 16-ounce cotton canvas, which is fire-retardant and both rot-proofed and weatherproofed. It was tailored to fit by Wanda Bennett; normally a completed yurt has a clear PVC cover over the roof wheel, and a heavy-duty groundsheet made from fire-retardant PVC.

The yurt, or ger as it is sometimes known, is of the Turkic-Kirghiz free-standing design; Mongolian yurts have a central support and straight roof poles. There are, of course, some changes from the traditional design and materials, although it is hard to improve on a dwelling that has been the home of people in central Asia for two thousand years." *Mark Humphreys*

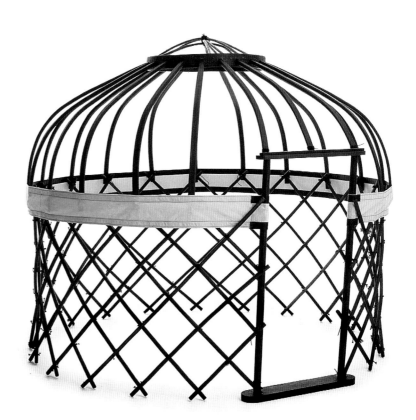

Mark Humphreys was born in Chester, Cheshire, in June 1967. He was educated at Dee High School in Chester and at Liverpool City College, where he took his City and Guilds in traditional furniture craft between 1987 and 1990. After leaving college he worked for Anthony James Design, a woodturner in Kendal, for a year, then for Lakeland Woodturners, also for a year. Stimulated by his interest in horses, he built a horse-drawn wagon and travelled with Wanda Bennett, his partner (in life and business), to Scotland. They stopped at Orchardton House, an artists' residence, where he was provided with work space and started woodturning.

An interest in environmentally low-impact dwellings, combined with a need for more space, led Mark to the build his first yurt in 1996. Since then orders for further yurts have followed. In addition to fulfilling these commissions, Mark works as a tree surgeon for Tilhill Economic Forestry.

Mark's work has been exhibited at Gracefield Art Gallery in Dumfries.

Yurt
Oak, cotton canvas
215 x 250 x 250 cm (84 x 96 x 96 in.)

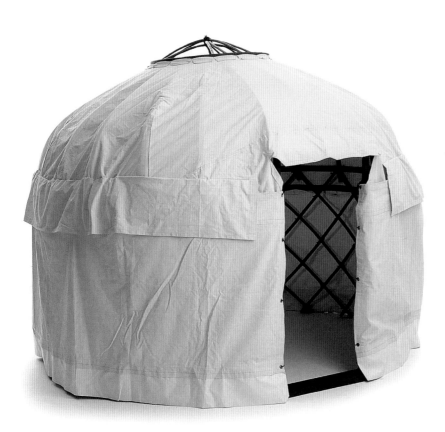

"I have always had a profound respect and passion for oak, with its figure and texture. It is one of the most versatile timbers in a craftsman's repertoire. It responds well to making processes and surface treatments. Because of its tannic-acid content it can be fumed, limed or ebonized, and it responds well to bleach. (Even beer produces an interesting colour if spilled on oak!)

Imagine my excitement when I was invited to participate in the onetree event. To use oak also triggered thoughts from my Arts and Crafts background. Using oak in the solid instead of a veneer recalled the aesthetic and constructional idioms of furniture from a bygone era. I have often said that I respect the past but prefer not to be conditioned by it. Within a few minutes of hearing about the exhibition I had come up with a design that combined the classic joint of Arts and Crafts furniture, the dovetail, with its application to my own interpretation of the practical and aesthetic requirements of a console table. I also had in stock some bog oak, reputed to be five thousand years old, naturally ebonized by having been buried, perhaps following an ancient storm, in peat land, where the tannic acid had reacted with the natural ferrous salts in the water to turn the wood black. Hence the old and the new have been combined to create my contribution to onetree." *Robert Ingham*

Robert Ingham was born in Delhi, India, in 1938; in 1949 his family returned to England. He completed a teacher-training course at Loughborough College, specializing in woodwork and metalwork, and then attended Leeds College of Art, gaining a national diploma in design. He later studied for a teaching qualification at the University of Leeds.

Robert set up a workshop with his brother George in Thirsk, North Yorkshire, designing and making one-off pieces. Subsequently they opted for independent careers, Robert teaming up with John Makepeace to set up the School for Craftsmanship in Wood, later Parnham College, in Dorset. Here he stayed as principal for twenty years, training a string of successful graduates who now form the backbone of the British designer–maker élite. In conjunction with this, Robert also ran his own business, Robert Ingham Designs, making one-off pieces to commission, and small batches of intricate collectable boxes, which he now produces full-time since moving to north Wales in 1997.

Robert is a liveryman of the Worshipful Company of Furniture Makers, and has been awarded nine Guild Marks by them for excellence. He is a Fellow of the Society of Designer Craftsmen, and exhibits at its annual London show. He exhibits regularly in Britain and the USA, and has significant pieces in collections in both countries, where he also teaches at annual summer schools. He has been invited to judge competitions in England and for the Irish Crafts Council.

Robert is employed by Buckinghamshire Chilterns University on a research and advisory basis.

Robert's work is featured in several books on modern furniture, including an extended section in Betty Norbury's *Furniture for the 21st Century* (1999).

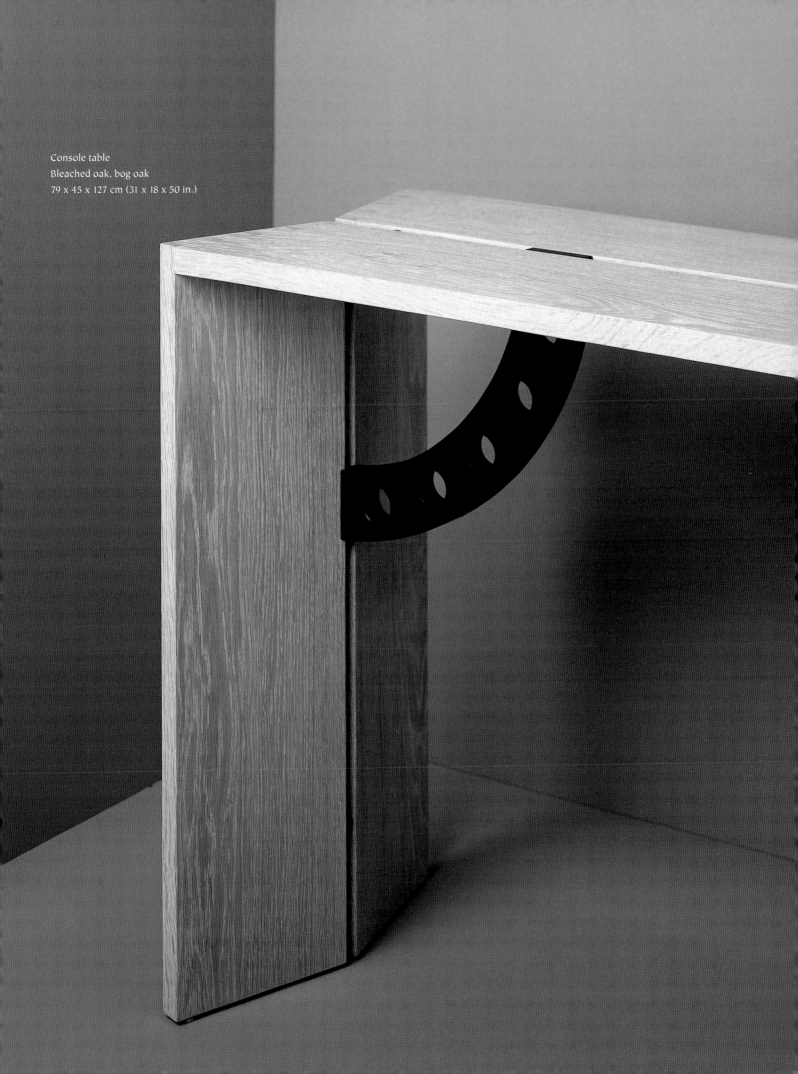

Console table
Bleached oak, bog oak
79 x 45 x 127 cm (31 x 18 x 50 in.)

HELEN JOHNSON

"My involvement in the onetree project has been to take the words written by Joan Poulson and arrange them in book form. The words led the design and layout, while the use of oak boards for the cover informed the binding style. The whole piece encompasses responses to the tree through words, calligraphy, paper-making and book-binding." *Helen Johnson*

Helen Johnson was born in 1963 in Exeter, Devon. She attended Pate's Grammar School, Cheltenham, and South Warwickshire College before moving on to Stratford-upon-Avon Central School of Speech and Drama. After fifteen years working in the theatre as a stage manager Helen attended the Roehampton Institute, London, to take a degree in calligraphy and bookbinding. Having gained her degree she took up the offer of a place on the North West Arts Board's setting-up scheme. She spent eighteen months at Blackburn Museum and Art Gallery, supported by the North West Arts Board, and since April 2000 has been working from her own workshop in West Yorkshire. Her work combines private commissions with making props for theatre productions.

One Tree
Oak, handmade paper (by Gill Wilson; see pp. 180–81),
Saunders Waterford paper, gouache, gold leaf, linen thread
34 x 26 x 4 cm (13½ x 10 x 1½ in.)

One Tree

OWEN JONES

"I am used to going into the woods and selecting and felling my material, normally young – twenty-five to thirty-year-old – coppiced oak, which is soft and pliant. The preparation of my material involves riving the oak into thin strips, which are shaped, smoothed and then woven into a basket. All processes are done by hand, using hand tools and feel. I spend a lot of time carefully selecting my raw material, so it was rather daunting to join the onetree project and be supplied with material from a tree far older than anything I would normally use, and grown in a different part of the country. It did turn out to be very challenging: the oak felt harder and coarser. The grain, which looked even and straight, was deceptive, making riving difficult. It was, however, very satisfying to get on top of the wood and succeed in making a swill basket from it. I am proud to be part of the onetree project." *Owen Jones*

Owen Jones was born in 1959 in Lyndhurst, Hampshire. His first career was as a helicopter engineer, but in 1988 he was taught to make oak swill baskets by John Barker of Grizebeck, Cumbria. Swills are traditional baskets from the Lake District, and Owen was lucky to find a maker who was keen to pass on his skills. Now the sole full-time swill-maker in Britain, Owen divides his time between working from his home in the southern Lake District and demonstrating swill-making at events and shows throughout the country. He also runs several short courses each year.

Exhibitions featuring his work have included the touring show *Working with Willow* (1992–93); the International Folk Art Festival, Kezmarok, Slovakia (1996 and 1997); and the Crafts Council's touring show *Contemporary International Basketmaking* (1999–2000).

Owen's work has featured in many publications, including *Practical Woodworking, Craftsman, Permaculture, The Woodworker* and the book *Last of the Line: Traditional British Craftsmen* by Tom Quinn and Paul Felix (1999).

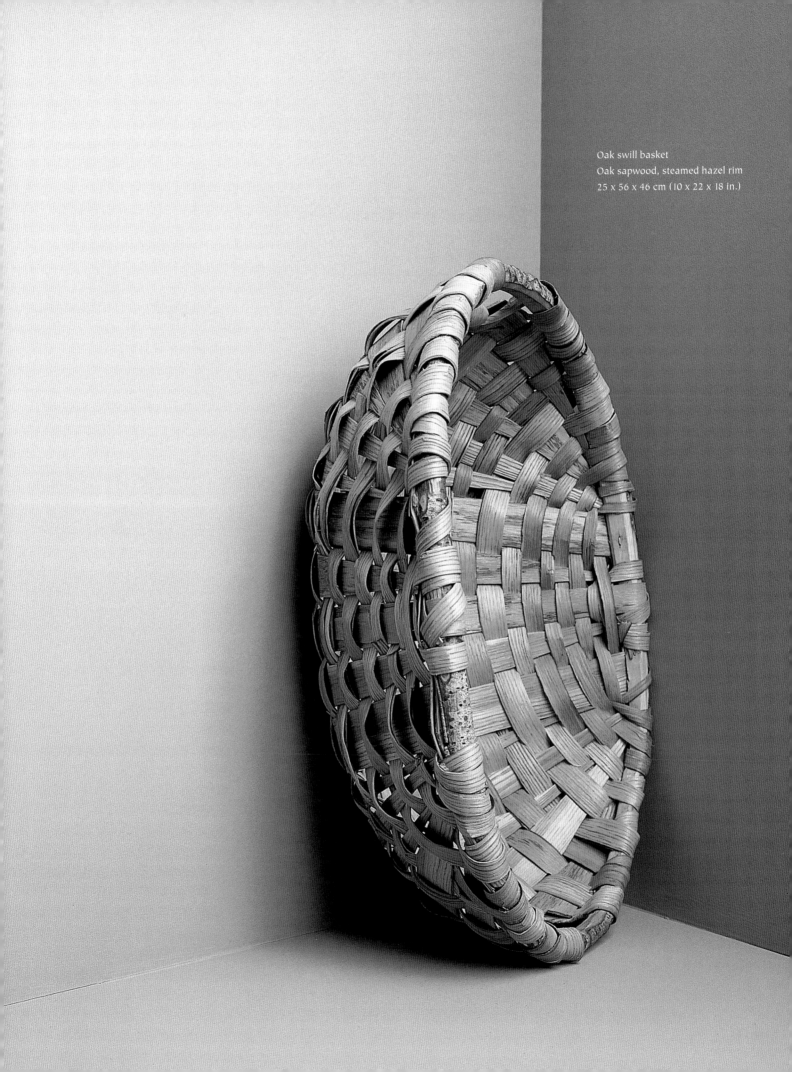

Oak swill basket
Oak sapwood, steamed hazel rim
25 x 56 x 46 cm (10 x 22 x 18 in.)

"When I was a child I often used to find bits of writing around school, in shrines, temples or other public buildings. In particular I often found messages in public toilets. They were written in a small, neat hand like short letters, but instead of being written on paper and sent, they were written directly on to the wall. When I recently moved to England I found similar messages in pub toilets. The messages were to old boyfriends and future boyfriends, to friends and relatives, but often to nobody in particular, or to everybody. At times a message would be followed by a reply – not from the person to whom it had been directed, but from more general readers.

The writer and reader always follow a set of unspoken rules, which come about from the situation in which the words are written: they are anonymous; the communicators don't need to know each other. The way of communication is one to one (because only one person at a time can use the toilet), and they are always frank.

The messages express strong emotion – a desire on the part of the writer to say or do something that they cannot or will not do in reality. For me they stand as witnesses to the wonder of the written word and its ability to provide catharsis – giving the writer (and the reader) emotional relief.

I had an image of this project before I knew of the onetree exhibition. I was looking for a material that would be appropriate for the message space, and I knew only that it would have to be a sacred, refined material. I was particularly interested in the brief from onetree because of the sacred presence that old trees have. The history of written language and paper have developed hand-in-hand. A paper message-board made from an old oak seems to be very appropriate.

My exhibit is handmade paper, made from the oak tree, on which messages can be written. Message writers will walk into a partly enclosed area so that they can write on the paper without others seeing (only one writer can fit in at a time). When nobody is writing, the paper can be viewed by many from outside the enclosure. There will be a different message paper for every exhibition, but the previous pieces will be shown at each venue – so at the first venue there will be just one, at the next there will be two, and so on.

After the show I want to return the paper, along with the messages that it has accumulated, by burning it and burying the ashes where the tree once stood." *Miyuki Kasahara*

Miyuki Kasahara was born in 1972 in Japan.
She studied theatre design and display design
at Musashino Art University in 1994, before
moving on to the Tokyo Glass Art Institute and
the Royal College of Art, London, where she
completed an MA in glass and ceramics in 1999.

Miyuki's work has been exhibited in many
galleries, including the Spitz Gallery and
the Print Room in London and the Maruzen
Gallery and the Tokyu Gallery in Tokyo.
She has also been involved in group exhibitions,
including the *Contemporary Art Show* (1999),
produced by Lackadaisical Productions,
Edinburgh, and the touring exhibition *Ikons of
Identity* (2001).

Message to …
Paper made from oak-leaf compost

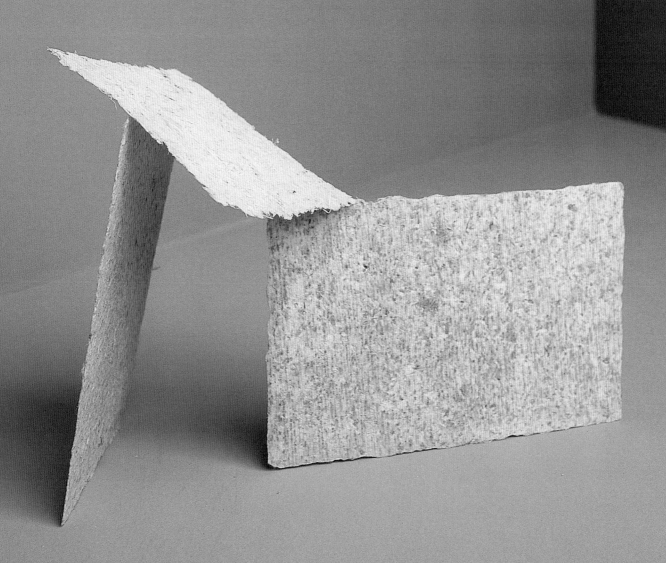

GILES KENT

"I was so inspired by the dynamic of the roots that I wanted to leave them as intact as possible. At first I considered carving the remaining wood of the trunk into angular forms to contrast with the shape of the roots. However, after doing some sketches and seeing the stump on its side, I decided to try to carve and burn the wood in a way that would flow into the roots and be aesthetically in harmony with them. I also wanted the finished form to contain references to a flower bud or seed pod opening, with sensual undertones.

I made the piece on the site where the tree grew, which I found to be a beautiful and stimulating work environment." *Giles Kent*

Giles Kent was born in 1967 in London. He studied sculpture at the University of East London (1993–96), and after graduating went straight to a residency at Grizedale Forest in Cumbria. Between 1996 and 2000 he was invited to residencies at Eye Town Moors Woodland, Suffolk; the Gardens of Gaia, Kent; the International Wood Sculpture Symposium, Czech Republic; Burghley House, Lincolnshire; Åkerby Skulpturenpark, Sweden; Broomhill Art Hotel Sculpture Garden, Devon; and Hannah Peschar Sculpture Garden, Surrey.

Giles has been selected for public commissions at Norbury Country Park, Surrey; Peterborough Sculpture Park, Cambridgeshire; Capstone Farm Country Park, Kent; Albury, Surrey; and the River Lune Park, Lancaster. He has also been commissioned to provide work private collections in the Cotswolds, Surrey, Lincolnshire and London. In January 1997 Giles was awarded a membership bursary by the Royal Society of British Sculptors and became an associate life member in October 1999. He has been featured in such publications as *The Economist*, *Contemporary Visual Arts*, *The Times*, *Art Review*, *The Sunday Express*, *The Daily Mail*, *Exhibit A*, *Resurgence*, *The Independent* and *Galleries*.

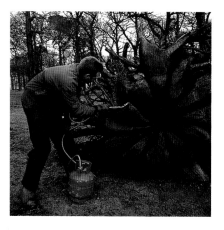

Untitled
Root ball
Height 150 cm (59 in.)

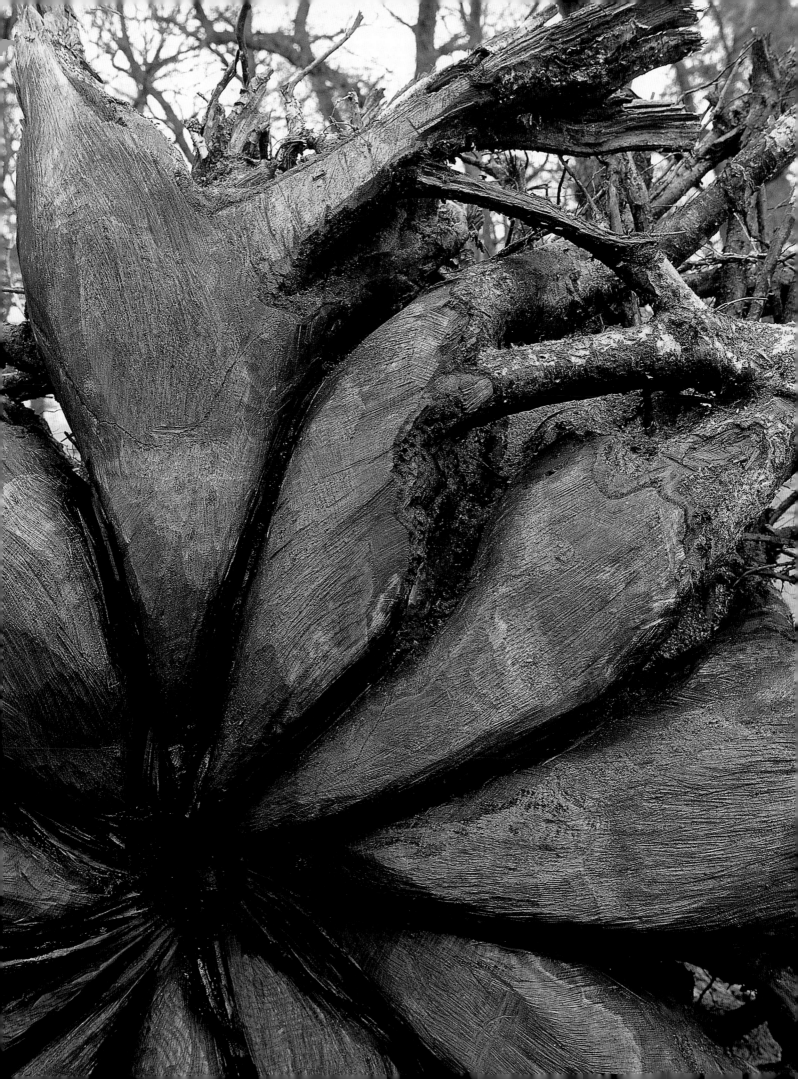

RAY KEY

"My usual designs are mostly of simple, flowing, unadorned form – the minimalist approach, if you will. Oak is a material I seldom use unless it has burr, as I feel it does not usually suit my style of work. So this project offered a challenge to which to respond while still keeping my design dictum to the fore.

My chosen route was to produce two of my well-proven designs that work in any size by scaling up and down the elements that make them successful. Each has wide flanges. One group is footed with a subtle ogee curve on the underside. The flange of this group has been black-scorched with a blowlamp, brushed out and sealed with oil, giving a pleasing, weathered-looking contrast to the polished surfaces. The second group (not illustrated) has a fluid curve from base to rim on the underside. The wide flange on top has an incised undercut on the inside rim to create a shadow image; this element changes as the sunlight moves across a room during the day.

A surprise element of this project was that when I collected my board I was offered a weathered spur from the outside of the tree. It was badly split on the cut face and bark-clad on the outer. I took it, but it was not my sort of wood at all. In the spirit of the project I have produced a weathered, black-scorched and wire-brushed large bowl (not illustrated) with just the one smooth polished element on the inside. It was an unexpected challenge, and few will think of it as a Ray Key, except for the shape." *Ray Key*

Ray Key was born in 1942 in Kenilworth, Warwickshire. On leaving school he completed a five-year wood and metal pattern-making apprenticeship. He spent the following two years making moulds for fibreglass swimming pools and a further seven years as clay-modelling project leader for Chrysler styling studios, Coventry.

Ray has been turning wood for over forty years, and since 1973 it has been his full-time occupation. His work has been featured in more than one hundred and fifty exhibitions across the world. He has also travelled widely, having regularly been invited to demonstrate at international seminars in the USA, Canada, Ireland, Norway, New Zealand, Israel, France and Germany. He has also run teaching workshops in most of these countries.

Ray's work is held in many major private collections worldwide and in the permanent collections of a number of museums and institutions, including Abingdon Museum, Oxfordshire; Stoke Museum, Stoke-on-Trent, Staffordshire; the British Council; Parnham House, Dorset; All UK International Craft Museum, Kuala Lumpur; Contemporary Craft Museum, Honolulu; Kunstgewerbe Museum, Berlin; Detroit Institute of Arts and Crafts; and Arrowmont School of Arts and Crafts, Tennessee.

Ray has been the subject of numerous articles and has written over thirty himself on the subject of woodturning, as well as three books: *Woodturning and Design* (1985), *Woodturner's Workbook* (1992) and *Woodturning with Ray Key* (1998). He has also made three videos on box-making.

In 1973 Ray was selected for membership of the Worcestershire Guild of Designer Craftsmen. He has served the guild in most of its offices and was made president in 1998. In 1987 he was elected founding chairman of the Association of Woodturners of Great Britain; in 1998 he was appointed president.

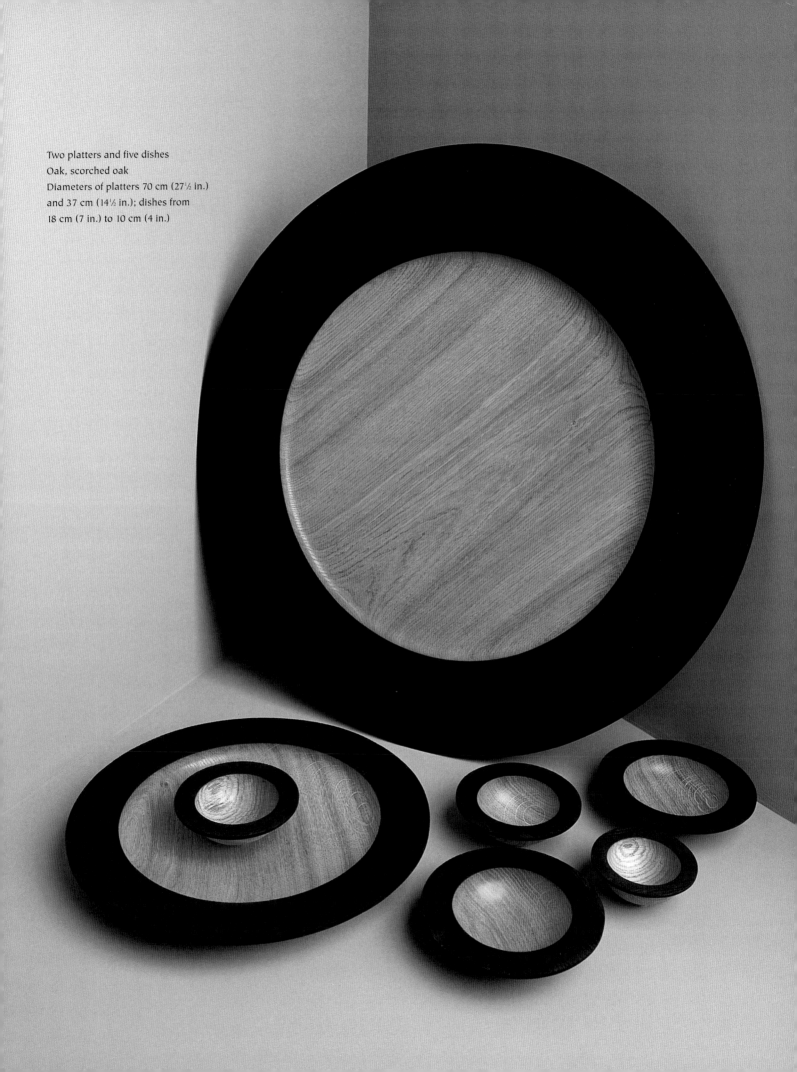

Two platters and five dishes
Oak, scorched oak
Diameters of platters 70 cm (27½ in.)
and 37 cm (14½ in.); dishes from
18 cm (7 in.) to 10 cm (4 in.)

"I was invited to join the onetree project, along with Petter Southall, at a late stage, after another maker had pulled out. With a limited amount of timber available our initial response was to collaborate on a joint project. However, the short timescale and distances involved led us to realize that this was over-optimistic, and we decided to split the available timber and work on our own projects.

Timber, although renewable, is a precious material and requires a responsible approach during the design process. Given that the timber I had comprised two 1-inch-thick boards, and that my initial objective was to minimize the amount of waste, I decided to make flatpack chairs, a design I have produced for some years now.

The design responds to the onetree project in its economic use of material, using timber directly from the converted tree trunk and avoiding costly machining and loss of thickness. The bandsaw marks add texture and pattern to the surface, and the natural curve created in the boards as they dry out adds comfort to the seat and back components.

I was able to make three chairs out of the two boards supplied. Each one comprises three timber components that slot together and are held in place by a stainless-steel pin. The chairs were made in January 2001 and are finished in three ways: one is natural, showing marks made during the conversion and drying process; the next is oiled, washed and finished with two coats of Danish oil; and the third is scorched and sealed with black polish." *Robert Kilvington*

Robert Kilvington was born in 1967 in Wantage, Oxfordshire. He studied furniture design and craftsmanship at Parnham College, Dorset (1989–91), and went on to the Royal College of Art, London, where he gained an MA in furniture design in 1994. In that same year he was awarded first prize in the British Steel Melchett Awards and first prize in the Storage for Europe competition run by the Worshipful Company of Furniture Makers.

In 1996 Robert established a new base in north Devon and was awarded a setting-up grant by the Crafts Council. His commissioned furniture has included both one-off and batch-produced pieces, as well as designs for manufacturers in the UK and Italy. More recently he has produced large-scale works for public spaces.

In 1996 Robert won the Ness Furniture Design Award for the design of a new stacking chair, and in 1998 he created gallery seating – which subsequently won the prestigious Scottish Design Award in the furniture category – for Art.tm, Inverness, commissioned by The Edward Marshall Trust. He was shortlisted for the 1999 Jerwood Prize for Applied Arts.

In 1997 Robert completed his first public art commission, entitled *Crossing the Line*, which took the form of a sculptured gateway to Tilsley Athletics Park, Abingdon, Oxfordshire, and which was commissioned by Vale of the White Horse District Council. Since then Robert has completed sculpture commissions for the Grosvenor Estate/Unilever in London (1998), the Dryburn Hospital in Durham (2000) and Aylesbury Vale Arts Council, Vale Park (2001), and has produced gates and railings for Look Ahead Housing and Care, London (2001).

Robert's work is included in *Makepeace: A Spirit of Adventure in Craft and Design* by Jeremy Myerson (1995) and *New British Design, 1998* by Peta Levi (1998).

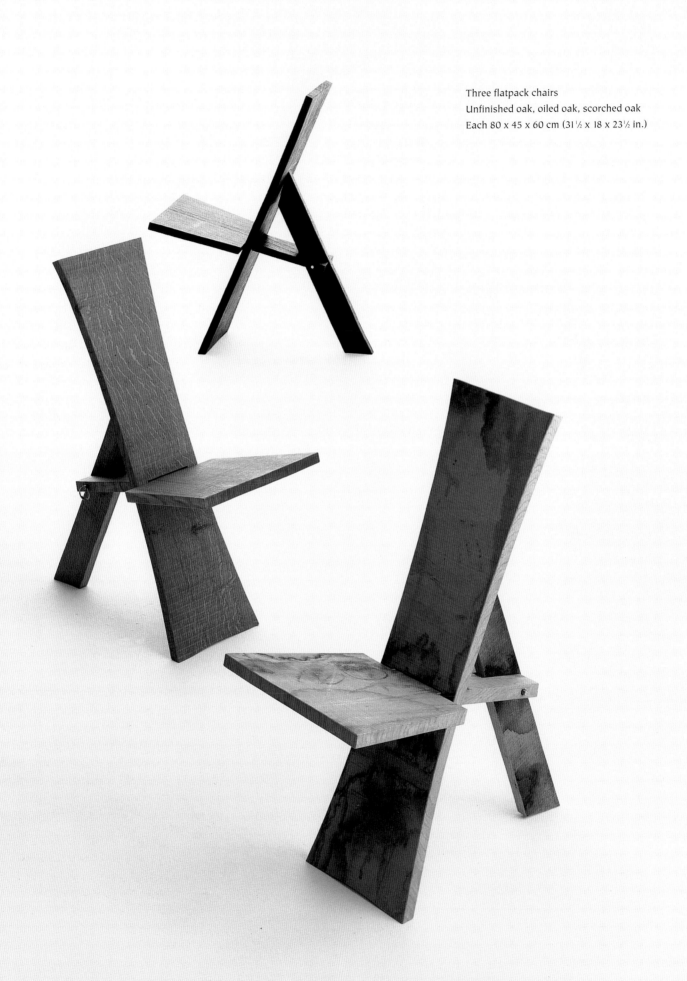

Three flatpack chairs
Unfinished oak, oiled oak, scorched oak
Each 80 x 45 x 60 cm (31 ½ x 18 x 23½ in.)

"The idea of transforming a raw hide, a transient thing on the point of decomposition, into leather, a stable and permanent material, seemed quite magical, especially when the substance that brought about such a change was the bark of a tree. Although I have had experience of processing such materials as paper in the past, and had used leather before, I had never attempted to make it from scratch. I was interested in the actions I would have to perform and the implications of transforming skin into a practical material.

To begin with, the process completely revolted me: liming and plucking the hairs out of the skin made me feel murderous. My first attempts illustrated the hardest trick in leather tanning: if the oak-bark-and-water solution is too strong, only the outer layer of skin tans and it is impossible for the inner layers to be penetrated. Time was running out. Eventually I consulted Claytons Tannery in Chesterfield. They agreed to oversee the process. I tanned all twenty-five of the cow bellies hanging for five weeks in the 1 x 1 m pits I had made in the Arboretum at Jodrell Bank, building up the solution strength slowly to as high a level as I could. I then passed half of the skins to Claytons, who finished them off. They did this using traditional oak bark and modern technology in a very concentrated solution. Eventually I had thirteen pieces completely tanned and another twelve tanned by myself to what tanners call scabbard leather.

My idea of building two floors for the exhibition rose out of the fascination I have with the way leather holds a history of use on its surface. I was intrigued by the way a skin's function hinges on it being made stable by this ancient chemical called tannin, and I wanted to create two floors to demonstrate this. The first floor (not illustrated) conveys this feeling of practicality and craftsmanship, implying use, while the other, raw and organic, reveals the ephemeral nature of our existence. This idea mirrors the spiritual beliefs of the soul leaving the body." *Helen Knowles*

Helen Knowles was born in 1975 in Hackney, London. She graduated in painting from Glasgow School of Art in 1998. During her time at college she also took a course in paper-making and spent three months on an exchange visit to Baroda School of Fine Art in Gujarat, India.

Helen won the Paul Cann Travel Award in 1994, a scholarship that allowed her to explore Spain and France, studying the effects of the Spanish Civil War on Miró and Picasso. Work resulting from this was exhibited at the Tate Gallery, London, that same year. In 1997 she went to India on a bursary from MTL Engineering.

In 1999 Helen was artist-in-residence at Jodrell Bank Science Centre, Cheshire. While there she curated *Radio Halo*, which was *CITYlife* magazine's "exhibition of the year", and was also featured in *The Guardian* newspaper. This artist-led initiative gained her awards from the Amateurs Trust, the Newspaper Makers and Stationers Educational Trust and the North West Arts Board. Her collaborative installation with Elizabeth Stuart Smith, *Sailing Species*, created for Brereton Heath Country Park in Cheshire, took Helen's interest in plants to a new level. She hopes to explore this area more deeply during her next trip to India in 2001 with the Hive Collective. A travel grant from the North West Arts Board is allowing her to collaborate on a film and art project in the Punjab.

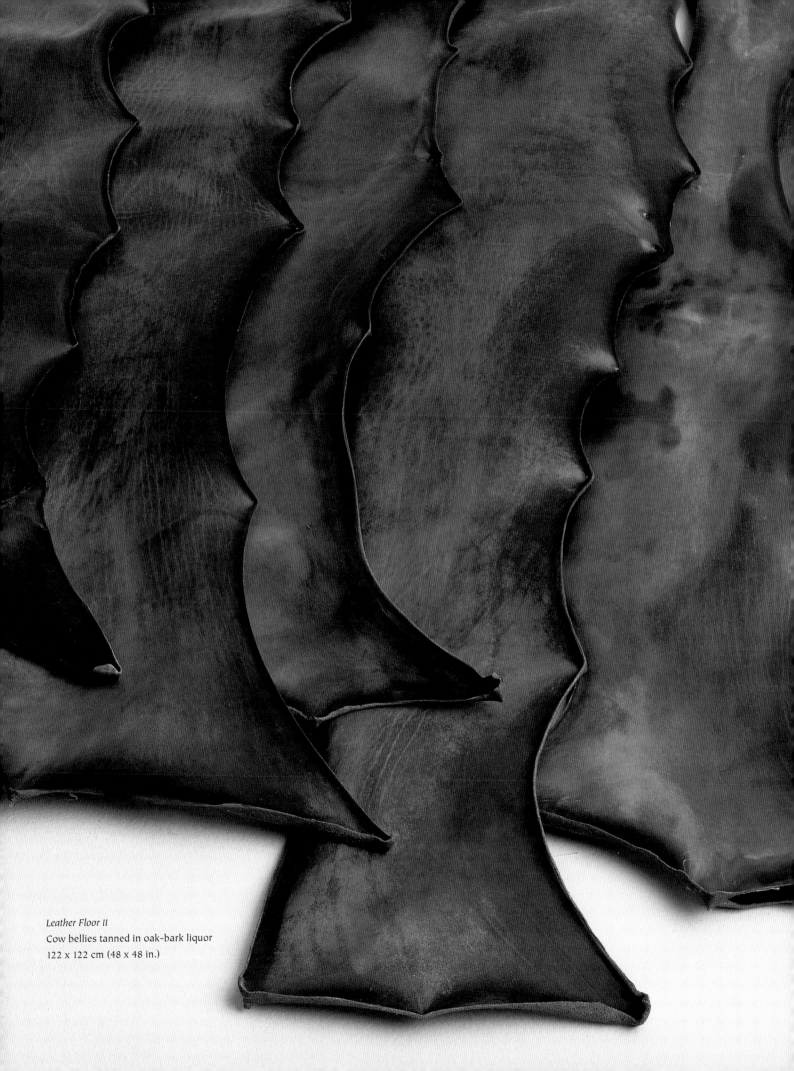

Leather Floor II
Cow bellies tanned in oak-bark liquor
122 x 122 cm (48 x 48 in.)

"When I started out as a student in the late 1950s and early 1960s, the key issue seemed to be how to deal with the idea of modernism – and first understanding what it meant.

As I got into my work, I found myself dealing with three interrelated considerations: first with structure (the performance of the overall geometry), next with construction (how things are joined together) and then with the material itself (the technologies of handling wood). These considerations, combined with the critical analysis of my professor, David Pye, made me aware of the issue of shape-determining systems.

This work, made from cleft green oak (that is, with the moisture from the living tree still in it), uses a technique I first experimented with twenty-five years ago after reading Herbert Edlin's book *Woodland Crafts of Britain*. The piece of the onetree that I was given was a section of branchwood. The limb had quite a strong bend and twist – with the heart (the centre) of the branch lying on one edge, not centrally. I do not know if branchwood was used for splitting when this technology was used in simple vernacular making, so it's an interesting experiment.

The chair I have made is a hybrid, using a fairly traditional design (first used by me in 1969) and normal mortise-and-tenon construction, both of which work well for flat-surfaced pieces, not irregular cleft components. The result is a certain aesthetic tension, albeit resulting from an uneconomical way of making." *Richard La Trobe-Bateman*

Richard La Trobe-Bateman was born in 1938 in London. He studied sculpture at St Martin's School of Art, London (1957–61), and furniture design at the Royal College of Art, London (1965–68).

In a long and illustrious career Richard has produced ground-breaking and influential designs for furniture, bridges and towers. His work has been extensively featured on television, in the national press and specialist design and craft magazines, and in many books, including *The Culture of Craft* by Peter Dormer (1997) and *The Crafts in Britain in the Twentieth Century* by Tanya Harrod (1999).

Among Richard's most important commissions are the High Table and chairs, Pembroke College, Oxford (1983); the River Beck footbridge, Beckenham, Kent (1989); the River Eden footbridge, Cumbria (1994); the River Mardyke footbridge, Davey Down, Essex (1996); and the National Pinetum footbridge, Bedgebury, Kent (1998).

In 1982 Richard was commissioned by the Crafts Council to produce work for HRH The Prince of Wales. His pieces are held in most major collections in the UK and in many overseas.

Chair
Cleft green oak
128 x 49 x 51 cm (50 x 19 x 20 in.)

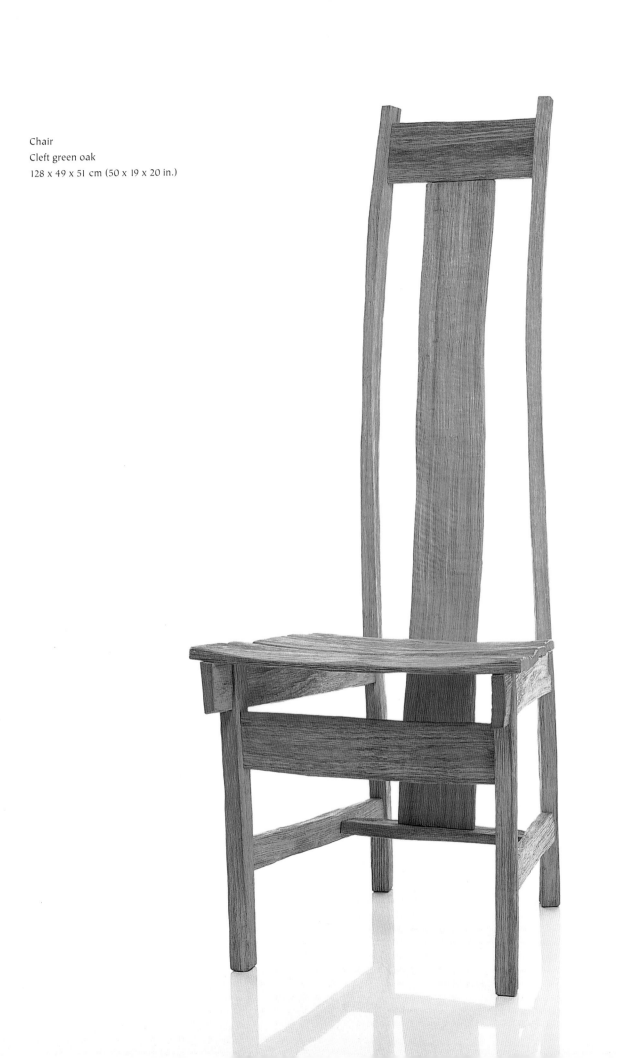

MICHAEL LEIGH

"The recycling ethic has always been a strong influence on my work, especially since I became involved in the international mail-art network; the A1 Waste Paper Co. Ltd – the name I mostly work under in this medium – echoes this perfectly.

I had previously organized postcard exchanges and recycling projects at Worcester Art Gallery (1997) and Oriel Myrrdin, Carmarthen (1999), and felt this was an excellent way to use the thin veneer from the tree and bring an international flavour to the project in a collaborative way – and also, of course, to reveal the workings of the mysterious mail-art world to a much wider audience.

So, when I got my large, floppy pieces of veneer, I was rather apprehensive and wondered if they could be fashioned into postcards that would stand the rigours of the postal system; but I soon discovered that a combination of three layers with the grain, and a middle layer going across for strength, was up to the task.

Each card had a flyer attached briefly explaining the onetree project and how I needed participants to add collage, rubber stamps, drawing or writing to the card and post it back to me. Before I sent the cards I added, as a starting-point, a stamp or piece of collage that was appropriate to the theme of recycling, ecology and trees.

I sent out 150 cards to mail artists in over 28 countries, and by November 2000 had had 57 cards returned. Some had not had much added, so I have added to them using recycled materials I have gathered over the last few months. Others were very elaborately collaged and weathered, and didn't need much in the way of additions." *Michael Leigh*

Michael Leigh was born in 1947 in London. He attended Southend School of Art and Manchester School of Art and Design, and completed an MA in fine art at Chelsea School of Art, London, in 1971.

Since discovering the international mail-art network in 1980 Michael has devoted most of his artistic career to mail-art collage and collaborative projects. His work has been widely shown in many countries, with one-man shows in Japan, Belgium and the UK. He has also shared exhibitions with his partner, Hazel Jones, in Stafford, Walsall and London. His own mail-art projects include the *Rubber Stamp Exchange* (1984), *Peace in the World or the World in Pieces* (1984), the *Waste* and *Postage* audio-cassette compilations (1986), *Pulling Faces* (1995) and *Recycling the Century* (1999).

Michael's work has appeared in many publications, including *Networking Currents* by Chuck Welch (1986), *I am a Networker Sometimes* by H.R. Fricker (1989), *The Magazine Network* by Geza Pernecsky (1991), *Networking: Art by Mail and Fax* (1997), *Arte Postale* by Vittore Baroni (1997) and *Rubber Stamp Art* by John Held Jr. (1999).

Michael also makes artists' books and publications in a variety of media. Self-published titles include *Curios Thing*, a small, photocopied magazine, including stickers and badges; and self-assembly mail-art magazines, including *Bric-a-Brac* and *Squint*.

You Can't See the Wood for the Trees
Oak veneer and mixed media
Two frames, each 97 x 57cm (38 x 22 in.)

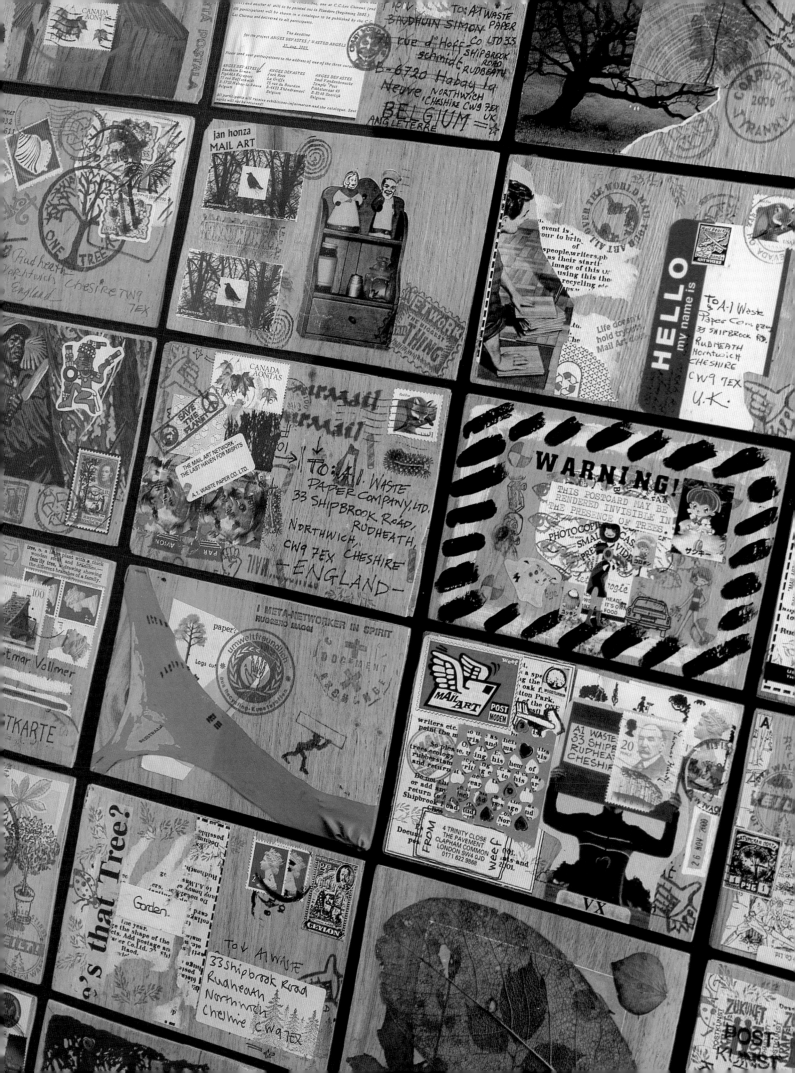

PETER LLOYD

"One of the very first boxes I made was from burr oak, given to me when I was picking up firewood from a local sawmill. The sawyer thought that it was too good for firewood but no good for pit props, so he asked me if I'd like it. It was that piece of wood that started my interest in box-making. I designed a box around the wood.

'I don't mind what it's like', was my response when I was asked about the wood from onetree that I needed for a box. 'Give me the gnarled and irregular bits that no one else wants.' Boxes don't need great structural strength, and where I can I like to include the 'wild and wacky' bits of the wood. It's these bits that have got character. I like to let the wood be itself.

When the oak arrived there were several pieces, some straight-grained and true, and some wild and gnarled. With careful planning I decided that there was enough for three boxes. I decided to make all three identical in size and shape but to use and emphasize the character of the wood to make each one look different.

I remember once gazing up at a gorgeous old oak and wondering how many boxes there would be in there ... It seems that onetree is going to give me some sort of answer to that." *Peter Lloyd*

Peter Lloyd was born in London in 1952. After working in air-traffic control at Heathrow Airport and then hotel and catering management, he spent a brief period as a bench joiner and then as a teacher, first in Cumbria, then in Botswana. In 1990 he started making boxes professionally.

Peter's work has been featured in numerous magazines and newspapers, including *The Woodworker, Furniture and Cabinetmaking, Cumbria Life, The Craftsman* and *The Daily Telegraph*, and also in several books, including *The Book of Boxes* by Andrew Crawford (1993); *Natural Order* (1996); *Furniture and Cabinetmaking Projects* (1998); and *Furniture and Cabinetmaking Techniques* (1999).

Twice winner of the main craft prize at the open exhibition at Tullie House Museum and Art Gallery, Carlisle, Peter has had solo exhibitions in the UK and Germany, and his work has been included in many group exhibitions.

As well as continuing to make boxes from his workshop in the tiny village of Hallbankgate, Cumbria, Peter is working on his own book, *Heirloom Boxes*, and is also working with Andrew Crawford on *Celebrating Boxes*, a touring exhibition of boxes from around the world.

Three boxes
Oak
Each 7 x 34 x 18 cm
(2¾ x 13½ x 7 in.)

DAVID MACH

"As a sculptor I am deeply suspicious of craft. Quite often an idea is sidetracked by an overconcentration on the way it is made. The idea gets obscured and the making becomes all. As a young student I remember talking to carvers about wood and how they might describe finding the object already in there, and that it was important to 'be one' with the material. I always found it difficult to deal with traditional materials such as wood and stone in this way, and basically didn't believe that this sensitivity was necessary or could be truly felt. It was only after working with lots of non-traditional materials, things that might be considered not to be art materials at all, that I began to find that this 'truth to materials', or even a 'truth to an idea', might be a real thing. Materials, no matter what they are – and my big experience is with real things: coat hangers, tyres, magazines, dolls, etc. – all have a kind of energy. It's important to know how you harness that and how to release it and not be led up the garden path by a convenient process. Because of that suspicion I want my sculpture to be unexpected.

The nature of this show might make certain types of work predictable; I hope that my *Nasty Piece of Work* is more confusing in its message. It's not a cute little garden gnome we are dealing with here; he's quite a violent character. Is he a product of his environment? Did he cut the tree down? Or did he come along afterwards? Is he a throwback or is he the shape of things to come?" *David Mach*

David Mach was born in 1956 in Methil, Fife. He attended Duncan of Jordanstone College of Art, Dundee (1974–79), graduating with distinction. He then progressed to the Royal College of Art, London, where he gained an MA in sculpture in 1982.

Since 1982 Mach, who lives and works in London, has exhibited his sculpture all over Europe, America, Australia and Japan. He was nominated for the Turner Prize in 1988 and won the Glasgow Lord Provost's Prize in 1992. Elected a member of the Royal Academy of Arts, London, in 1998, he was appointed visiting professor to the sculpture department of Edinburgh College of Art in 1999 and professor of sculpture at the Royal Academy of Arts, London, in 2000.

Mach unveiled Britain's largest contemporary sculpture in Darlington in 1997. *Train* is a life-size steam train made of engineering bricks, 37 m long and 9 m tall at its highest point. *Big Heids*, three heads made of steel beams and rods placed on 20-foot freight-container plinths stood vertically, were permanently sited beside the M8 motorway in Scotland in 1998. Mach was also commissioned to make a 78 x 3 m *National Portrait* for the Self-Portrait Zone at the Millennium Dome in Greenwich, a giant, seamless epic of collage, featuring thousands of photographs of people of the UK at work and play.

Mach's recent sculpture involves thousands of wire coat hangers, the largest piece being an 8-foot-tall spaceman.

Nasty Piece of Work
Oak logs, fibreglass, stone-cutter
160 x 180 x 150 cm (63 x 71 x 59 in.)

JOHN MAINWARING

"I was very pleased to be asked to contribute to the onetree project. It was an inspired idea to utilize every part of an oak tree felled and now given another existence.

I chose a maritime theme for my piece. I prepared a sketch examining the vertical movement of sea kelp and the forward direction of fish over an undulating seabed. Woodworkers are always aware of the fragility of the grain direction, and sometimes design suffers as a result. This problem can be alleviated by using several pieces of wood. It can strengthen the sculpture and also 'lift' the piece, preventing a heavy look. *Shoal* represents a feeling of continuous, graceful motion: fish, vegetation and seabed moving in unison with the sea. Having finished this piece I am inspired to create a much larger one on a similar theme. This is how ideas sometimes develop. My reference book is becoming full and time waits for no one.

The smell and tactility of wood are intrinsic to my profession. Both traditional and modern tools have their place.

I am a great admirer of Henry Moore, who said, 'I don't think it matters how a thing is produced, whether it's built up, modelled, welded, carved, constructed or whatever. What counts really is the vision it expresses – that is, it's the quality of the mind revealed behind it, rather than the way it's done.'" *John Mainwaring*

John Mainwaring was born in 1948 in Wem, Shropshire. After leaving school at the age of fifteen he began an apprenticeship as a carpenter, during which time he also undertook private tuition in art. The two disciplines came together in 1974 when he embarked upon a new career as a carver.

John gained experience first by watching, then by helping his father in his workshop, mostly making furniture. This experience influenced his interest in wood and design. He remembers vividly his father planing a piece of yellow pine with a large wooden plane. The shavings would curl up very quickly with a lovely hissing sound as the iron cut crisply through the wood. Although John, too, uses traditional tools, he is nonetheless willing to experiment with modern techniques.

John's work has been featured in television programmes and in numerous publications, including *Miller's Collectables 1995–96*, where his pieces were described as "collectables of the future".

John has had many solo exhibitions at such venues as the Royal Exchange Theatre, Manchester (1991), the Cecilia Colman Gallery, London (1994), and the Higher Street Gallery, Dartmouth (1991 and 1995), and joint exhibitions at Burford Woodcraft, Burford, Oxfordshire (2000), the Montpellier Gallery, Cheltenham (1999), and the Ombersley Gallery, Ombersley, Worcestershire (1997), among others. All these galleries, and many more, sell John's work on a regular basis, and his pieces have found buyers as far away as the USA and South Africa. Others are on display at Nature in Art, the centre for international wildlife art at Wallsworth Hall, Gloucester, and Brigham Young University, Provo, Utah.

Shoal
Oak
20 x 38 x 15 cm (8 x 15 x 6 in.)

GUY MARTIN WITH CHRIS FOGG

"Gripped between fear and excitement. Adrenalin running at its peak. Imagination creating a riot of unreal pictures, but a deep and awesome sense of curiosity tethered me to the seabed. Would I be the one to touch some lost intimacies of a sixteenth-century disaster? In murky water, my face-mask inches from its eye's task, I gently wafted soft mud into the sucking mouth of the air-lift. Then, time seemed to hover, seconds became hours, my imagination was caught in suspended wonder. Without any fuss objects began to appear – a human skull, a leather belt, a dagger's wooden handle.

The brief event was over, but with mind racing as if locked in mortal combat – needing to run but transfixed by its deed. The surface support tugged insistently on the thin line linking my moment to the vessel above, calling me back.

During the late summer of 1970, I was privileged to be involved in cutting the first trench across the sub-sea site which revealed the *Mary Rose*.

I love the skills I possess and am thankful that my parents valued an artistic training. Where would we find life without the spirit of curiosity, imagination, danger and love? The onetree vision and project, spiritually majestic in all that it embraces, left me in no doubt that I wanted to be involved.

My contribution is a collaboration with friend and poet Chris Fogg. We hope it gives as much pleasure and intrigue as we had in creating it." *Guy Martin*

Guy Martin was born in 1946 in Emsworth, Hampshire. He studied at Portsmouth School of Art and at St Martin's School of Art in London, where he gained a degree in sculpture. He now lives in west Dorset with his painter wife, Anya, and family.

Guy, born of a sculptor father and artistic mother, enjoyed a physically and spiritually creative childhood from the unusual home environment of a converted motor-torpedo boat. A diverse and varied career began in 1969, when he became assistant to the sculptor Sir Anthony Caro. Throughout his life Guy has retained a love for working in wood. He set up his first furniture practice in 1984, and in 1988 became chief design tutor at John Makepeace's internationally renowned Parnham College, Dorset.

The Parnham experience inspired change and a rigorous reappraisal of values. Since leaving in 1994 with a new vision, he has been principally engaged in the design and making of furniture using the renewable resources of English cultivated willow and locally coppiced hardwoods. His current furniture marks a significant shift in the development of contemporary furniture design, combining some old values with modern technologies and ecological concerns.

Guy is a member of the Devon Guild of Craftsmen and the Ecological Design Association. He has won several awards, and his work is in various public sites and collections in the UK and USA, including the American Craft Museum, New York.

Guy's work has been featured in many publications, including journals, books and exhibition catalogues.

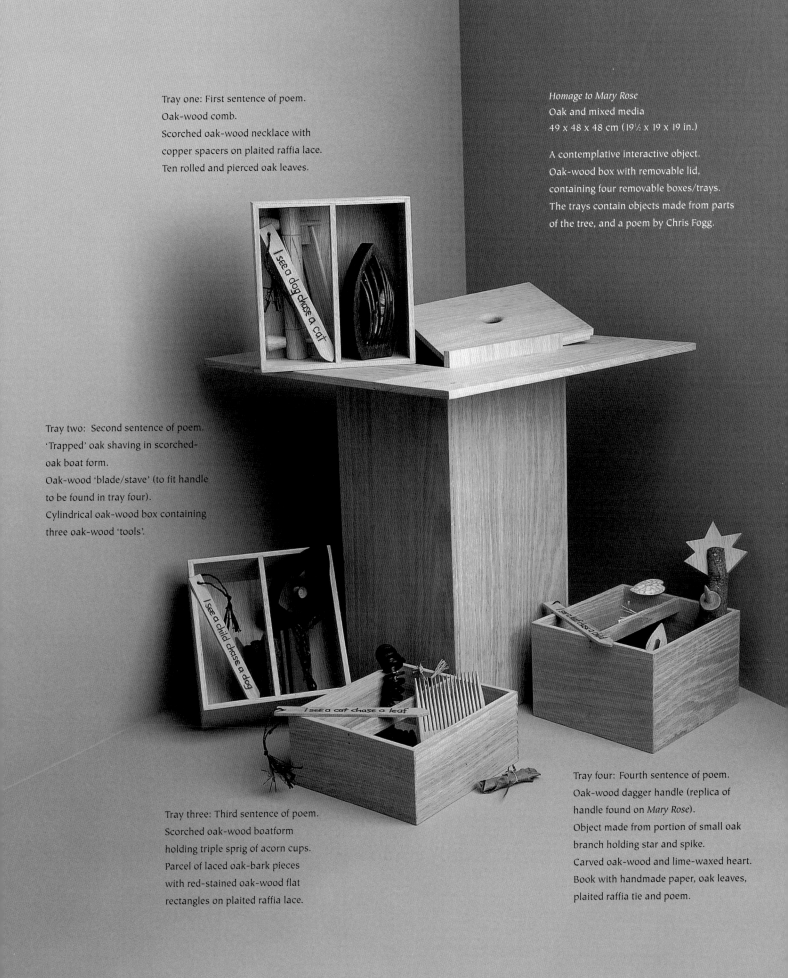

Tray one: First sentence of poem.
Oak-wood comb.
Scorched oak-wood necklace with
copper spacers on plaited raffia lace.
Ten rolled and pierced oak leaves.

Homage to Mary Rose
Oak and mixed media
49 x 48 x 48 cm (19½ x 19 x 19 in.)

A contemplative interactive object.
Oak-wood box with removable lid,
containing four removable boxes/trays.
The trays contain objects made from parts
of the tree, and a poem by Chris Fogg.

Tray two: Second sentence of poem.
'Trapped' oak shaving in scorched-
oak boat form.
Oak-wood 'blade/stave' (to fit handle
to be found in tray four).
Cylindrical oak-wood box containing
three oak-wood 'tools'.

Tray three: Third sentence of poem.
Scorched oak-wood boatform
holding triple sprig of acorn cups.
Parcel of laced oak-bark pieces
with red-stained oak-wood flat
rectangles on plaited raffia lace.

Tray four: Fourth sentence of poem.
Oak-wood dagger handle (replica of
handle found on *Mary Rose*).
Object made from portion of small oak
branch holding star and spike.
Carved oak-wood and lime-waxed heart.
Book with handmade paper, oak leaves,
plaited raffia tie and poem.

"When I was first introduced to the idea of the onetree project I thought what a clever idea it was and how exciting, challenging and environmentally important it would be. I was enthusiastic that onetree gave me the opportunity to work in this way again. (I had taken part in an exhibition at Viewpoint Photographic Gallery, Salford, in 1992, producing work in a similar way, using natural and waste materials to create sculpture on the body.) Working with unpredictable materials not naturally worn on the body is what I find exciting, and this challenges my creativity when constructing a piece.

When producing work for onetree some of the materials had surprised me, like the wood used to construct the jacket shown in this book. Each piece warped in more or less the same way, so when I overlapped the pieces to connect them they formed their own shape naturally, and the wood therefore dictated the final design.

It was important for me to see the felling of the oak tree in Tatton Park, because this was the starting-point from which my inspiration was to develop: I could see and feel the materials I was going to work with. After the felling I collected some materials such as the sawdust, leaves and branches, because it is the materials that inspire the flow of ideas.

To produce this jacket I used a bandsaw to cut slices as thin as possible from the trunk so as to cause warping in each piece, just like a potato crisp. The wood was cut thin for practical reasons as well as creative ones: the jacket was going to be worn, so it had to be lightweight, with the least amount of strain on the pieces around the shoulders. After cutting the pieces I soaked them all in vegetable oil to stop them going brittle and also to bring out the grain in the wood. In constructing the jacket I overlapped each piece to create an effect like fish scales, and then drilled fine holes through two pieces at a time. Using strong, clear, plastic thread, I sewed them together, shaping them round a mannequin figure." *Paula McNamara*

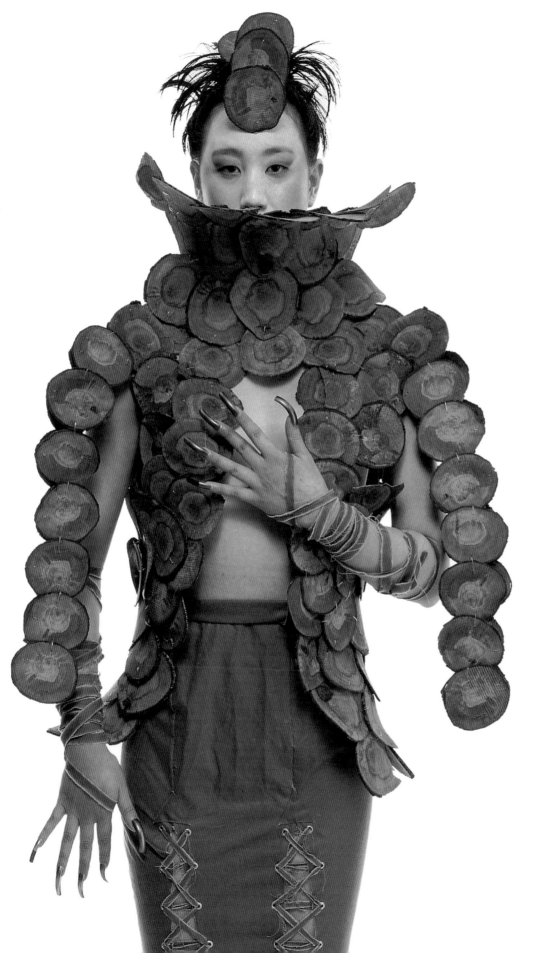

Paula McNamara was born in 1968 in Manchester. She attended Cardinal Vaughan School for Girls, and studied graphics, 3-D design and fashion at Adelphi College in Salford for two years before enrolling on a course in fashion design at Salford College of Technology.

In 1990 Paula had a proposal for an exhibition accepted by Viewpoint Photographic Gallery, Salford, and in 1992 the exhibition became a part of the European Festival of Expressionism. The festival in turn was documented by Granada Television, which filmed Paula's work for the arts programme *What's New*.

In 1994 images of Paula's work were exhibited at Viewpoint and also featured in the *Manchester Evening News*. The following year she contributed exhibits to Mantos' Café Bar, Manchester, consisting of a series of fashion illustrations in an Art Nouveau style. In 1996 Paula began studying ceramic design. She continues to work as a freelance fashion stylist, sourcing clothes for photographic shoots.

Untitled
Oak branchwood, clear plastic thread
Height 51 cm (20 in.)

JULIE MILES

"With my work I try to communicate the importance of the natural environment around us. I use objects collected from the landscape such as leaves, feathers or seed heads that evoke a sense of place, a smell, a sound, a memory. These elements can provoke different interpretations – a leaf a forest, or a feather a bird of prey – reflecting the uniqueness of personal experience and memories of landscape.

With the onetree piece I experimented with various materials from a different oak tree, from creating surfaces and patterns with the leaves to casting bark textures in clay. I eventually used the bark from the wedges cut from the base of the onetree oak at felling to create the works, casting the surface textures to give a negative mould, then draping this with fabric dipped in porcelain slip to produce the final pieces. This has transformed the tough outer layer of protective bark into a thin sheet of porcelain, which has been displayed with a light behind it to reveal the textures of the rough and deeply fissured bark as a delicate and fragile surface.

The concepts behind the onetree project are very similar to the ones that underpin my work as an artist, and I am very glad to be involved in such a worthwhile project. With it we are all celebrating nature and landscape, preserving part of our environment for the future, raising public awareness of the fragility of our natural surroundings and highlighting the tree as a valuable renewable resource." *Julie Miles*

Julie Miles was born in 1971 in Stoke-on-Trent, Staffordshire. She took a foundation course in art and design at the University of Central Lancashire, then studied at Cumbria College of Art and Design, gaining a degree in design craft in 1996 before taking an MA in ceramics at the University of Wales Institute in Cardiff (1998).

After graduating, and with the help of the North West Arts Board's setting-up scheme, Julie was an artist-in-residence at Drumcroon Art Education Centre, Wigan. There she produced pieces for exhibition and worked in schools. Since leaving the scheme she has continued to work with various schools and on a number of community projects. She has recently spent time as potter-in-residence at Giggleswick School, North Yorkshire, and has produced work in conjunction with the Platform Gallery, Clitheroe, Lancashire, about the Ribble Valley Sculpture Trail.

During the summer of 2000 Julie was awarded a Year of the Artist grant to work with the local community at a country park in Blackburn, producing ceramic work in response to the natural surroundings. She went on to work with the Horse and Bamboo theatre company on *Feeding the Dragon*, a millennium project that included working with schools and helping to construct and fire an Anagama-type kiln. In 2001 Julie was awarded a place on the Artist Access to Art Colleges scheme at Manchester Metropolitan University, working with its course in contemporary crafts to develop new pieces for exhibition.

Untitled
Porcelain, polycarbonate, whitewashed wooden box frame, strip lights
73 x 62 x 13 cm (29 x 24½ x 5 in.)

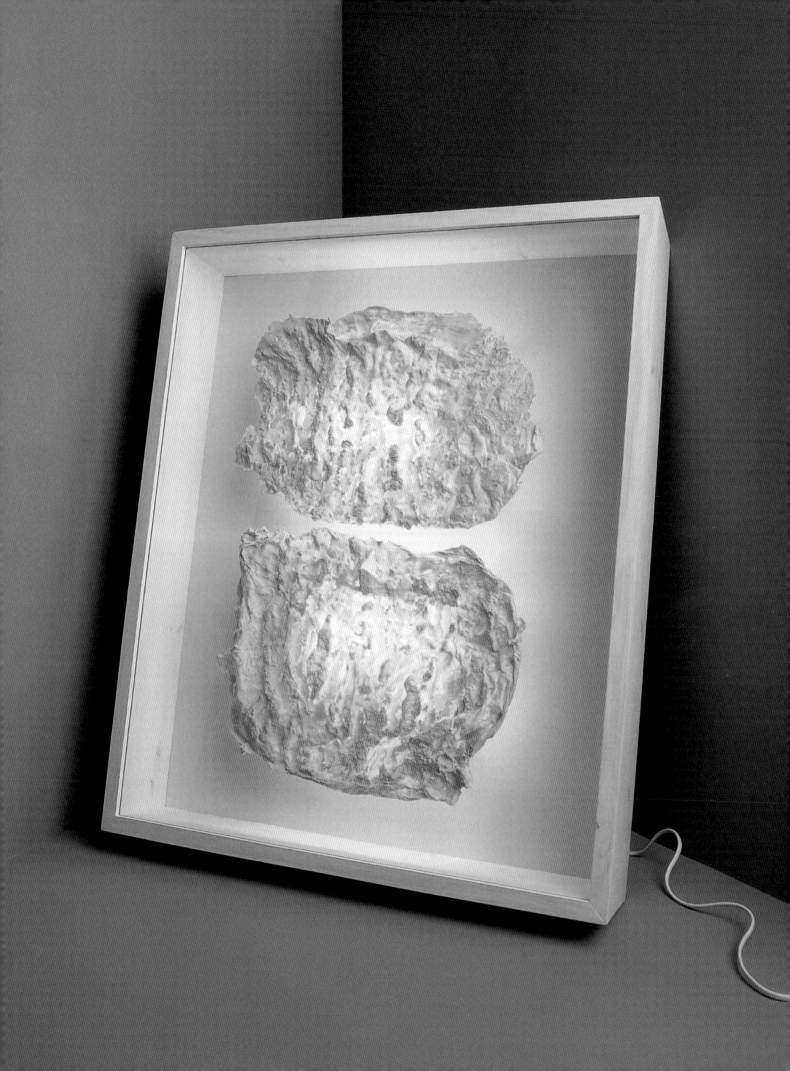

JO MILLS

"The way the lump of pine cracked, just when I didn't want it to, ended my brief venture into woodcarving years ago. I went on to investigate more obedient materials. Being a magpie and lover of all things shiny, I discovered metals: whack metal and it changes its form, heat it and it purrs. Here were invisible joins and trial by fire.

I began my onetree project with trepidation and curiosity, knowing only that my end result would be small-scale – dictated by my available workshop. Along the way, I found things out about the way I work – I'd been all about function and minimalism until now. I realize that I need – and love – the reaction that happens when the world of art and ideas meets the world of craft and function. I started a sketchbook of oak-tree research – photographs, observations, drawings; I collected bits and pieces. The idea of the tree took on a character like that of the dismantled Berlin Wall: each little scrap seemed significant.

Then, through the post, came my own twiggy bits of oak. They struck me as far too messy: all that dirty, untidy bark. I tore it off to leave a nice smooth finish – nearly as good as metal. I tried to turn the bark to dust, to paper, mangling and crushing it. Then I realized what I'd done: I'd taken away the tree's protection, its life force, its clothing, its precious skin. The bark became my focus. Carefully, I sandwiched it in layers of copper, rolled it, covered it with gold leaf, mounted it on silver … ." *Jo Mills*

Jo Mills was born in 1955 in Shropshire. After a first career producing training videos for the civil service she attended Sheffield Hallam University, graduating in 1999 in metalwork and jewellery design.

Jo's work is driven by a desire to produce practical, functional objects that are also interesting and beautiful. She works in silver together with other metals and plastics, and is open to experimenting with unconventional materials. Her reputation as a designer is steadily increasing: one of her vases was chosen as a gift for Janet Anderson MP, Minister for Tourism, Film and Broadcasting, at the Creative Industries Finance Conference held in Sheffield in May 2000. In 1999 she won a Worshipful Company of Goldsmiths Silver Award for her work as a student.

Her work is sold in galleries and shops, including the Royal Exchange in Manchester and Dean Clough Design Gallery in Halifax. Her work has been included in exhibitions in the UK and Europe, such as Harmstone Travel Bequest and Exhibition (1998); German 12th Silver-Triennial Touring Exhibition (1998–99); *New Designers*, Business Design Centre, London, (1999); Galerie Marzee, Nijmegen, The Netherlands (1999); and *Pick of the Best*, Beatrice Royal Contemporary Art and Craft (2000).

Five brooch pins
Oak, copper, silver, gold leaf
Each 4 x 2.5 x 0.5 cm
(1½ x 1 x ¼ in.)

ROBIN NOTT

"Because of the timescale involved, the development of the work on paper has gone through many changes, but the end result remains remarkably true to the original sketches. The simplicity of the idea, 'What if Judy's rolling pin were to be bruised when used to hit Punch?' and its cartoon-like nature removed any urge to overcomplicate and encouraged the non-functional and nonsensical nature of the *Swollen Pins*.

The aims of onetree appealed to me greatly: a refreshingly unrestrictive format, encompassing all kinds of makers. Much of my work around the time of the project had been wrestling with notions of the demarcation of disciplines through the use of furniture and other domestic forms within sculpture, and the associated 'line' that supposedly divides craft and art. The *Swollen Pins* was a light-hearted doodle, half reaction to and half development of these ideas. Onetree provided an ideal opportunity to address these themes through making; to exhibit with common purpose, provided by the project and most importantly the tree." *Robin Nott*

Robin Nott was born in 1974 in Exeter, Devon. In 1998 he graduated in fine art from the Southampton Institute, where he specialized in sculpture. Since then he has combined his making with work as a technician at galleries in Southampton and Portsmouth, along with trying to establish studio space as part of a local artist-led co-operative.

Robin has shown work in various group exhibitions in Hampshire, including *Knowledge* at the Bargate Centre, Southampton (1999); *Towards the Millennium* at Artsway Gallery, Sway, in the New Forest (1999); *Festive Allsorts* at the Hampshire Sculpture Trust, Winchester (1999–2000); *Intimate* at the West End Centre, Aldershot; *Louder than Bombs, Part II* and *Visions of the Future* at the Millais Gallery, Southampton (2000); and *Airfix* at Whitespace, Southampton (2000–01).

Swollen Pins: Judy,
The Swedish Chef and Mammy
Oak, pillows
Each 97 cm (38 in.) long

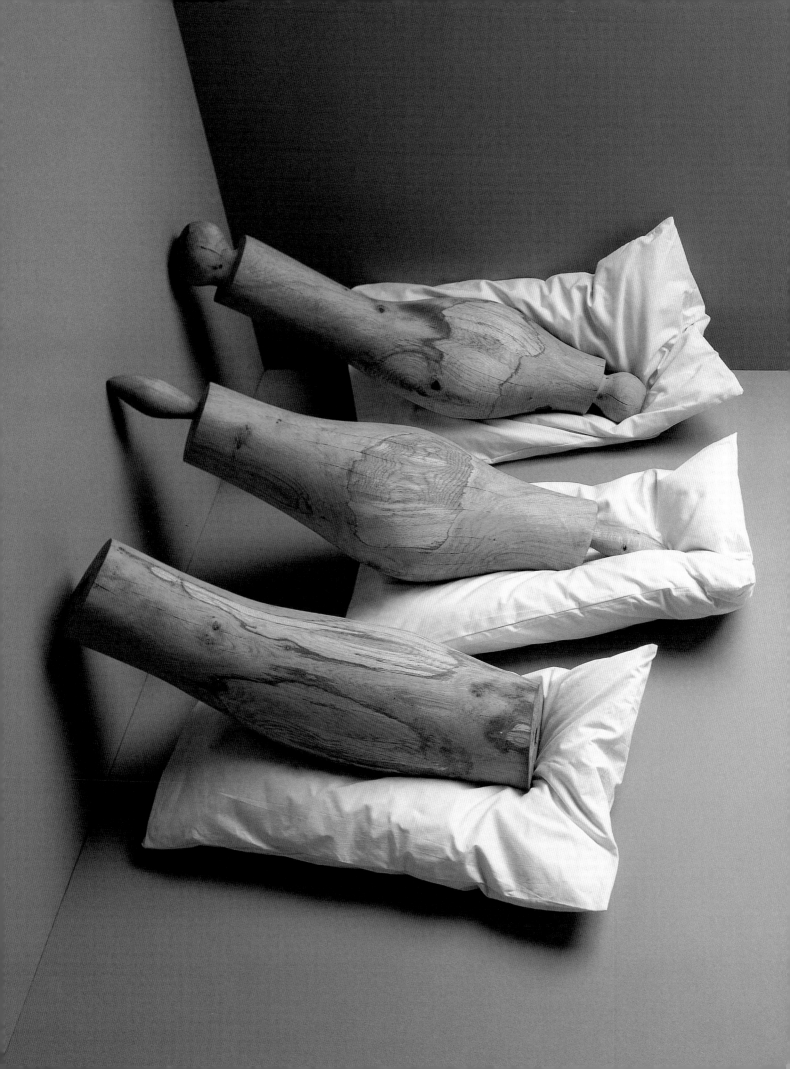

GARRY OLSON

"For a long period I assumed that I wouldn't make a piece from onetree. Being joint co-ordinator was quite enough involvement, and I was happy to leave the making to others. Various people persuaded me otherwise, however, and my small chest of drawers is the result. Very few applicants had chosen to do carcass work, so I felt I was filling a gap in the exhibition.

Having been partly responsible for the distribution of timber to everyone else I was nervously wondering what I could save for myself at the end. I did keep two thin, beautiful, quarter-sawn boards for the interior drawer parts. I had hoped someone would want them for this purpose when I supervised the milling of the tree two years before. I also had two 25-mm-thick boards from the top end of the main trunk. They were quite large but full of massive knots and wild, difficult grain. By cutting around the problems I was limited to short lengths and had to produce a piece with small components. This suited me, as the design is an idea from my past that I had always wanted to develop. I was grateful to other makers who returned useful offcuts, and, with the remains of the pack of veneer sliced from one of the branches, I was able to complete my cutting list. The handles are from a small piece of bog oak given to me by Peter [Toaig] when he left the workshop. Nothing could be more appropriate.

The making has been long and disjointed, with constant interruptions from the demands of onetree administration. That has been the story of my working life for three years, but I have survived happily and am pleased with my contribution." *Garry Olson*

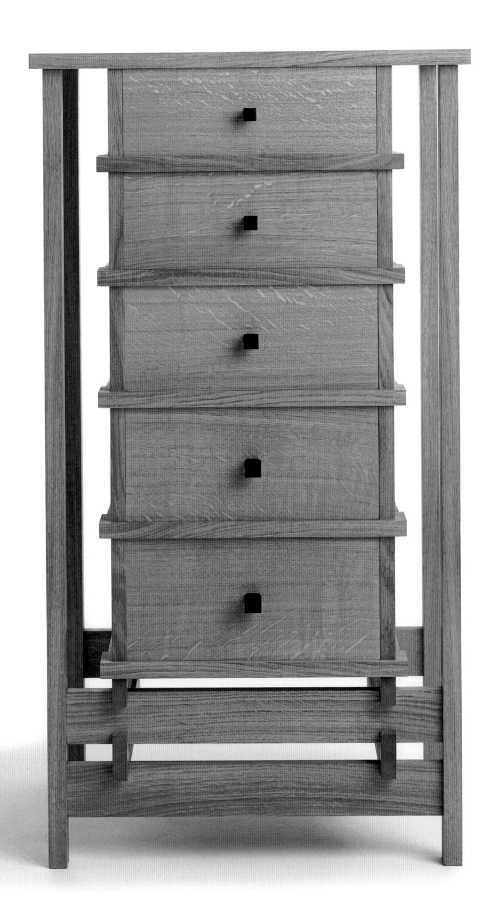

Garry Olson was born in 1950 in Sydney, Australia. He gained a Certificate of Education from Bathurst Teachers' College, New South Wales, in 1969, and taught in the bush for a year before doing national service. This was followed from 1973 to 1976 by studying as an external student at the University of New England for a degree in education and geography.

Having travelled the world for eighteen months, Garry settled in England in 1978 and began a new career as a furniture-maker, a craft in which he is largely self-taught. After gaining experience in two workshops he established his present premises in 1984, and has had a steady flow of commissions from private clients and various churches in the North West. He works mainly with home-grown hardwoods, and considers the sustainability of timber as a resource to be very important.

Garry has tutored in furniture design and cabinetmaking at Manchester College of Art and Technology (also taking City and Guilds qualifications), Manchester Metropolitan University and the University of Central Lancashire.

Garry has organized and hosted several exhibitions of his own work combined with the work of others at his own workshop gallery in Wilmslow, Cheshire. The most significant of these were *Furniture of Excellence* in 1989 and 1990, and *A Celebration of Wood* in 1997. The latter show was in collaboration with Peter Toaig, who was sharing Garry's workspace at the time. As a result of the success of this show Peter developed the idea of onetree and, in March 1998, asked Garry to co-ordinate it with him. It has been a large part of their lives ever since.

Chest of drawers
Oak, bog oak, epoxy resin,
oak veneer on birch ply
92 x 53 x 40 cm (36 x 21 x 16 in.)

TRACY OWEN

"When I first came across the onetree project I thought it was a really interesting idea to take a group of artists and designers and see what could be made from just one oak tree – and, in the process, to raise funds to plant trees for future generations to enjoy.

As a woodturner who uses mainly native timbers, including oak, and who visits Tatton Park regularly and has taken part in their 'Wood Weekend', an annual event organized by the foresters, I was especially interested in the project.

For my contribution I selected two pieces of branchwood from the oak tree and decided to make a small bowl and a tall vase from them. The bowl is about 8 inches in diameter. I chose to leave a wide rim with a flowing curve to the inside. The outside of the bowl is decorated with a fluted pattern made using an arbortech.

The shape of the second log suggested a natural-edge end-grain vase with the bark left on. This proved quite difficult, as the logs had been lying out in the weather and some of the bark was coming loose. With some careful cutting and sanding I managed to keep the bark on. The vase has a wall thickness of 5 mm. It is of a type made using green, or unseasoned, wood, and there is always some movement in the finished piece when it is drying. This adds to its character." *Tracy Owen*

Tracy Owen was born in Northwich, Cheshire, in 1961. He began his working life on a local farm and was then employed in a bakery; during his time there he took up woodturning as a hobby. He had one day's tuition at a local woodworking shop and in 1995 began entering competitions. He was successful in every one he entered.

Tracy's work has been included in many exhibitions, including the *Good Woodworking Show* at Alexandra Palace, London (1996); and the *Practical Woodworking Show* at the National Exhibition Centre and Dukes Oak Gallery, Birmingham (1996–2001). He has won first prize in a number of competitions, including at the *Good Woodworking Show* in 1996. In September 2000 he took part in Cheshire Open Workshops, a project sponsored by Cheshire County Council Arts Services to promote artists in the county.

Tracy's other achievements include devising a texturing tool that is now produced and sold worldwide by Robert Sorby, toolmakers in Sheffield. Tracy turned professional in 1997. His work is sold through various galleries and through the retail outlets John Lewis Partnership and Divertimenti, London.

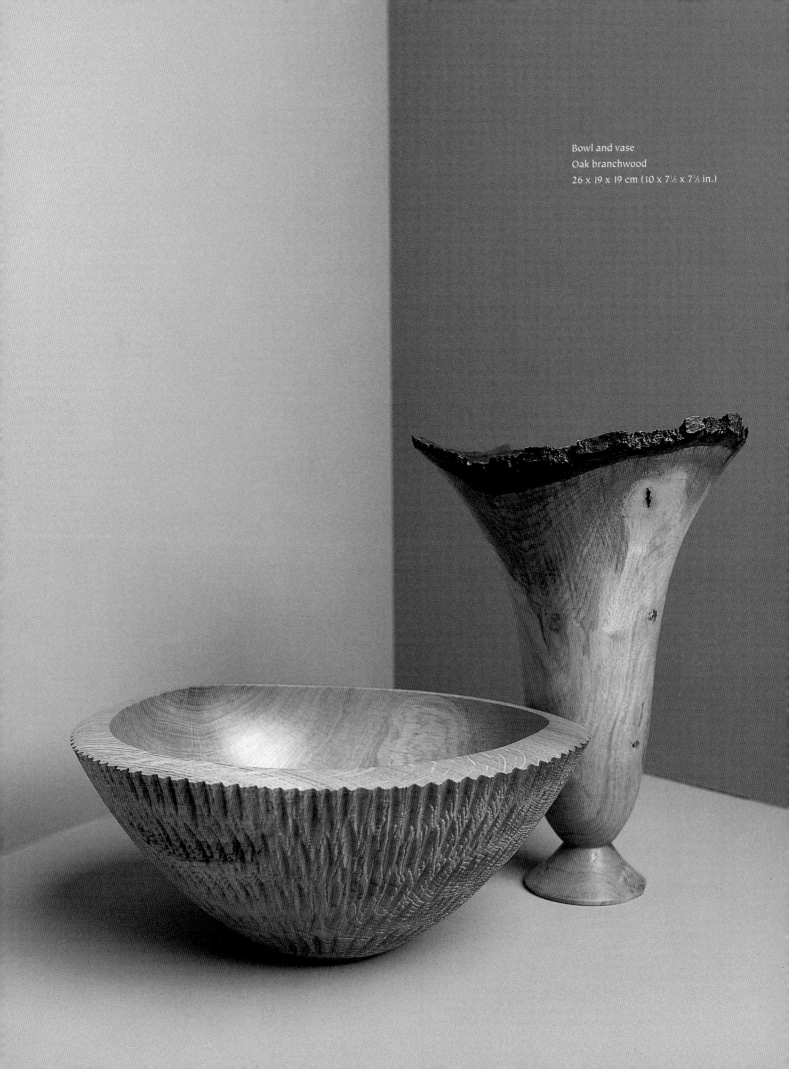

Bowl and vase
Oak branchwood
26 x 19 x 19 cm (10 x 7½ x 7½ in.)

CATH PEARSON

"This sculpture is a representation of the treehouse I built with my brother. It evokes memories of childhood adventure. Once I was sitting on the rope, slung between two branches, talking to my friend who was in the treehouse, when I lost my footing and fell out backwards. I landed on my head and was knocked unconscious for ten seconds. I didn't tell my mum.

This work corresponds to a series of sculptures I previously made using matches. They were all of houses I have lived in and recalled from memory." *Cath Pearson*

Cath Pearson was born in 1965 in London. She gained a degree in photography at North Staffordshire Polytechnic and has taught at Goldsmiths College, London, for five years.

Major exhibition venues include: Salon International de Recherche Photographique, Royan, France; Ikon, Birmingham; Tate Modern, London; Wolverhampton Art Gallery; Gerrit Rietveld Academie, Amsterdam; Paris Photo; and *The Young Unknowns*, London. Solo shows have been held at Photofusion, London (1996); Duncan Cargill, London (1998); Laurence Miller, New York (1999); and as part of *Trace*, the Liverpool Biennial of Contemporary Art (various venues, 1999).

Cath works in series, using photography, sculpture or drawing. Her work has been published in *The Art of Reflection* by Marsha Meskimmon (1996) and *I Spy: Representations of Childhood* by Catherine Fehily, Jane Fletcher and Kate Newton (1999).

Her work is held in the Centre Georges Pompidou, Paris, and the Eric Franck collection.

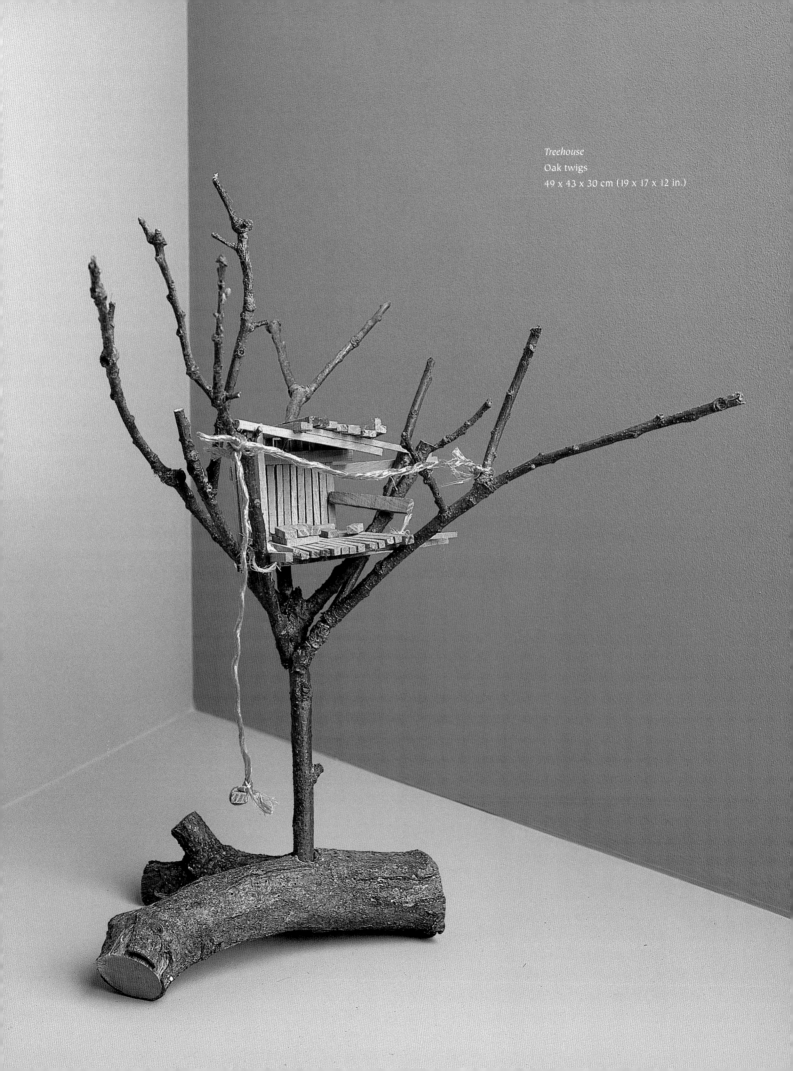

Treehouse
Oak twigs
49 x 43 x 30 cm (19 x 17 x 12 in.)

"In November 1998 I was one of the lucky few furniture-makers on 'day one' at Tatton Park to witness the incredible skill of head forester Brian Goulden and his team as they felled 'our' oak, limb by limb. It was a miserably cold day, so we were all quite pleased when we eventually moved indoors for the opening speeches and very welcome food in the most wonderful setting of the Old Hall.

Now, after two years of tremendous effort on the part of the original organizers and many others, I am amazed that our tree has supplied so many different creative stimuli for more than seventy individuals.

The idea for my piece germinated in 1993, when Laura and I spent a month in Romania visiting our daughter, Christine, who was on a year's scholarship studying monastic and church wall paintings. My role was to be chauffeur and take her and her tripod to the remoter mountain regions.

Besides visiting the birthplace of Brancusi and seeing his sculptures, notably *Coloana Infinitului* (the endless column), I absorbed enough visual stimulation in Romania for another lifetime's work. Then, conveniently, in Christine's flat in Bucharest I discovered my first Romanian clothes chest, which I photographed from every angle, knowing that one day I would develop a piece from it. What fascinated me was not the main feature, the peasant carving, but the method of hinging the lid with a wooden hinge. Then, five years later, bewitched by some of the finest quarter-sawn oak I have ever seen, I realized 'our' tree was going to be perfect for it." *Alan Peters*

Alan Peters was born in 1933 in Petersfield, Hampshire. At sixteen years of age he was apprenticed to Edward Barnsley CBE in nearby Froxfield. He thus formed a direct link between the Arts and Crafts Movement and bespoke furniture-making in the latter part of the twentieth century.

From 1957 to 1959 Alan undertook craft teacher-training at Shoreditch College, London, and in 1959 won a scholarship to study interior design at the Central School of Arts and Crafts, London. After a brief period of teaching he went on to set up his own workshop, and in 1968 was elected Fellow of the Society of Designer Craftsmen. In 1973 he moved to Kentisbeare, Cullompton, Devon, and has been at the forefront of his craft ever since, producing furniture of the highest quality.

Alan was awarded a Crafts Council bursary to visit Japan in 1975, followed by a Winston Churchill Travelling Fellowship to South Korea and Taiwan in 1980, and he acknowledges Eastern influences in his work. He was impressed by the solid timber construction in Oriental architecture, as it fitted easily with his love of wood. He has also been influenced by his travels to the USA, Australia, New Zealand, Spain, Morocco and, most recently, Romania.

Alan has always been in demand to run workshops and lectures. In 1984 he wrote *Cabinetmaking: The Professional Approach*, which is now considered a core textbook. He has exhibited widely, won many honours and been featured in numerous books and articles.

Romanian-inspired chest
Oak
65 x 109 x 61 cm
(25½ x 43 x 24 in.)

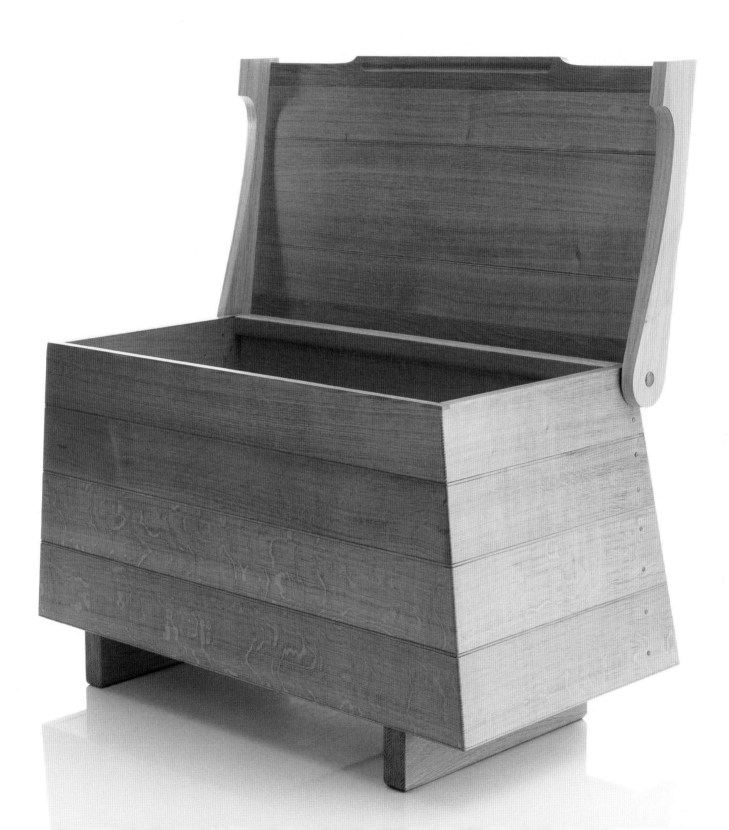

JOAN POULSON

"I have always delighted in an awareness of life's mystery and of my connection with all things that exist. It has informed my life since childhood, although only in the last twenty years, after extensive reading and experiential work, have I reached some intellectual understanding of my instinctual knowledge.

This sense of being part of a vast web of life where all things interexist has been enriched by my involvement with the onetree project. After meeting the tree at Tatton Park in October 1998 I went there several times each week, often in the early hours, or late in the day when no one else was around. I would sit, touch, hold and listen. Sometimes I made notes, a kind of journaling: writing that forms the bedrock of my onetree work.

I was with the tree on the day of felling and many times afterwards when all that could be seen by the eye was a cut surface and protruding roots. I sat, made ritual, listened, continuing to go there even after the root ball was lifted. Over the months I made talismans: small bundles to carry the tree's existence from past to present, on into the future. I used tiny pieces of the tree, gathered when the root ball was lifted or after high winds, adding wool spun from tufts left by grazing sheep or twine found around the tree. Photographs of the talismans, together with calligraphy commissioned from a Japanese artist, are included in my book of writings and poetry. There is also an image of growth rings based on the work of one of the makers and using ink I made from toadstools and their spore found growing in the tree's space.

Later I visited some of the makers, observing them at work and retaining images from which to make poetry. These poems complete my writing.

Meeting other artists involved, I built up an impression of something extraordinary coming together across the country. For my part, I have tried to document, in ways natural to me, a remarkable project and deeply satisfying experience. I shall always think of Garry Olson and Peter Toaig, initiators of the project, with gratitude, holding them and the tree in great regard." *Joan Poulson*

The First Song

Rain mazes through blackthorn and bramble,
through air that is yellow as a lizard's eye.
A dragon might be standing here.

Her green-mantled garden is wet as a pond
and lush with Woden's glorious herbs:
mugwort, lamb's cress and plantain, mother of all.
This herb is called stime. It grew on a stone.

She took feathers from the blackbird,
inviting storm, ribs paper with yew,
the herb that strove with the snake.
I taste the jade boon of the standing-pool,
watching as she moulds and makes:

> *from earth and sun*
> *come stick and stone*
>
> *fold of paper*
> *bone of twig*

The first song was given by wolves in a dream.
She sleeps in a house that is red
as Sleeping Beauty's blood, floats paper discs,
light as owl feathers, among the reed mace.
She knows of the border
beyond which solar winds do not blow.

'It grew on a stone': from the Anglo-Saxon *'Nine Herbs Charm'*

Joan Poulson was born in Manchester and educated in Leigh and in Derby, where she studied ceramics.

She began her writing career in food history and exploring the interface between customs, festivals and traditional food. She wrote fourteen books on this subject between 1973 and 1989. In 1979 she presented a series for Yorkshire Television based on her book *Yorkshire Cookery* (1979).

Joan's work as a poet and dramatist has frequently been featured on BBC radio. She was a scriptwriter for the radio soap *The Merseysiders* and an adviser on the Channel 4 television series *The Perfect Pickle Programme*.

Her mixed-media work includes residencies with musicians and visual artists (Schumacher College, Dartington, 1995), with the dance company Scherzo (The Dancehouse, Manchester, 1997), and with the sculptor Colin Rose (Durham Art Gallery/Norton Priory Museum, 1997).

Joan has been a tutor with the Arvon Foundation (1996 and 1998), and received commissions from the Arts Council (2000), the BBC (1984–98) and publishers, including Hodder Headline, Wayland and Oxford University Press.

Joan's poetry has been awarded prizes at literature festivals and by publishers in Canada, the USA and the UK in recent years, and in 1994 she was awarded a bursary by the North West Arts Board. Her poetry for children appears in over two hundred anthologies around the world. Her most recent publications include an anthology, *Sling a Jammy Doughnut* (2001), and a novel, *Dear Ms* (2000). Other collections of her poetry include *Celebration* (1995), *Pictures in my Mind* (1999) and *earth-being* (2000). She has given readings of her work throughout the world.

The sky bone-pale.
The tree in silhouette
a giant Lost World spider.

Enormous saws chunner and growl.
Two left in V-shape on the grass
metal-toothed shark.

One great branch cracks
 slams into earth.

Round her trunk, emerald-flame branches.
A man creeps upward.
Small branches fall, flick her sides,
 leaves like midges.

Cameras click, flash.
Another branch hits the ground like a body.
She is left with one hand it
points to a mourning sky.
Jolt of falling beetles, spiders.
Butterfly larvae squashed.

The real
comes out of relationship.

The tractor in reverse, another saw drawn up
and cutting starts again.

A man passing strikes his dog
for some misdemeanour.

The ground shudders
as the last leafed branch falls.

The tree draws us into her consciousness.
Her crown dragged off by foresters in red hats,
one cuts a wedge from her side.
Sawdust gushes.

It's a good job we planted acorns
a black-eyed child whispers.

A film cameraman focuses
on the palisade of branches I built round her.
She is
pole star

Inverted Vs sliced into her base
massive elephant feet cut away.

A man abseils from her height.
Saws taken up, final cuts.

There's a clank of chains,
her parts dragged off.

She stands upright …

bark bilberry-smudged heavy purple heat
sludge-tangerine uniforms

kicking-out cut sections
testing the saw
cutting deeper cut to her core
skimming the ground
one last swipe
foot-tap clears the wedge

Now the big one!

the sawing
spurts of sawdust,
groans a howl

she crashes
bounces
hollows earth

children applaud
It's like the Queen's birthday!

damp mustardy smell of her gut
resistant as honey

cold blaze of her …

~ ~ ~

Her spirit fills the space.

Joan's work for onetree is to be found in *onetree singing*: photography by Jean Grant, calligraphy by Nozomi, designed by John Morgan (Omnific); Manchester (Blackthorn Books) 2001.

"In 2000 we began working with a new sterling-silver alloy that hardly tarnishes. It seemed a good test of its properties to marry it with some oak, a material we would normally avoid as its high tannin content tarnishes silver quickly. The onetree project was an interesting opportunity for this. The wood itself dictated the thickness of the surviving bowl, the first having split in two during turning." *Anton Pruden and Rebecca Smith*

Anton Pruden and Rebecca Smith set up their workshop in Ditchling, East Sussex, in 1989. This picturesque village is famous for its arts and crafts. Anton's grandfather, Dunstan Pruden, was a silversmith in the Guild of St Joseph and St Dominic, founded by Eric Gill.

Using sound Arts and Crafts values and aesthetics as their starting-point, Pruden & Smith quickly established a name for high-quality, handmade, contemporary silverware. Pruden's three generations of uncompromising craftsmanship is complemented by Rebecca's fine-art training to ensure design excellence. Each piece is lovingly formed, hammered and finished in the knowledge that its individuality will far outlive its maker.

The wooden elements in their work are turned by Kevin Hutson, who has twenty-five years' experience of commercial and artistic woodturning.

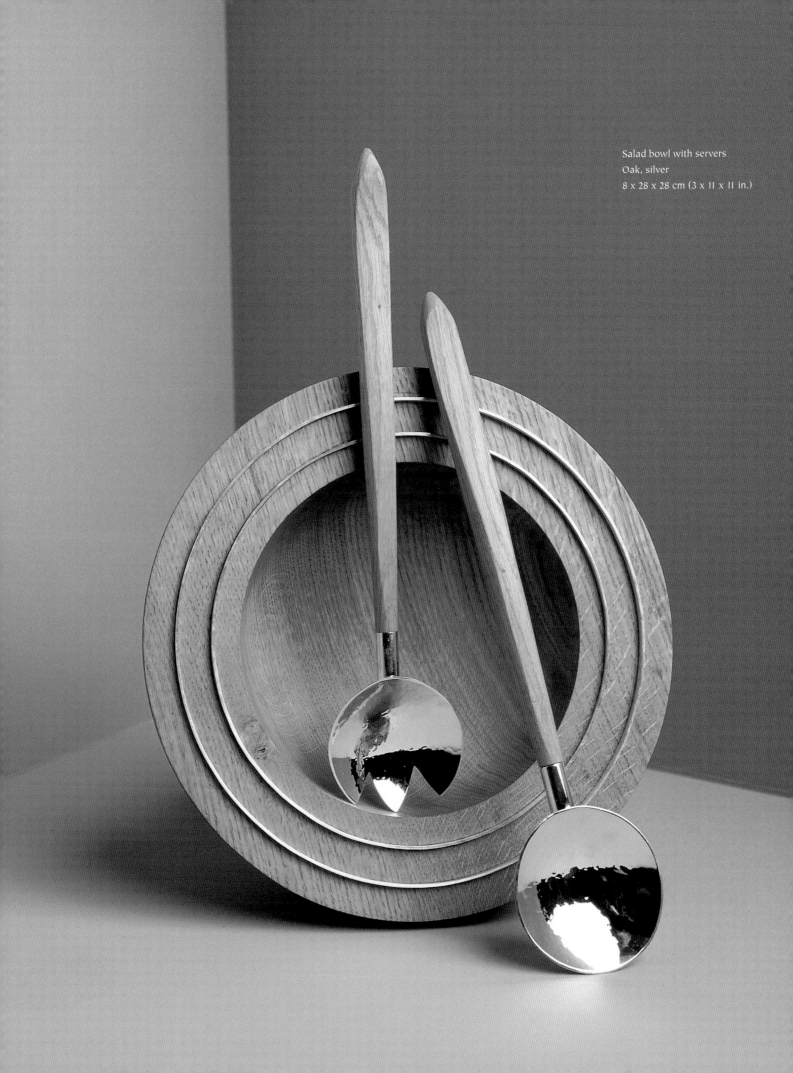

Salad bowl with servers
Oak, silver
8 x 28 x 28 cm (3 x 11 x 11 in.)

ROBERT RACE

"Everybody to whom I have described the onetree project instantly recognizes it as a brilliant and stimulating idea. My reaction was the same when I first heard about it from Jeff Soan. He then explained the *really* exciting bit: that the project was not just a dream but was well under way and being run with enthusiasm and efficiency.

When my box of assorted twigs and small logs and a couple of short bits of board arrived, I had a lot of other work to complete before I could start using it. All to the good really, as it gave me plenty of time to sort and re-sort, picking over ideas and bits of wood. I work a lot with driftwood, and one of the pleasures of this is exploring the interplay between ideas and the available bits of wood.

I wanted to make a range of small pieces that would reflect my own style and use the oak in a number of different ways. One of my inspirations has always been simple, moving folk toys, which, at their best, fully exploit the properties and forms of the materials from which they are made.

In the end I decided to make onetree versions of some of my current designs, making all the wooden components out of onetree oak." *Robert Race*

Robert Race was born in 1943 in Beccles, Suffolk. He studied natural sciences, history and philosophy of science at Trinity Hall, Cambridge (1962–65) and then trained as a teacher at the University of London. He returned to university in 1974 to complete a diploma in education.

Robert has been a full-time toymaker for over twenty years. Starting with dolls' houses and miniature furniture, he subsequently concentrated on moving toys and simple automata, which have been widely exhibited in the UK and abroad. Drawing on his previous teaching experience, he still occasionally works with adults and children, using his own work and a collection of moving toys from around the world as a resource for education in design and technology.

In 1992 Robert won the Grand Prize in the fifth Hikimi Wooden Puzzle Competition in Japan. He is a member of the British Toymakers Guild, winning the Guild Cup in 1991, 1992 and 1998, and winning the Malsbury Memorial Cup for automata and kinetic toys in 1995, 1996, 1997 and 2000. He was named Toymaker of the Year in 1999.

Commissions he has executed to date include interactive toys for the exhibition *Dynamic Toys* at Banbury Museum (1992); donation boxes for the Salisbury Playhouse (funded by Southern Arts), the Black Swan Guild, Frome, and the Victoria Art Gallery, Bath; a collection of toys for the education department of the Museum of Childhood, Bethnal Green, London; the exhibition design for *Transformations: The Art*

of Recycling at the Pitt Rivers Museum, Oxford (2000–02); *Clock with Mechanical Figures* for the artist Michael Oxenham's studio at Bromyard, Herefordshire; and *Beaks*, a set of moving sculptures for the Notting Hill Brasserie, London.

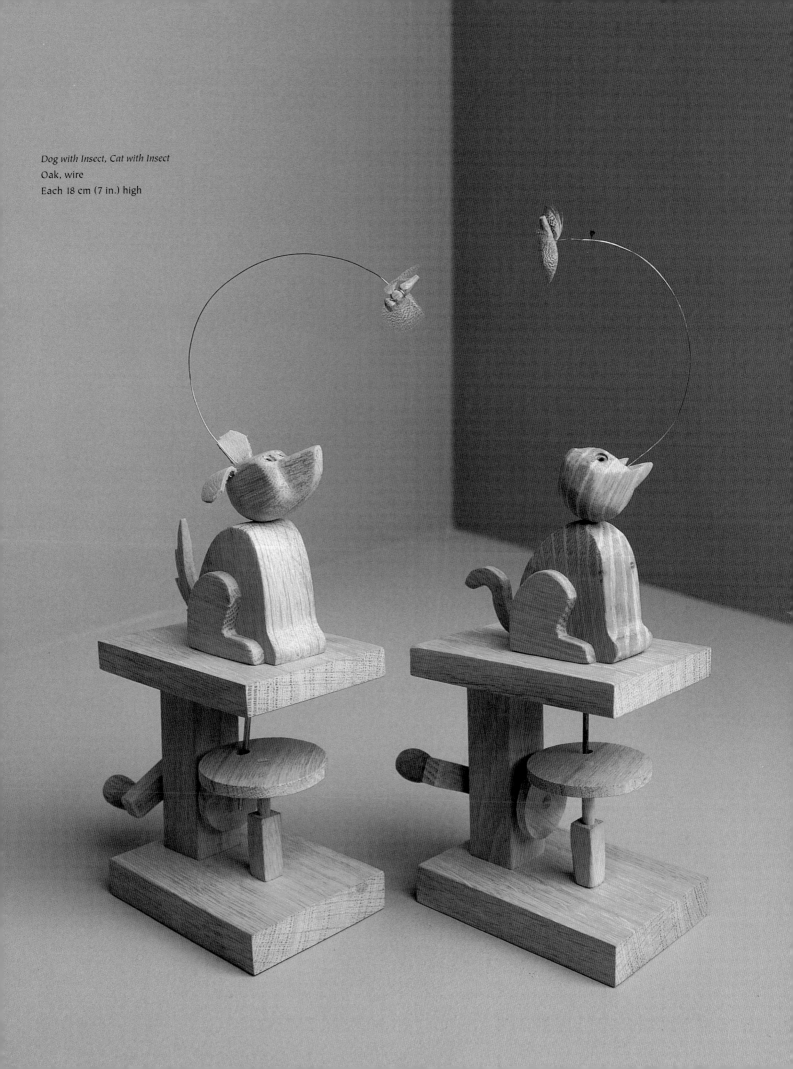

Dog with Insect, Cat with Insect
Oak, wire
Each 18 cm (7 in.) high

"The onetree project came to my notice during a period when I had been exploring the subject of trees in our environment. In October 1999 I visited Tatton Park, where I spent an intense week working on preparatory drawings, making notes and taking photographs. I was particularly interested to see the limbs of the tree: my aim was to explore each one as a unique and individual form. Seeing the larger branches cut down to logs, they seemed to me like sleeping figures lying side by side in the grass. At this time I was also able to sketch the buttresses that had to be cut away from the oak in order to fell it: I was interested in their unusual forms and inspired by the vital rôle they played in supporting the oak during its life.

To show the size and solidity of the limbs it seemed natural to draw them larger than life. I was very aware while I was working on them of the life and energy of the tree as it was growing. The scars, cracks and cuts unique to each branch are significant, as although their meanings are sometimes obscure to us, they tell the story of the tree's life. Later, when I was studying my notes and drawings and reflecting on my visit, I was struck by the significance and symbolism of the stump. It was like a footprint, a reminder of the tree, marking the place where it once stood. It is all that is left to show where this extraordinary individual life began and ended." *Malca Schotten*

Malca Schotten was born in London in 1961. She completed a foundation course at Hornsey School of Art, London, in 1980 and gained a degree from Brighton Polytechnic, Sussex, in 1983.

She was employed as a book designer in 1983 by Thames and Hudson book publishers, where she worked for ten years. During this time she also took on various private commissions from other book and magazine publishers. Her drawings and paintings have been exhibited in various group exhibitions, including the Royal Academy Summer Exhibition, London (1986),

the National Portrait Gallery John Player Award Exhibition, London (1987), and Kettle's Yard Open Exhibition, Cambridge (1998, 2000).

Her solo exhibitions include *Monotypes* at L'Escargot restaurant in Soho, London (1989), and the Dôme restaurant in Hampstead, London (1990); her more recent work, which focuses specifically on trees in the human and urban environment, has been exhibited in conjunction with Norwich City Council's Tree 2000 campaign (1999) and in a major solo exhibition, *Treelines*, at the John Innes Centre, Norwich (2000).

Malca worked exclusively on the onetree project from 1999 and produced a large body of work. Unfortunately, it has been possible to show only a small selection of this work in the final exhibition.

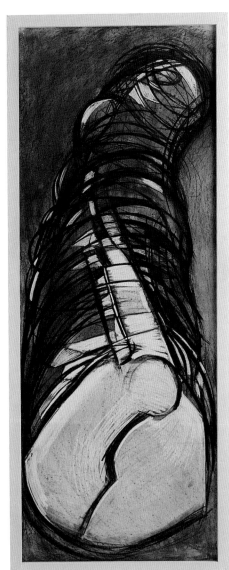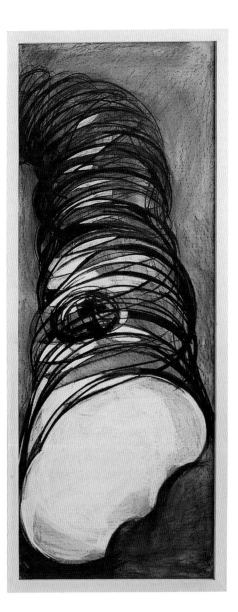

Limb I, Limb II, Limb III
Charcoal on paper
Each 198 x 77 cm (78 x 30 in.)

IAN SIMPSON ARCHITECTS

"Our projects are generated from a realization of location, site and use. The building becomes a setting for the user's activities. The resulting spaces are defined by materials and ways of making. We strive to find the timeless through simple detailing to reinforce the idea behind a design. Particular attention is given to what the user touches, what guides the user through the building.

The Manchester Museum contains a series of science and humanities collections, little known in the city although ranking within the top five nationally in each discipline. The galleries are in a series of neo-Gothic buildings designed by three generations of the Waterhouse family.

The building design involves surgical demolitions, additions within the existing building fabric and a new entrance building. The theme of the design is connections: reinforcing existing links and connecting all buildings. New structures are in a contemporary idiom divorced from fashion through the handling and expression of materials.

Three new public stairways provide important routes between the galleries. The new stairs are minimal structures in steel and terrazzo. The balustrading is glass with handrailing in stainless steel and Tatton oak. Existing timber handrailing within the museum provided the clue for the new handrailing, which is designed to fit the hand with a simple and clearly contemporary profile. The profile is universal: the selection of materials and detailing make the design specific to the museum project. Onetree's wood will become one of the natural science displays as well as a part of the fabric." *Ian Simpson*

Simpson Associates Architects was formed in 1987 and became Ian Simpson Architects Ltd in 1994. Its principal directors are Rachel Haugh and Ian Simpson, and the practice has offices in Manchester and London. It has established a national and international reputation through competition-winning schemes.

The practice has worked on a variety of building types throughout the UK, including museums and galleries, universities, large-scale residential buildings, commercial buildings and arts/theatre venues. The work ranges in scale from single building components and built-in furniture to city masterplans and regeneration strategies. The practice also has considerable experience of the restoration and conversion of historic and listed buildings for new uses, and preparing submissions for lottery funding.

Projects completed or under construction include the refurbishment of the Grand Apartments, Manchester (2000); the Chadwick Building, University College London (2000); and Hartley's Jam Factory Apartments, London (2002). Work on new-build projects includes Urbis (2002) and No. 1 Deansgate (2002), both in Manchester.

The practice has won numerous awards, including a commendation in the David Urwin 2000 Awards and the RIBA Silver Medal Eastern Region (1999) for Trinity College, Cambridge; a housing design award for The Birmingham Foyer (2000); first prize in the Urbis 'The Building of the Modern City' design competition (1998); and first prize in the Rebuilding Manchester design competition (in association with EDAW, Baxter, Benoy; 1996).

The Manchester Museum: handrail
Oak, stainless steel
Cross section 6 x 4.6 cm (2⅜ x 1⅞ in.),
various lengths

ANDREW SKELTON

"I was asked to make an outdoor seat – oak is a great timber for outside. Feeling that the timber I was given was not large enough in section for the legs, I went in search of a bigger piece. What I didn't have seemed to assume more importance than what I had. I spent a lot of time developing the cast shell, but the tree was a constant reference point for the form, size and structure of the piece. The seats are for indoors or outdoors, using simple shapes that can be combined in many different ways, giving flexibility and visual interest. In making the seats I wanted to address the problems of creating both private and sociable space in public seating and, importantly, the provision of arms to help the less able rise from the sitting position. I am indebted to Blanc de Bierges for their help and patience in developing the seat shells.

Cutting the oak to make the two seats left me with 'short ends', which, in the spirit of the project, I felt I should use. The small table bears many similarities, or perhaps preoccupations, with the *Heart Seats*. They are both built of repeating elements (even repeating wiggles) and they both use simple forms which can be combined in a variety of ways. Just as the seats can form linear units or clusters, given more than one tree the tables could grow and stack to form larger tables, plinths or display shelves." *Andrew Skelton*

Andrew Skelton was born in 1958 in Littleover, Derbyshire. He studied at the University of Newcastle upon Tyne, graduating in architectural studies in 1979.

In search of the 'good life' Andrew began making furniture in Kent in the early 1980s. He later moved to Sheffield and then to a remote farm in the Derbyshire Peak District, where he continues to live with his family and run his workshop. His work has developed from one-off pieces, with an emphasis on materials and handwork, to increasing involvement in public commissions with more interest in form and production. Andrew incorporates a variety of materials within his furniture and, inspired by architectural forms, his pieces are strikingly contemporary in their clear design. He also writes about and teaches furniture-making and design.

Recent major commissions include a case for the Association of British Designer Silversmiths' Millennium Canteen (1998); eighteen bronze and timber seats for the New Peace Gardens, Sheffield (1998); display cases for John Rylands University Library, Manchester (1999); complete furniture for St Aidan's Church, Sheffield (2000); and complete furnishings for the Resource Room at the Lowry Centre, Salford (2000).

Heart Seats
Oak, stainless steel, cast by Blanc de Bierges
Two seats, each 80 x 148 x 54 cm (29 x 58 x 21 in.)

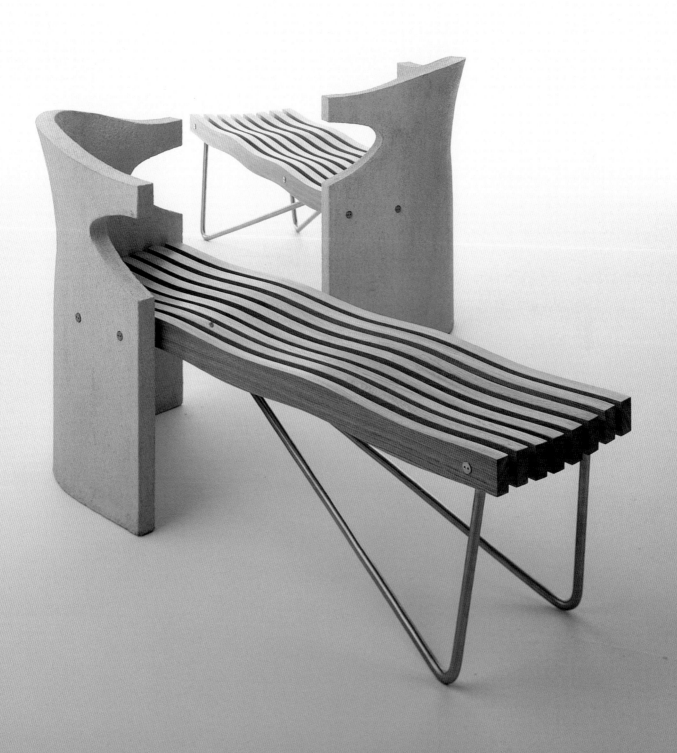

MICHAEL SLANEY

"The process of cleaving (or splitting) timber to produce component pieces with a natural and irregular form has led the development of my current body of work. My involvement in the onetree project confirmed my suspicion that branchwood might lack the structural integrity of coppice wood, and compounded the technical difficulties that I had already encountered. On re-evaluating my ethos it became clear to me that the best way forward was to adapt my initial design to use sawn rather than cleft timber for the underframe. This more formal style led to the decision to make a feature of a gap in the top: this provided a solution to the problem of the full-width board cupping rather badly and having an unsightly knot in the centre. The unusual technology combined with the contrast between the fumed and natural elements has created a distinctive piece of furniture.

Gap Table was made in January 2001 out of oak from the tree felled in Tatton Park in November 1998. The two boards of the top are fumed to produce a rich dark-brown colour. They are joined together using a type of wedged dovetail-key technology – designed to create a deliberate gap. The dovetail keys and underframe are left natural to contrast with the top, and the whole table is treated with several coats of tung oil to produce a low-build but protective finish with a medium lustre." *Michael Slaney*

Michael Slaney was born in 1952 in Worksop, Nottinghamshire. He gained a diploma in furniture craft and management from Buckinghamshire College of Higher Education in 1990, and has since taken City and Guilds qualifications in teaching and most recently an MA in 3-D design (furniture) at Leeds Metropolitan University.

Michael won the silver medal at the London Woodworker Show in 1989 while still a student, and the following year his work was selected for the Business Design Centre's *Young Designers into Industry* exhibition.

After graduating, Michael returned to Cumbria and spent twelve months working as assistant manager for a furniture-maker, to gain experience. Since then he has run his own practice as a designer–maker, and has also been teaching furniture craft at Carlisle College since 1994.

Michael's work has been exhibited in various galleries in Cumbria and at the Shipley Art Gallery in Gateshead.

By 1997 a deepening relationship with wood inspired Michael to look beyond his formal training and practical experience and to develop a new ethos that spoke more eloquently of materials and processes. In his research for his MA he explored the desire for simplicity. This is evident in the sensitive way in which he selects and manipulates materials, which, combined with his choice of low-tech solutions, reflects a concern for the environment. This approach, driven by an insistence on a high level of craftsmanship "because both the material and the concept demand it", lends a more expressive and sculptural quality to his new œuvre.

Gap Table
Oak, natural and fumed
74 x 99 x 50 cm (29 x 39 x 20 in.)

JEFF SOAN

"My response to the onetree project was immediate and positive. I thought it was a beautifully simple and brilliant idea for the beginning of the new millennium. What also impressed me were the wonderful graphics and photography employed from the outset.

I visited the site of the tree and the park and pondered what sort of creature I might create, and decided on a pig as the main piece, as this seemed closely associated with oaks and acorns. As well as the three-inch plank from which the pig and fish are made, I brought home a log from which I have made some rocking chickens. With the smaller offcuts I have also made wrens, which I love and are the 'soul' of the oak (Robert Graves, *The White Goddess*).

In my day-to-day working I utilize waste as much as possible, and as this project required that we return all the waste I have decided to use as much as I possibly can, making smaller and smaller items. My aim is to return only scraps and sawdust." *Jeff Soan*

Jeff Soan was born in London in 1945. He attended Goldsmiths College, London, from 1964 to 1968, gaining a diploma in art and design and then an art teacher's certificate. Later he returned to education, taking City and Guilds qualifications and a diploma in creative crafts at the London College of Furniture (1985–87).

After fifteen years as a self-employed builder Jeff was more than ready for change. A chance meeting with a wooden rat from Chile – an articulated folk toy – changed everything. The very next day he enrolled on a toymaking course at the London College of Furniture, and spent two years pursuing the many ideas that the course presented. He made his first articulated fish soon after leaving, and began selling his creations at Greenwich market, where he was spotted by a producer of BBC television's *Handmade* series in 1991. He joined the British Toymakers Guild and won the Guild Cup in 1990, 1993, 1994 and 1995. He also won the Charles Bolton 'Toymaker of the Year' Cup in 1995 and 2000. He has exhibited frequently at the Chelsea Crafts Fair and the Medici Galleries, London.

In 1998 an appearance on Channel 4's *Collectors' Lot* showed him constructing a full-size crocodile. He has continued to develop his technique and now supplies collectors worldwide.

Pig
Oak, canvas, leather, bead eyes
Height 25 cm (10 in.)

Large chicken and small chicken
Oak, canvas, leather, bead eyes
Heights: large chicken 18 cm (7 in.),
small chicken 12 cm (5 in.)

"My first concern when asked to design and make a piece for the onetree project was time. I then realized that my design brief was to celebrate the passing of time during the life of our tree. Forests of oak were cut to build the great sailing ships of Europe. Even a little rowboat would have been as important to someone then as a car is today. Now a wooden rowboat is something we might put in our gardens and fill with sand for the children.

With two boards and a few pieces of the branch of our oak tree, I couldn't make a Viking longboat but I could stretch a keel, steam-bend the planks for the hull and create a playful piece to bridge the gap of time. My youngest apprentice craftsman, the talented Aiden James, has worked on *The Dory Shelves* with me, just as I built boats with Jon Askvik when I was eighteen years old.

My perception of handmade wooden objects is as the contemporary expression of a timeless tradition of craftsmanship. Knowledge and technique are passed down through generations of craftsmen in a line that goes back into the past and forward into the future. Each new designer-craftsman must use his design skills to meet the needs and express the issues of his own time as he sees them. The objects we make will join the work from the past and the future in celebrating and enjoying our most venerable natural renewable resource, the tree – in this case, the one oak tree." *Petter Southall*

Petter Bjørn Southall was born to Norwegian and American parents in 1960 in Okinawa, Japan. After an early education in Paris and California, he took a diploma in boatbuilding at Jondal Wooden Boat Building College, Norway, followed by a further course with Jon Askvik and Carl Sovik in Bergen. In 1984 he studied cabinetmaking at the College of the Redwoods, Mendocino, California, with James Krenov. In 1990 he completed a course under John Makepeace in sustainable manufacturing in wood at Hooke Park College, Dorset.

Petter has been designing and making furniture in the UK since 1991. He works to commission, making one-off pieces and limited batches for private, public and commercial clients. He produces all his designs himself with his skilled team of young craftsmen/apprentices at the i tre furniture studio at Chilcombe in Dorset.

Petter's first furniture commission was a dining suite for the late sculptor Dame Elisabeth Frink. Always a boatbuilder at heart, he makes his furniture in solid native timbers – primarily oak – steam-bent into twists and arches and often fixed with copper rivets and innovative joinery.

Petter has furnished rooms for the National Gallery and the Barbican Art Gallery, both in London. His *Twist Table* is in the National Collection at the Shipley Art Gallery in Gateshead. He is an elected member of the Devon Guild of Craftsmen and a Fellow of the Society of Designer Craftsmen. He has exhibited in New York and widely throughout the UK and Europe.

The Dory Shelves
Oak, copper rivets, natural soap finish
180 x 90 x 40 cm (72 x 36 x 16 in.)

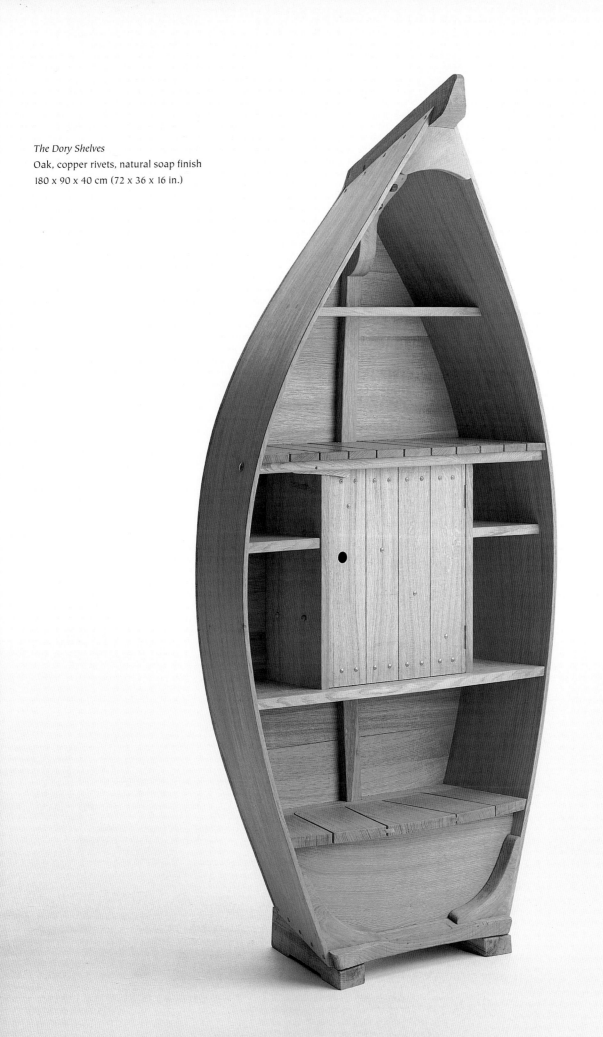

"When a tree is sawn through, each board is different and reads like a massive book, revealing colours and lines that formed in the past. Suddenly they reflect light after a hundred years or more. The smell of wet, sawn wood fills the air and the noise of the machines is drowned by the monumental clarity. Brushing away the sawdust, touching the wood, which is cold, wet and solid, never fails to release a cascade of thoughts and emotions." *Tim Stead*

"In July 1999 the oak limb was delivered to the workshop. Tim was very enthusiastic about the onetree project and was going to work on the onetree project after one of his many treatments, but on 18 January 2000 he went into hospital, where he died on 21 April.

Tim had discussed the project with his workshop, and the workshop decided to take on the onetree project. The piece they have produced is called *Homage*, as in 'Homage to Tim'. It relates to his 'layers' pieces – lumps of firewood revealing the mysteries that lay within. I have given the individual sculptures within the big sculpture names that were part of Tim's vocabulary.

For me, *Homage* is a very tender piece, revealing David Lightly's skills as a sculptor, but also revealing what a good teacher Tim was, how generous he was in passing on not only his skills as a sculptor and furniture designer–maker, but also, and above all, his love of wood and trees." *Maggy Stead*

"I've watched Tim doing sculptures many a time over the past twelve years, and it was a privilege to be able to do one on his behalf." *David Lightly*

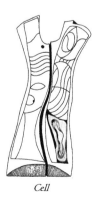

| *Torso* | *Folds* | *Cluster* | *Axehead* | *Cell* |

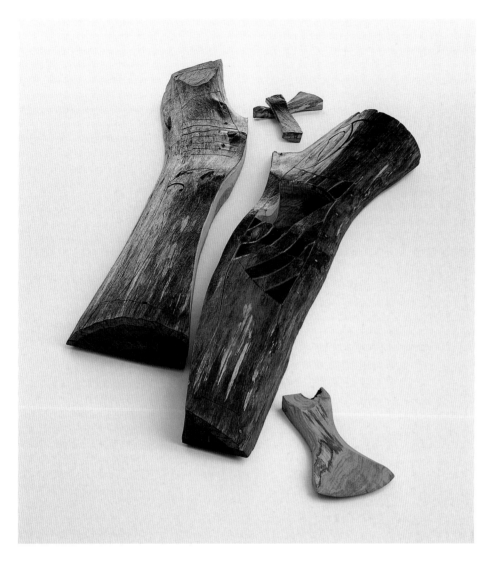

Homage: Exploring the Oak
Wet oak, stained oak, burnt oak, linseed oil
27 x 234 x 132 cm (11 x 92 x 52 in.)

David Lightly was born in Edinburgh in 1971. He attended Selkirk High School, and when he left school he was determined to work with wood. He applied for an apprenticeship in Tim Stead's workshop in September 1988 via the Scottish Development Association apprenticeship scheme, with part-time study at the Edinburgh School of Art's department of furniture design. David is now in charge of The Workshop of Tim Stead.

Tim Stead was born in Cheshire in 1952. He studied sculpture at Trent Polytechnic (1974) and at the Glasgow School of Art (1975). He opened his first workshop in 1975 in the Gorbals in Glasgow, and moved to the Scottish Borders, near Jedburgh, in 1976. In 1980 Tim and his wife, Maggy, and their two children, Sam and Emma, moved to Blainslie, where the workshop has been ever since.

Tim's work has featured in articles, films and numerous exhibitions, and pieces from the workshop have been commissioned by museums, galleries and other institutions throughout Scotland and north-east England.

In January 2000 Tim Stead was made an MBE for his contribution to national woodland and community participation. When he died in April 2000 he left behind a skilled team of woodworkers, an extraordinary collection of interesting timber (mainly elm and burr elm) and numerous designs, which continue to be produced by his workshop.

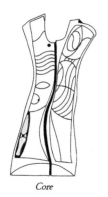

Core

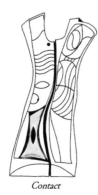

Contact

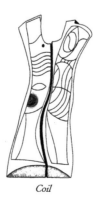

Coil

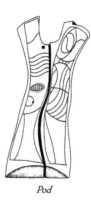

Pod

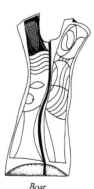

Boat

"For me one of the simplest pleasures in life is to sit under a tree and take time to dream. On one such occasion I was thinking about what I was going to do for the onetree project. I was enjoying the sun filtering through the leaves and casting intricate shadows. I wanted to capture this atmosphere along with the delicacy of the leaves overhead in my piece. *Many Moons* (the title refers to the lifespan of a tree) is part furniture, part sculpture, playing with light and gravity, using wood in its most delicate form as veneer. The glass defines space and adds a 'zingy' quality. The leaves have depth in a piece that is essentially two-dimensional, the light from the base filters through the glass, natural light casts leafy shadows; yet the whole piece, which is very heavy, seems to float off the floor and at night takes on a dramatic presence." *Jonathan Stockton*

Jonathan Stockton was born in 1965 in Warwickshire. After studying the viola at the Royal Northern College of Music he set up his furniture-making business, De Stockton, based in Cheshire. An invitation by Bill Grant in 1989 took Jonathan to the beautiful Grizedale Forest in the Lake District as the first Craftsman in Residence (*The Grizedale Experience*, 1991). Living in the heart of the forest, surrounded by fantastic sculptures by many famous artists, was a wonderful experience that has influenced Jonathan's work ever since.

Jonathan returned to Cheshire, and a progression of commissions resulted in work being exported to Japan and the USA; exhibitions, including a one-man show in Manchester; magazine features; and an appearance on television.

In 1995 Jonathan married his opera-singing wife and settled in the Sussex Downs for ease of access to London. His enjoyment of contemporary stage design and lighting, through many nights spent at the opera, has had an undoubted effect on his work, which has also become increasingly influenced by architecture.

Jonathan has designed and executed a series of exciting commissions over the past six years for one particular client, both for a new London house and for the client's country estate. The majority of his work is designing and making for private clients, but he also does a limited amount of batch-production work, selling through London design shops and mail-order companies. In his own time he enjoys experimenting with sculpture, which he has also exhibited.

Many Moons
Oak veneer, glass, steel, light
196.5 x 190 x 68.5 cm (77 x 75 x 27 in.)

ELIZABETH STUART SMITH

"I am delighted to be taking part in onetree because I am a landscape artist and my work is often concerned with trees. I can relate closely to this tree because I live very near Tatton Park, where it grew. I particularly like the unifying theme of onetree: this is a wonderful concept, bringing together a wide diversity of makers and artists. Our work is linked together by the material of the tree itself.

For onetree I wanted to make a sculpture about the tree using thin branches combined with paper made from their bark. To this end I chose nine branches from the stack at Tatton. Then I set about scouring off the bark using a wallpaper steamer and a wire brush. I reserved the bark from each branch separately, made it into pulp separately and transferred the wet pulp back on to its branch. This was hard work, and involved crushing the bark in a vice and a lot of boiling. The bark was greatly reduced in the process. I found that the resulting paper covered about two-thirds, or sometimes only half, of its branch, revealing how extravagant the paper-making process is in its use of natural materials.

Stacking up the finished branches it occurred to me that they looked a little like bony legs, while the paper covering them resembled warm clothing. The title *Satyrs' Socks*, a light-hearted reference to woodland mythology, suggested itself." *Elizabeth Stuart Smith*

Elizabeth Stuart Smith was born in 1942 in London. She gained a degree in fine art from Liverpool Polytechnic in 1977, and became a Fellow of the Royal Society of Arts in 1999.

Elizabeth was one of the first artists in Britain to use paper as a medium. Since 1977 she has developed its use to express ideas about the landscape. More recently she has pioneered its application in temporary outdoor installations. Her work is widely exhibited, both in the UK and internationally. She gives lectures, teaches in art colleges, is involved with environmental projects and welcomes collaboration with other artists.

Exhibitions in which Elizabeth's work has been shown include *The Paper Show*, Oriel Mostyn, Llandudno, and UK tour (1990); *Salvaged!*, South Bank Centre, London (1991); *The Paper Group: Field*, Pitshanger Manor Gallery, London (1998); invited artist, *The Invisible Exhibition*, Pezinok Zamocky Park, Slovakia (1999); *Radio Halo*, Jodrell Bank Science Centre, Cheshire (2000); and Liverpool/Köln Artists Collaboration, working with Helga Reay-Young (2002).

Elizabeth's work has been extensively featured in the media, including BBC Radio 4, *Crafts* magazine and *The Guardian*.

Public collections in which Elizabeth's work is held include Liverpool University, Cheshire County Council, Cheshire Libraries and Museums, Crewe and Alsager College, The Wigan Metropolitan Collection at Drumcroon Education Art Centre, Bedfordshire Education Authority, The Turnpike Gallery, Leigh, and Huddersfield Art Gallery.

Satyrs' Socks
Oak bark
165 x 122 x 81 cm (66 x 48 x 32 in.)

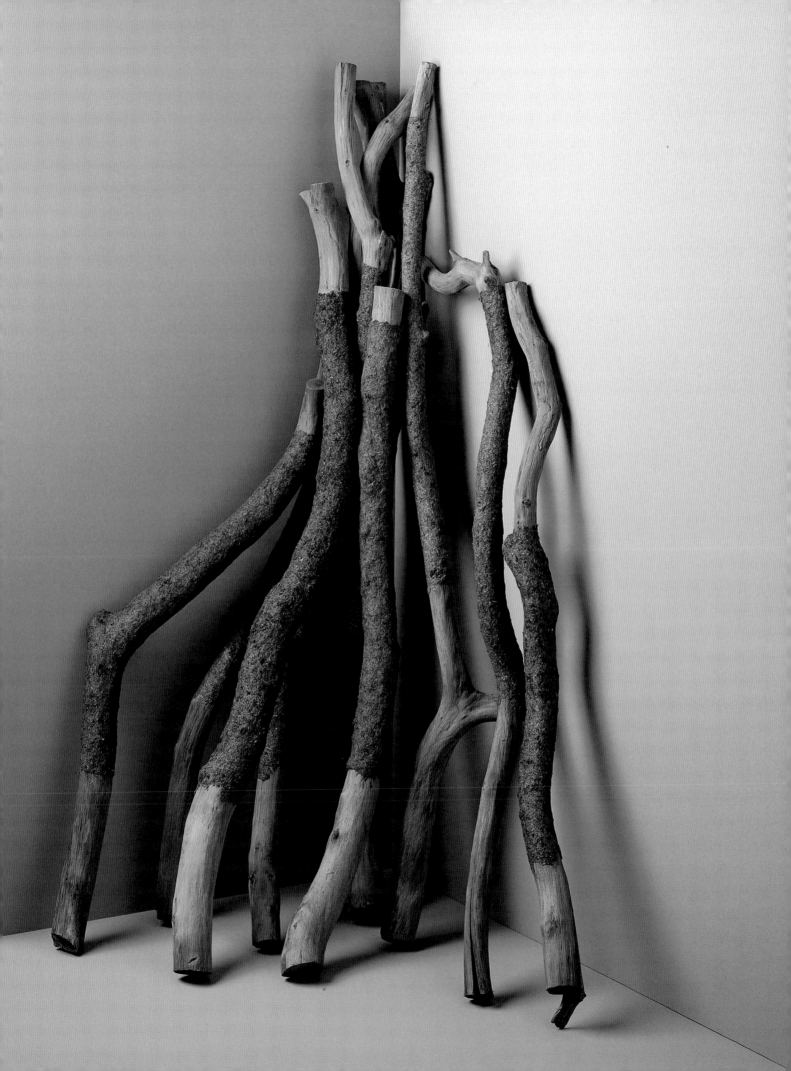

GUY TAPLIN

"My path has not been a concise one, but one of the heart.

When I was first sent information on onetree my response was very positive. So much in our society is connected with ownership and money (from which artists and craftspeople have benefited, perhaps more than at any time in our history). Unfortunately I was contracted to a gallery and could not take part in the onetree project, but in 2000 the contract was terminated and I quickly took the opportunity to get hold of the little remaining wood to make three birds – a blackbird, a wren and a grey wagtail.

I stood the piece of work on our Rayburn to 'enhance' the drying process. On hearing this, onetree were understandably taken aback. My work methods are very basic.

Wood has always been my chosen material (except for a brief dalliance with bronze) – wood from many sources, including skips and rubbish dumps, as well as driftwood – so it was a pleasure to work straight from the tree (and with no nails in it!). Whoever conceived this idea needs to be given a medal – which no doubt they would decline. I hope it has given all involved as much pleasure as it has given me." *Guy Taplin*

Three carved birds
Oak finished with emulsion paint and wax
Blackbird: 28 x 13 x 8 cm (11 x 5 x 3 in.)
Wren: 10 x 10 x 6 cm (4 x 4 x 2½ in.)
Grey wagtail: 18 x 10 x 5 cm (7 x 4 x 2 in.)

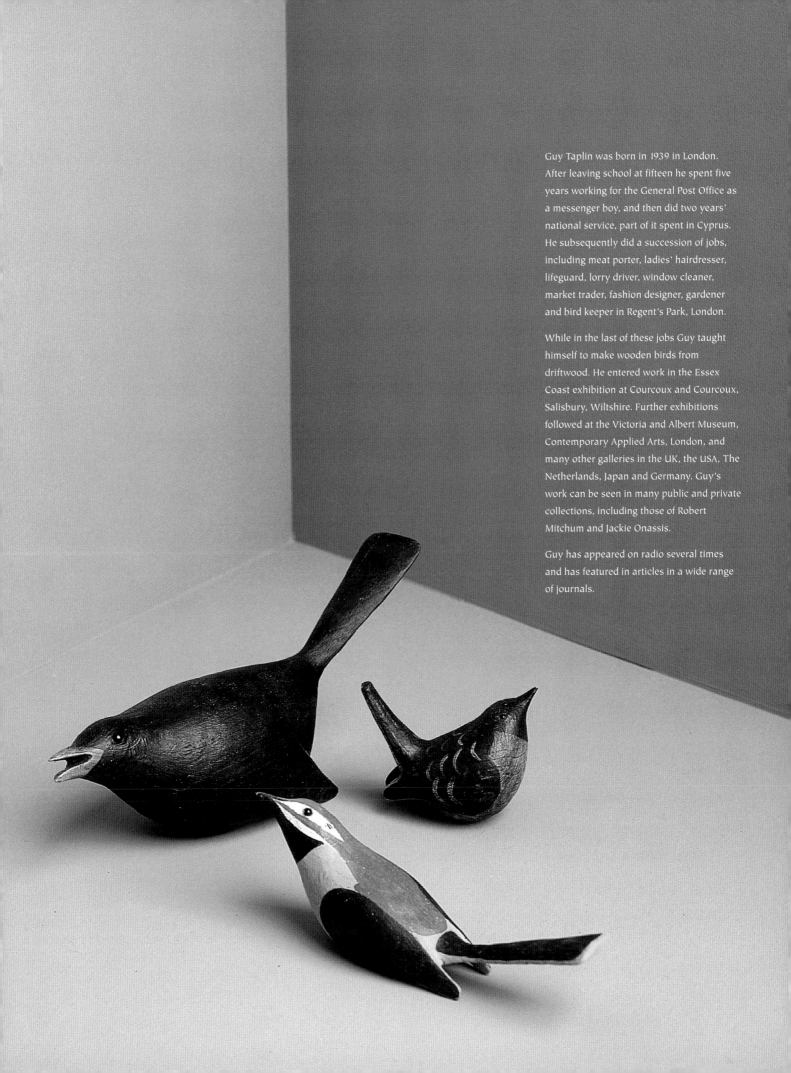

Guy Taplin was born in 1939 in London. After leaving school at fifteen he spent five years working for the General Post Office as a messenger boy, and then did two years' national service, part of it spent in Cyprus. He subsequently did a succession of jobs, including meat porter, ladies' hairdresser, lifeguard, lorry driver, window cleaner, market trader, fashion designer, gardener and bird keeper in Regent's Park, London.

While in the last of these jobs Guy taught himself to make wooden birds from driftwood. He entered work in the Essex Coast exhibition at Courcoux and Courcoux, Salisbury, Wiltshire. Further exhibitions followed at the Victoria and Albert Museum, Contemporary Applied Arts, London, and many other galleries in the UK, the USA, The Netherlands, Japan and Germany. Guy's work can be seen in many public and private collections, including those of Robert Mitchum and Jackie Onassis.

Guy has appeared on radio several times and has featured in articles in a wide range of journals.

BRIAN TAYLOR

"I have felt an affinity with onetree since I became aware of its existence. The aims of the project and my reasons for making art have much in common. The issues I am exploring in the making are to do with personal spirituality and the correct utilization of resources. My work has developed through an approach to material and is still very much material-driven. I find satisfaction in understanding the properties and limitations inherent in materials by exploring different ways to join component parts together using their own nature. On my initial visit to the timber stack at Tatton Park I found a reasonable amount of brushwood (my elected material) available to work with, enough to allow for experimentation and for a medium- or perhaps large-scale piece of work to evolve. The chosen oak wood had not featured in my work until now, so I approached the material with the sensitivity and understanding acquired using previous materials.

When I began to explore possible ways to use the oak I found that in addition to the wood's well-known properties of durability and strength, it splits relatively easily. I have utilized this willingness to split and adapted it into the binding element of the work, which has become a dominant feature in the finished piece. I wanted to retain as much of the original quality of the wood as possible, and so by keeping the making process minimal and low-tech much of the natural character of the wood has been preserved.

Being a lifelong woodland visitor, I have found my appreciation and respect for this environment enhanced since engaging with woodland through my art. *Layer upon Layer* is a reflection of this growing relationship, from the past and for the future." Brian Taylor

Brian Taylor was born in Wigan, Lancashire, in 1953. In 1992 he gained a degree in fine art from the University of Central Lancashire.

On leaving university Brian set up a studio above a local garage, where he spent the next two years developing a body of work using recycled timber and a range of natural materials.

In 1994 he gained a residency at the Drumcroon Education Art Centre, Wigan. This ran for two years, culminating in the exhibition *Time and Tide*. The contacts and working relationships made at Drumcroon have given him substantial experience in residency work in schools and colleges at all levels of education. In 1998 he won a fellowship award at the Vermont Studio Center, USA, the first annual sculpture residency funded by the US International Sculpture Center.

Layer upon Layer
Oak branches
274 x 92 x 92 cm (108 x 36 x 36 in.)

NEIL TAYLOR

"I first became aware of onetree through the *Artist's Newsletter* magazine, which I subscribe to for its exhibition opportunities. Immediately I was excited by the thought of the tree itself. The oak is such a beautiful tree, conjuring up a certain passion for the countryside. How fortunate we are to have this splendid tree growing in Britain.

I had had some experience in using this material before for the balusters at Shakespeare's Globe Theatre in London. Through shaping the oak with what tools I had – side axe, draw knife and spokeshave – I'd built up a connection with the wood. This connection was both secular, in evoking notions of England's great historic oak forests, and spiritual in terms of the wood's association with the Green Man of English folklore. I have great respect for the characteristics and qualities of the oak tree.

I contacted Garry Olson with my proposal and was very glad later to hear that it had been accepted. I was to make a Welsh stick chair (the design I am currently producing), totally pickled from comb to leg using wire wool and vinegar to react with the tannin in the oak. I had used this technique before only on smaller areas of a chair, so it posed a challenge to pickle a whole 3-inch-thick seat. In fact, each new chair I make is a challenge because of the way a piece of wood (whether it be oak or chestnut, yew or hawthorn) may cleave and split along its grain to expose the character." *Neil Taylor*

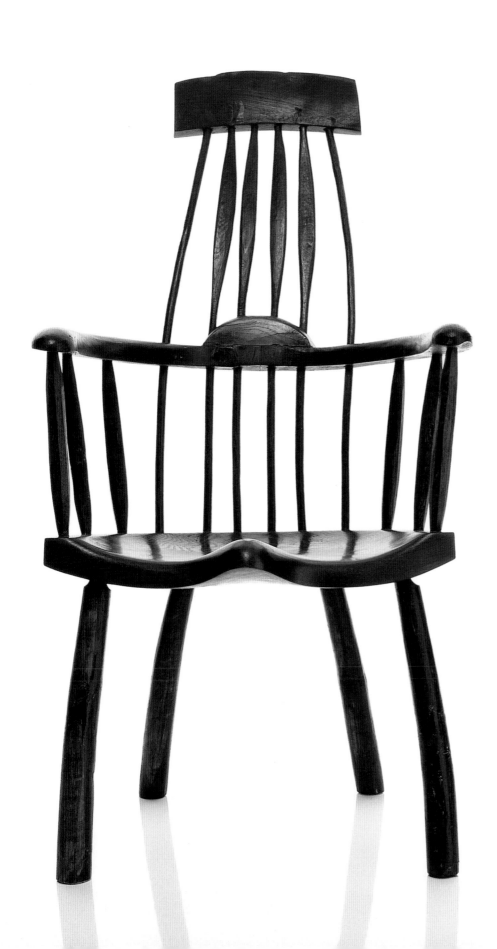

Neil Alexander Taylor was born in 1971 in Weston-super-Mare, Somerset. After a foundation course (1987–89) he took a degree in ceramics at West Surrey College of Art and Design. In 1995 he completed an eight-month green woodworking apprenticeship at Clisset Wood, near Ledbury, Herefordshire, with Mike Abbott. This was followed by work on the balusters at Shakespeare's Globe Theatre, London, with Gudrun Leitz.

Neil's career went on to become one of intuitive learning and exploration. He has used two workshops within the beautiful settings of Herefordshire and the Border counties, and has gained much local recognition. A collection of his work can be seen at the Kemble Gallery (Society of Craftsmen) in Hereford, and he has received many commissions for for his Welsh stick furniture. He is currently a member of the Herefordshire Guild of Craftsmen.

His work has been featured in *Country Landowner* and *Practical Woodworking*, and he has received an award from the Association of Pole Lathe Turners.

Pickled Welsh stick chair
Oak pickled with wire wool and vinegar
122 x 66 x 71 cm (48 x 26 x 28 in.)

"Like onetree, the 'inside-out' table is a simple idea. It came to me while I was contemplating a split log given to me by Jonathan Stockton, who was clearing out 'dead wood' from his workshop. The piece was about to spend years littering my own workshop when suddenly the table was fully formed in my mind.

These tables are a progression from my first 'inside-out' table, which was square. I like to think I have simplified the original design. The cylindrical outer surfaces cut through the cylindrical growth rings to reveal every facet of the wood, but the original character of the log is not lost. This type of timber is very rarely used for furniture and is more often than not burnt or left to rot. The technique also works very well on small trees thinned during woodland management or on trees that have outgrown domestic gardens. This last idea really appeals to me, taking the concept of a local resource to its limits: 'grow your own furniture'.

The sizes of the tables were determined by the sections of branch I was left with, but I am very happy that they now form a group of individuals rather than a matching set." *Peter Toaig*

Peter Toaig was born in Marske-by-the-Sea, Yorkshire, in 1968. He graduated in mathematics from the University of Manchester in 1989, but was not impressed by the career options open to him. Having maintained an interest in woodwork since his school days he started making small pieces and selling them through galleries and craft markets. In 1991 he enrolled at Manchester College of Art and Technology to study for City and Guilds qualifications in cabinetmaking and furniture design and construction, which he was able to combine with further furniture commissions.

It was at Manchester College of Art and Technology that Peter met Garry Olson, as Garry was teaching there part-time. A good short-term solution for both was for Peter to share Garry's workshop in Wilmslow, Cheshire. The relationship was a success, and the next five years provided a valuable opportunity to experiment and develop ideas. Together they organized a series of successful exhibitions, which led ultimately to onetree.

In 1998 Peter moved to Scotland, where he established his own workshop in Kippen, near Stirling.

Peter's work varies tremendously in style and scale. He has made jewellery and dining suites, and produced rough rustic work and finely engineered precision pieces. He has sold work in galleries across the UK, and while in Cheshire developed a very successful relationship with the Artizana Gallery in Prestbury.

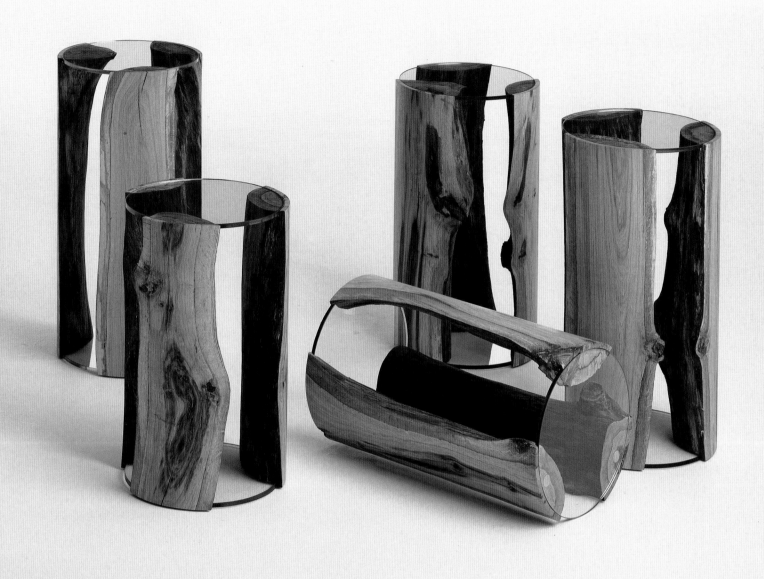

Five 'inside-out' tables
Oak branchwood, toughened glass, stainless steel
Each 29 cm (11½ in.) diameter, heights 47–58 cm (18½–23 in.)

THE TRADITIONAL CHARCOAL CO. – CARL COOPER

"The ancient craft of charcoal-making was originally practised within the woods using coppiced timber in earth kilns. I now use steel-ring kilns but still use local coppiced and recycled timber. In reviving this craft the countryside and wildlife thrive.

The high-quality charcoal that I produce and sell has enabled my business to be successful. I am also able to help others in starting up their charcoal businesses by supplying kilns and tuition up and down the country.

British charcoal is easy to use as it is pure and has no additives. This means that lighting it is a pleasure, and a barbecue is ready for cooking on in approximately fifteen minutes. It cooks at a very high temperature and is therefore more efficient than other fuels." *Carl Cooper*

Carl Cooper was born in 1963 in Sudbury, Suffolk. He started producing charcoal as a hobby while working on an estate near his home. It was originally made for personal use and for family and friends, but finding there was a demand for the material he decided to set up The Traditional Charcoal Co., selling high-quality charcoal made using steel-ring kilns. Carl lives and works in Middlewich, Cheshire, with his wife, Linda, and two sons, Joseph and George.

Bag of charcoal
Oak branches
48 x 28 x 16 cm (19 x 11 x 6 in.)

TO OPEN-HOLD TAPE AND PULL CORD

TRADITIONAL

B -B -Q

CHARCOAL

EASY TO LIGHT
READY TO COOK
IN 15 MINUTES

MADE IN
MIDDLEWICH CHESHIRE

"When we were asked if we would like to be part of the onetree project the idea immediately appealed, but of course the field was wide open in terms of what to make. Owing to the moisture content of the timber we did not feel happy making a finished piece of joinery such as a window or a door, but we very much wanted to make something that was part of the local area here in Shropshire.

We therefore chose to make a model of a crown-post truss that forms part of a local half-timbered building occupied by Bodenhams of Ludlow. This truss is unlike any other examples so far found in Shropshire, and dates from 1404 (following dendrochronology tests).

The crown posts provide the central support, the roof being so constructed that the thrust of the roof is evenly distributed on the wall-plates. There is no ridge plate, and the collar purlin provides the only longitudinal stiffening within the roof.

Our model is one-third full-size as this was the largest we could make with the timber available. We hope it helps to illustrate the ingenuity of the fifteenth-century carpenters and the continuity of craftsmanship down the years." *Stephen Treasure*

Treasure & Son Ltd was established as a building company in 1747. Since moving to Ludlow, Shropshire, in 1938 they have carried out a large number of restoration and conservation projects on buildings and monuments in the area. Their work covers all the main building trades, and they have an in-house joinery shop making everything from windows and doors through to staircases, kitchens, bookcases and bedroom fittings.

The company has carried out substantial conservation work to historic buildings such as Stokesay Castle, Shropshire, and repairs and extensions to many vernacular buildings of stone, brick and half-timbered construction.

Raymond Sale started working with Treasure & Son in 1962, undertaking a five-year City and Guilds apprenticeship. He is currently manager of the joinery workshop, overseeing an extremely varied workload. An early project involved the construction and fitting-out of a circular house by Raymond Erith (since listed). More recently a new oak staircase was built for Warwick Castle, and in 1997 the workshop received the Carpenter Award for its work on the Mappa Mundi building at Hereford Cathedral (for which the company also won the Building of the Year award).

Raymond masterminded the company's response to onetree, and the work was carried out by Colin Angell. Colin also did his City and Guilds apprenticeship with the firm and has worked in the joinery for twenty-nine years. He has participated in many public and private projects, including the Mappa Mundi building, and has made everything from oak stairs to Gothic windows.

1:3-scale crown-post truss
Oak
116 x 182 x 96 cm (46 x 72 x 38 in.)

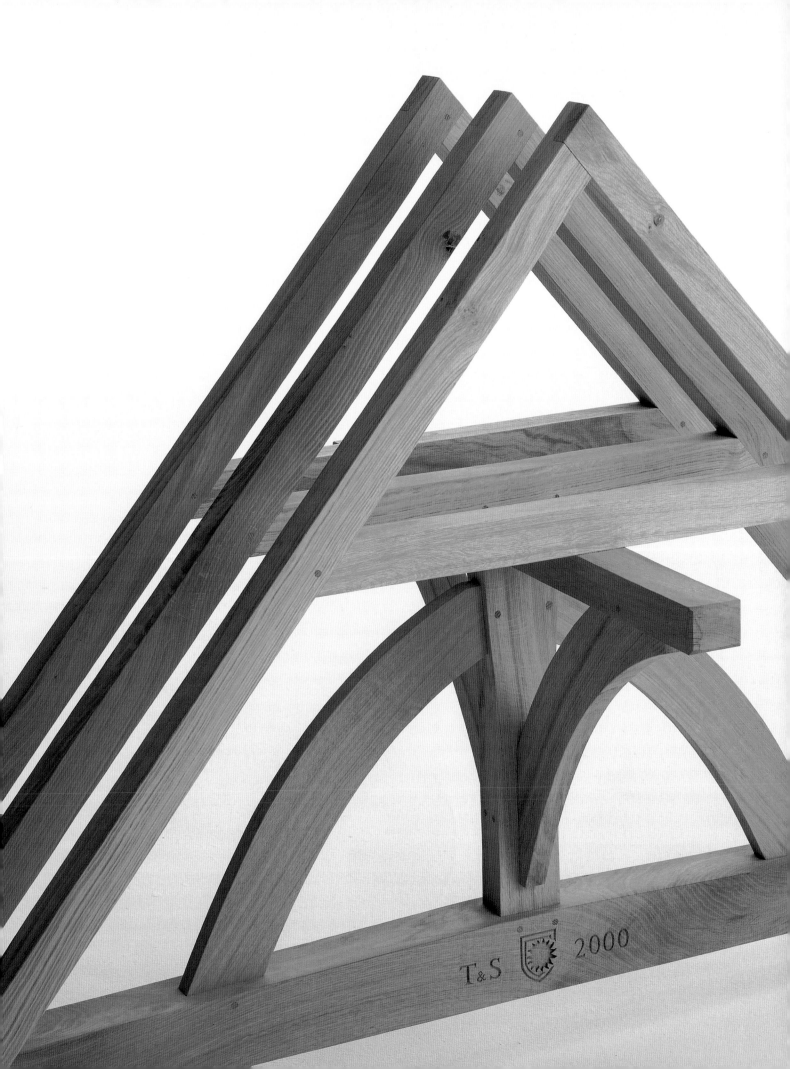

SYANN VAN NIFTRIK

"The *Rosary of Time* comes from the thought that this tree has stood witness to a span of time with which no single human is blessed. Just as time and conditions have been recorded by the growth rings within its trunk, I wanted to consider and record the life it had witnessed. When I began to look for information about this tree and oaks in general, I discovered a parallel that fascinated me. During the time of this tree's growth and the development of its own population of animal life, the countryside around it was regressing, particularly in its wildwood resources. And it was this that I decided to meditate on. Strings of beads are used in many cultures as a focus for meditation. Instead of beads, I'd use chips of wood from the tree as symbolic markers of the years. A chip for every year of its life gathered in decades, and between them, the growth of life in the tree itself."

Syann van Niftrik

Syann van Niftrik was born to Dutch parents in South Africa in 1947, and trained as a ceramic designer at Johannesburg College of Art from 1965 to 1968. This was followed by work designing lamps and ceramic wall cladding. Contact with architects led to opportunities for freelance mural-making, which provided her with freedom to experiment with technical and stylistic elements as well as the challenge of exciting architectural settings, including a two-storey atrium. In these murals metal was combined with the ceramics until metal eventually became the focal point.

Syann left South Africa in 1971 and worked as assistant to the designer–jeweller Geertje Pijper in Amsterdam. Her interest in jewellery grew, and led her to set up her own workshop. In 1979 she moved to the UK, where she established herself as a studio jeweller.

In 1977 Syann exhibited at the San Francisco Gift Fair with the assistance of the UK Crafts Council. Her work has also been exhibited in The Netherlands, France, the USA and Japan, and in the UK at the Chelsea Crafts Fair, London, and at Dazzle jewellery shows throughout the UK (1996–2001). Photographs of her work appear in *Jewelry Design* by Elizabeth Olver (2000).

Syann van Niftrik's husband, Nick Barberton, is also included in the onetree project (see pp. 38–39). The chips produced by Nick while carving his vessel are featured in Syann's work.

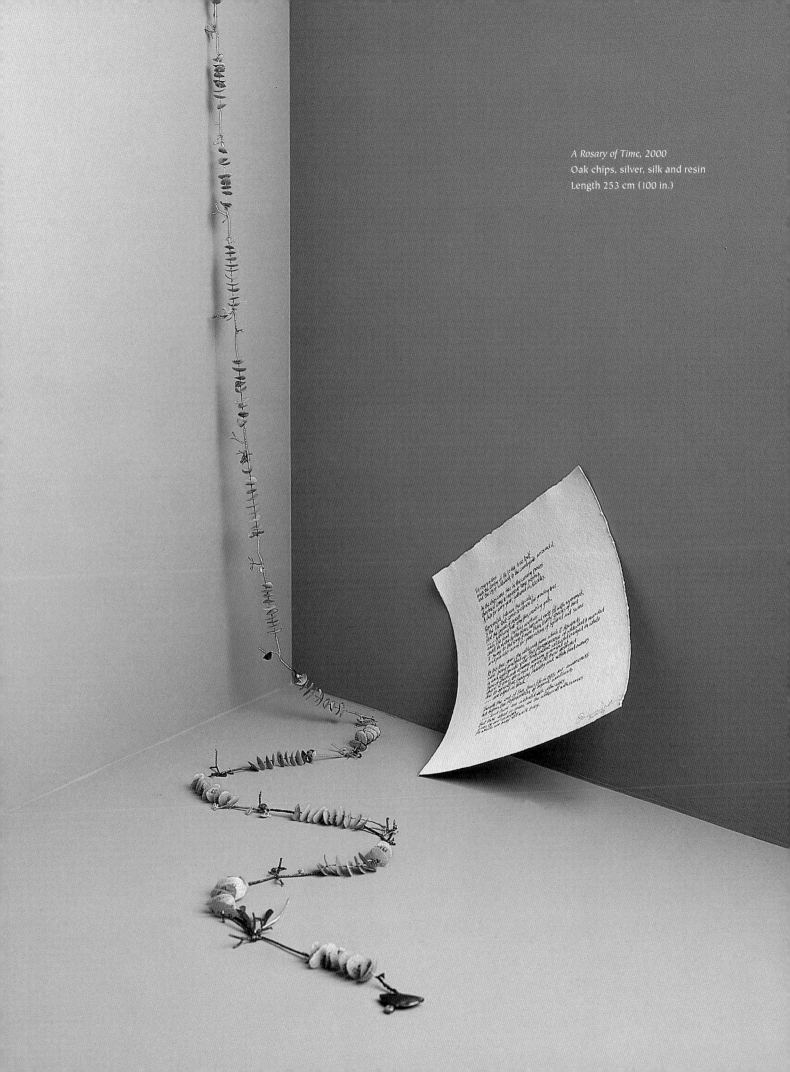

A Rosary of Time, 2000
Oak chips, silver, silk and resin
Length 253 cm (100 in.)

ANDREW VARAH

"The concept of onetree is quite brilliant and long overdue. As with all good ideas one asks why it has not been done before. When I was invited to produce a piece of furniture from a board sawn from the main trunk I had no hesitation in choosing the 2-inch centre board, over 4 metres in length, and showing the medullary rays. This board was the actual length and width of the felled trunk. Once I saw this piece I realized that perhaps I might be the only maker who had kept his board in the original length. By placing two circular glass discs on each end it is possible to visualize the exact diameter and length of the original trunk as felled. By incorporating a stainless-steel tube I have created backrests so that this board becomes a bench, with each seat position sculpted out of the board surface. The end grain, seen through the glass, also reveals the annual rings so that it is possible to establish the age of the tree. A chessboard has been inlaid between two seating positions. I wanted to try to re-create this trunk by creating an illusion that by viewing the glass edge you could imagine you were looking at the original trunk. I was also keen not to introduce any other wood, apart from the original board. This piece would perhaps suit a museum or art gallery, or a public place, preferably indoors." *Andrew Varah*

Andrew Varah was born in Blackburn, Lancashire, in 1944. Having completed a three-year course in furniture-making in 1965, he taught in London for two years as deputy head of a technical department. From 1968 to 1974 he ran a bespoke furniture-making company in Northern Rhodesia, now Zambia, controlling forty-six Zambian craftsmen and taking responsibility for all design and production.

On returning to England he established his present workshop in converted eighteenth-century barns in Warwickshire. There he has made bespoke one-off pieces of handmade furniture. He employs five cabinetmakers and has an international client base attracted by his reputation for exclusive work.

In 1996 he was made a Freeman of the City of London and a member of the Worshipful Company of Furniture Makers. For nine years he has been external examiner for Letterfrack College of Fine Furniture Making in Ireland and is guest lecturer at Buckingham Chilterns University College. He is currently serving a three-year period as a member of the Livery Company's Guild Mark Committee. In 1997 he was joint author of *The Hamlyn Book of Woodworking* (1997). He has appeared on television, has been the subject of approximately twenty articles and has been included in Betty Norbury's book *Furniture for the 21st Century* (1999).

Bench
Oak, stainless steel, toughened glass
75 x 413 x 87 cm (29 x 163 x 34 in.)

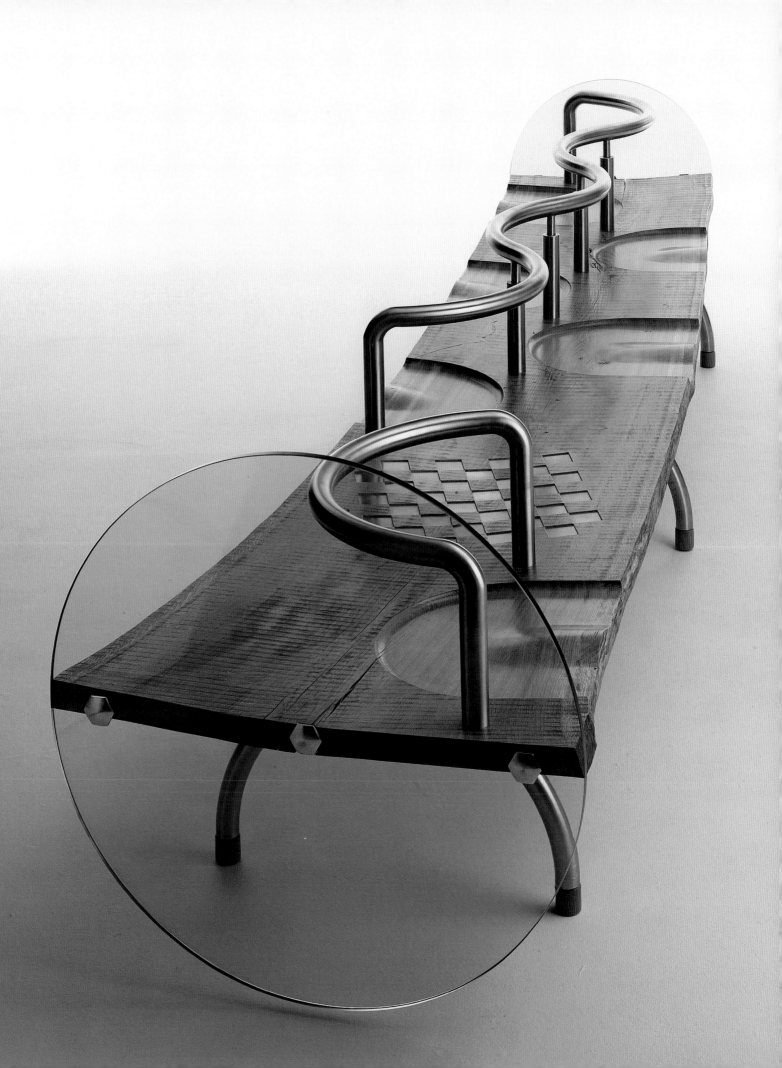

"First things first. It seemed to be such a naturally engaging concept – one of those 'why-hasn't-anyone-done-that-before?' ideas. Not without its risks of course, but is anything?

We're not sentimental, still less mystical about oak (or any other timber): it is as vulnerable to abuse as any other material; it can become bland or boring, can be too much of a good thing. So we're not evangelizing, but we just happen to find it consistently the most versatile of materials for what we do. Which is saying something, considering that our work ranges from (distinctly unsentimental) fast-food furniture to the hallowed precincts of museums, by way of corporate boardrooms and street furniture from Dundee to Dubai.

Onetree has given us leave to doodle. The material is familiar and we haven't attempted to innovate in any particular way, but to make small expressions of identity and relationship, some careful and considered, others quite casually improvised. It should be apparent which is which. Our two pieces have opened up some new possibilities for us. We hope to get the doodle bug again." *Wales & Wales*

Rod Wales was born in 1950 in the Belgian Congo. He studied at Rycotewood College, Thame, Oxfordshire (1975–77), and Parnham College, Dorset (1978–80). From 1980 to 1981 he worked as assistant to London-based furniture designer Martin Grierson.

Alison Wales was born in 1952 in London. She studied fine art at Reading University (1970–74). After attending Rycotewood College (1978–79), she spent a year as a trainee at John Makepeace Furniture.

Wales & Wales resist easy categorization, their work consciously blurring the distinctions between design, craft and art. Since the inception of their business in 1981 they have gained a reputation for timeless, intelligent design, emerging from a background in craft without being confined by it.

The early years were devoted almost exclusively to one-off items of domestic furniture for private clients, but they have also developed batch-produced pieces and standard repeatable designs, which have gradually led to an increasing involvement with design and production for the contract market and architectural interiors, including major commissions for Broadgate and Canary Wharf, both in London.

A decade later Wales & Wales have gained an international reputation for their street furniture and have recently combined forces with another company to market that range, leaving themselves free to concentrate on developing new ideas. These include designing for industrial production as well as studio pieces for private and corporate clients.

The work of Wales & Wales has been extensively published in journals, magazines and books. It may also be found in many public collections, including Manchester City Art Gallery; the Crafts Council collection; the Victoria and Albert Museum, London; Shipley Art Gallery, Gateshead; and Cheltenham Art Gallery and Museum.

Wales & Wales have received awards from, among others, *Design Week* and the Worshipful Company of Furniture Makers, and have won international prizes and fellowships.

Left
Wall-hung chest
Fumed and natural oak
38 x 51 x 25.5 cm (15 x 20 x 10 in.)
Below
Fairly Prairie
Oak
24 x 130 x 43 cm (9½ x 51 x 17 in.)

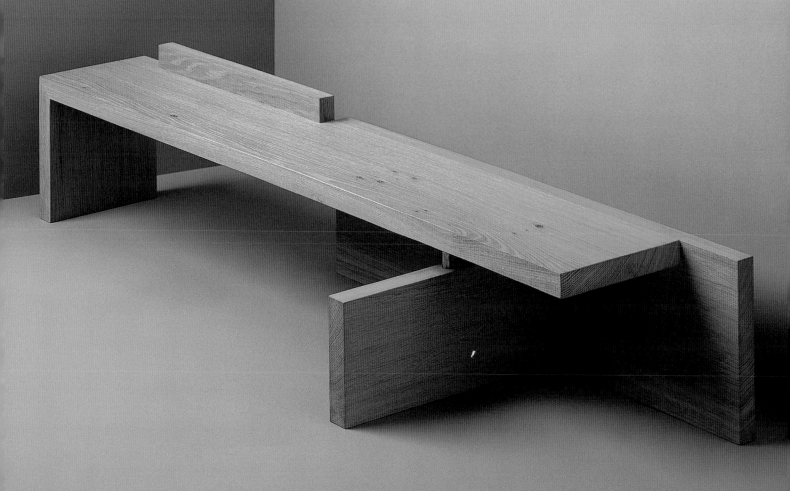

KATIE WALKER

"I am concerned about the impact we, as consumers, have on our environment and how, as a designer, I can influence this.

Wood is still perceived by many as primarily a traditional craft material. My rôle in the onetree project is to advocate and promote the use of wood in contemporary design.

With the Modern Movement of the 1930s came the creation of forms needing new processing techniques; this brought to the fore an interest in wood as a 'designer' material. With the processing techniques and machinery that are available to furniture manufacturers today, wood is as accessible as any of the other, less sensitive, less environmentally friendly materials. If grown in properly managed forests wood is a sustainable material that uses only natural energy in its production.

Most importantly to me, wood has 'life' and an inherent structure. I also believe that, whatever process is used in the production of a piece, the most ecologically sound approach is to design with the longevity of the object in mind, thus respecting the length of time it has taken for a tree to reach maturity.

My mirror design uses timber in both solid and laminated forms. Moving the position of the highly polished steel ball tips the balance and changes the angle of the mirror while providing a contrast between the highly machined, highly polished steel ball and the laminated natural finish of the curved wood base.

I am developing the design for production, using the laminating process, in order to add it to my 'product-to-order' range." *Katie Walker*

Katie Walker was born in 1969 in Wimbledon, London. She took a foundation course in art and design at Kingston Polytechnic (1987–88), and graduated in 1991 in furniture and related product design from Ravensbourne College of Design and Communication, Kent. In 1993 she was awarded an MA in furniture design by the Royal College of Art, London.

Katie formed Katie Walker Furniture in 1994 after receiving widespread press coverage for her major project at the Royal College of Art – a public-seating commission for English Heritage.

Commissions from a media company in London provided Katie with a portfolio with which to apply to the Crafts Council for a setting-up grant, awarded in 1994. Since that time she has combined one-off site-specific commissions with the development of a 'product-to-order' range.

In 1996 she received a Creative award from the South East Arts Board to develop new work. In 1997 a piece was purchased by Brighton and Hove District Council and the South East Arts Board for their arts and crafts collection. The same piece, a console table, is illustrated with her gallery seating in the *1998 International Design Yearbook*. In 1998 she had a solo exhibition at Hove Museum and Art Gallery, and her gallery seating, which has since been commissioned by Worcester City Art Gallery, was awarded a Guild Mark by the Worshipful Company of Furniture Makers.

Other important recent commissions include foyer seating for Walsall Leather Museum, a large domestic dining suite (also awarded a Guild Mark), combined seating and screens for the reception area of the South East Arts Board's offices, and public seating for a shopping centre in Leatherhead, Surrey.

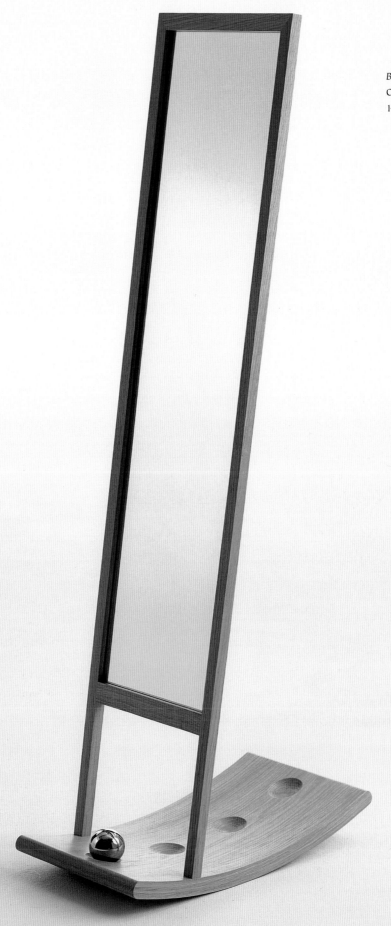

Balance mirror
Oak, silvered glass, steel ball
144 x 31 x 60 cm (57 x 12 x 23½ in.)

LOIS WALPOLE

"My response to the onetree project has always been enthusiastic. It was the holistic concept that appealed. I had always hoped that all parts of a tree were fully exploited, and hoped that perhaps, through this project, creative uses would be found for the leaves and sawdust, which in a commercial environment would be wasted. With that in mind I offered to try and work with some leaves and small twigs. My experiments with these included paper-making (I could not get excited by the sludgy olive colour) and sewing the leaves into a bowl shape, using parts of the leaf vein as pins (too Andy Goldsworthy). The leaves are very attractive when wet, but when dry they are brittle and dull, and I do not like to use varnishes or glues.

I attempted assembling the small twigs into basket forms, but again that concept was someone else's (the contemporary American basketmaker Gyongy Laky's). Onetree then sent a shoebox full of small branches. I immediately felt happier with them: they were such solid objects. I never found the dead leaves as interesting or attractive; I just wanted to compost them.

I knew straight away that I would slice the branches into discs, but it wasn't until I had tried various ways of assembling them that I started to think about the form the final piece would take. I then developed the title, *Log Basket*: I liked the double meaning and knew it could work. After that the log-pile form came easily. I drew the piece, and then there was what is always for me the tedious work of putting it together. The excitement for me is always the designing, the experiments, the problem-solving and seeing the finished piece. The putting-together I could happily leave to others." *Lois Walpole*

Log Basket
Oak and reused copper wire
29 x 32 x 10 cm (11½ x 12½ x 4 in.)

Lois Walpole was born in London in 1952. She went to schools in England, Germany and Wales, and then took a foundation course at Bristol Polytechnic (1971–72). In 1975 she graduated in sculpture from St Martin's School of Art, London, and in 1981 she gained a City and Guilds qualification in basketry from the London College of Furniture. Since 1999 she has been a full-time research student at the Royal College of Art, London.

Lois was the first person in the UK to exploit basketmaking forms and techniques as a creative medium for self-expression. Her use of colour and recycled materials was unique in the country in 1984 when her work first featured in *Crafts* magazine. She uses the basket form because it allows other people to engage easily with her work: the basket is a universal artefact familiar to everyone.

Since 1984 she has exhibited nationally and internationally in numerous solo and group shows. Her work is held in many public collections in the UK and abroad, including the Victoria and Albert Museum, London, and the Royal Museum of Scotland, Edinburgh. Alongside exhibiting she has taught, lectured and designed (both for production by her own company and for others, including Body Shop, Paul Smith and Esprit de Corps). She is the author of two instructional books on basketmaking, *Creative Basketmaking* (1989) and *Containers from Recycled Materials* (1997). She has also written magazine articles, as well as catalogue essays for such exhibitions as *Transformations: The Art of Recycling* at the Pitt Rivers Museum, Oxford (2000–02). She conceived and co-curated the ground-breaking Crafts Council exhibition *Contemporary International Basketmaking*, which opened at the Whitworth Art Gallery, University of Manchester, in 1999, before touring the UK.

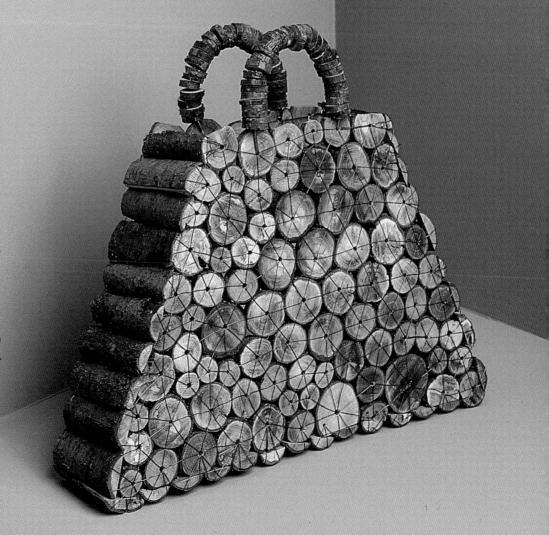

ROBIN WELCH

"My piece for the onetree project is a vase form glazed with an oak-wood ash glaze. It was thrown using a textured stoneware clay. (It would have been interesting to research the possibility of using clays from the area in which the tree had grown.) The lettering around the base was impressed into the leather-hard clay with old printers' lead type. When dry it was then biscuit-fired to 1000°C. A glaze was made with equal parts of china clay – ball clay – feldspar and sieved oak-wood ash; after glazing, and while still wet, unsieved ash was scattered over the surface. The final stoneware firing was to 1280°C in a reduction atmosphere.

In relation to using the wood ash I was using the last scraps of waste material from the tree: twigs, bark, shavings, sawdust and so on. The vessel I made is almost incidental to the covering of semi-matt oak-wood ash glaze I used on the surface of the form, but I felt it had a feeling for the original tree trunk – solid and stable, flaring out at the top like the canopy of the tree, although I felt it didn't associate itself with the wood of the tree as such. Hence my attempt to increase the association by impressing lettering around the base and hopefully making the result more recognizable as part of the onetree project."

Robin Welch

Robin Welch was born in 1936 in Nuneaton, Warwickshire. He studied sculpture and ceramics at Penzance School of Art, and spent some time working at the Leach Pottery in St Ives before completing his National Service with 2nd Battalion Parachute Regiment. He attended the Central School of Art in London as a postgraduate student, and was later appointed technical assistant in ceramics.

Since starting his own workshop in London in 1960, Welch has developed a considerable reputation for his freely constructed individual pots, the making of which has been interspersed with tableware production, architectural work, teaching and residencies in Australia and the USA. His ceramic education was unusually broad: his weekends at the Leach Pottery taught him much about materials, but his time at the Central School took him beyond the Oriental world that was so influential for the Leaches. Such innovative teachers as William Turnbull and Gordon Baldwin helped Welch to look outside ceramics for ideas, stimulating a broader, more sculptural perspective. He learned that good pots could develop out of the discipline of drawing in the same way that painting does. After returning from a three-year trip to Australia in 1962, Welch set up a studio in Suffolk, where he is still based, and from which a steady stream of distinctive thrown, coiled and slab-built forms has emerged alongside his output as a painter.

Robin's work has been exhibited across the world and can be found in many major collections, including the Victoria and Albert Museum, London. He is a member of the 3-D design board for the Council for National Academic Awards and serves on many adjudicating panels. As well as his own studio work he has produced designs for Wedgwood, Midwinter Stoneware, Rose of England and Denby.

Vase
Stoneware with oak-ash glaze
Height 60 cm (24 in.)

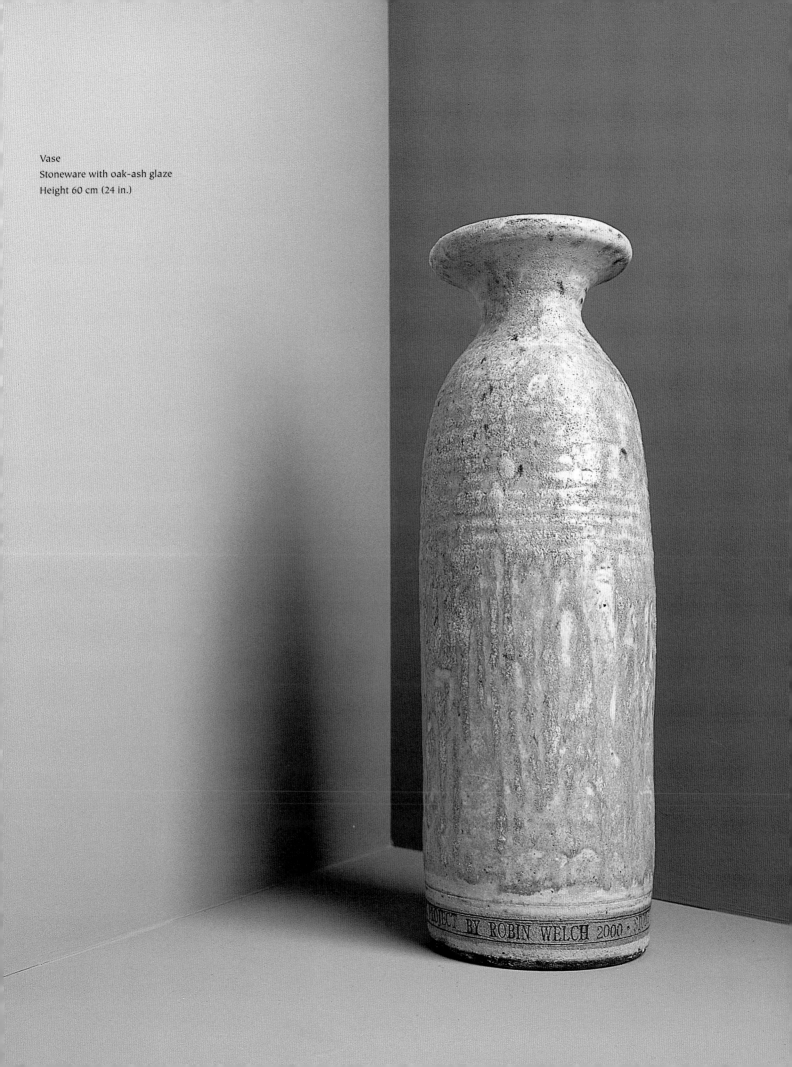

JANE WHITAKER

"'For centuries people have spoken of the Greek myths as if of something to be rediscovered, reawoken. The truth is it is the myths that are still out there waiting to wake us and be seen by us, like a tree waiting to greet our newly opened eyes.' Roberto Calasso, *The Marriage of Cadmus and Harmony*

I decided to work with one planed section of the tree, as the piece expressed so many notions associated with the oak itself: strength, resilience, the sinuous dynamic of primeval growth and life. In itself, the plank had a charged presence that the machine slicing and planing it had undergone served only to emphasize. The beauty of the grain and the bark edge remained unviolated, and I wanted to create prints that had the same confrontational and 'straight-out' quality – the quality of an *objet trouvé*, or rather, in this case, an *objet donné*.

I worked with relief ink, oak ink (black from shavings, brown from bark) and watercolour on Japanese Okomoto paper as I felt this was the best way of allowing the prints to find their meaning in the simplicity of the materials.

After having the plank shot-blasted, I sanded the surface smooth to take the ink and then carved into the line of the grain. All the time I was preparing and carving the plank I never lost the idea of the oak as *imago mundi*, as having a symbolic and mythical nature. From time immemorial the oak has been invested with the symbolism of regeneration, constant renewal and mythical power. It was a tree sacred to Zeus, Cybele and Demeter – hence the idea of a triptych. Zeus consulted the oracular, holy grove of Dodona and dipped an oak branch in a sacred spring to charm the rain. Associated with Zeus and fertility was Cybele, mother of the gods, who in turn had a great fondness for Atys, a young and beautiful herdsman who some thought was not her lover but her son. So the three are inextricably linked, both to one another and to the sacred oak.

In constantly observing the oak as I worked, it was natural to imbue it with this spirit as the ideas generated from the inert passed into the realm of the imagination." *Jane Whitaker*

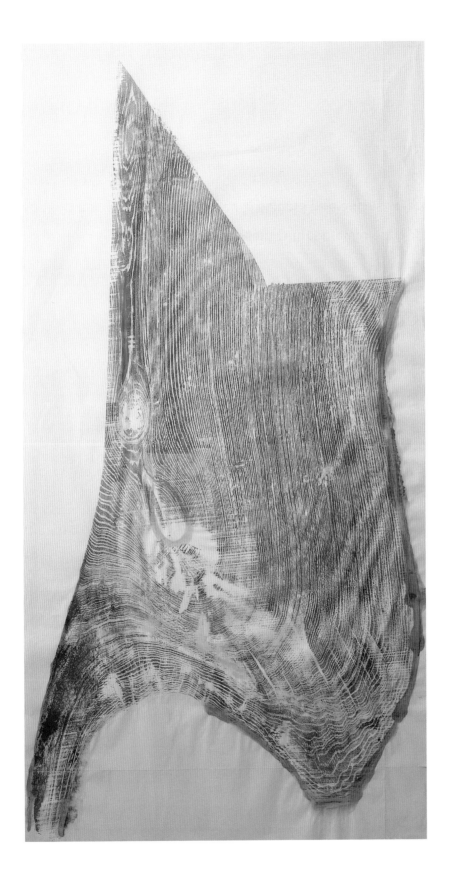

Jane Whitaker was born in Leeds, Yorkshire, in 1943, and read American literature and history of art at the University of Manchester (1962–66). In 1996 she gained a fine art degree at the University of Humberside; during this course she spent a semester at the school of the Museum of Fine Arts, Boston, Massachusetts. She went on to study printmaking at Camberwell College of Arts in London, gaining an MA in 1999.

From 1986 to 1989 Jane was deputy director and education organizer at Yorkshire Contemporary Art Group. Following that, she worked on a number of freelance projects, including a pilot study for cataloguing the Brooking Collection of architectural artefacts at the University of Greenwich (completed in September 1990); a report on behalf of Leeds Art Space artists working with children in schools (1992); and an education project associated with the exhibition *Venice through Canaletto's Eyes* at York City Art Gallery (1998).

Since 1992 Jane has exhibited her prints in Farnham, Fulham, Hull, Leeds, Sheffield and Welbeck and, in 1997, at the Boston Print Symposium, Boston, Massachusetts. In 1998 she undertook an autumn residency at Burton Agnes Hall in East Yorkshire, where she produced a series of prints in response to the gardens. She is a member of Continuum, a Leeds-based group of women artists who all met at Jacob Kramer College and have continued to strengthen their artistic practice together.

Jane's work is held in private collections in the UK and North America, and has been the subject of journal articles and exhibition catalogues.

Listen and the Oak will Speak, a triptych of three framed pieces individually entitled *Zeus*, *Cybele* and *Atys*
Woodblock print on Okomoto paper with watercolour and oak ink
150 x 78 cm (59 x 31 in.)

JULIENNE DOLPHIN WILDING

"My work is motivated in part by ecological concerns. A great deal of it is made from salvaged and recycled materials. The day I went to collect my share of the onetree materials my trained eye spotted a pile of rain-sodden offcuts and end boards still with the bark intact. Garry Olson and Peter Toaig enthusiastically handed these over to me, keen to see the tree put to maximum use.

The challenge of using waste materials is an exciting one: they take on a new rôle, which exploits their individuality and irregularity – precisely those characteristics that preclude their use in most applications. In this case the onetree philosophy demands that as much of the tree as possible be transformed into an object of some use. Offcuts from offcuts must be kept to a minimum. This leaves me with an opportunity to play with scale. I allow the material to dictate the form and enjoy the discipline of revealing and redirecting the suggestions contained in it. This is very evident in the two chairs made for this project.

The form I prefer to experiment with is the chair. At a functional level, a chair makes physical and psychological connections with the individual sitting in it. By constructing a chair with as much volume of material as is 'domestically' possible I can work within the realm of sculpture, and to give the piece a title therefore becomes inevitable. The chairs are called *Barking Mad* because they are tall and eccentric, and the board backs are the bark-covered outside of the tree.

The jigsaw puzzle, entitled *Profile of an Oak Tree*, is a complete cross-section of the oak, cut into 177 individual, uniquely interlocking jigsaw pieces. This work is made from the 'official' piece of high-grade oak given to me before I collected the waste material for the chairs. The puzzle is to be taken seriously in the sense that it could take a jigsaw enthusiast days to complete. The picture is the oak-tree trunk; the grain and edge are the guides." *Julienne Dolphin Wilding*

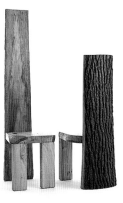

Two chairs (*Barking Mad*)
Oak
Heights 177 cm (70 in.) and
127 cm (50 in.)

Julienne Dolphin Wilding was born in London in 1960. She studied furniture production and design at the London College of Furniture and then 3-D design at Middlesex University.

Julienne is well known for her large-scale one-off chairs made from a wide selection of unconventional materials. She describes herself as an applied artist/designer. She is determined to remain open-minded and experimental. Her concerns for the environment and ecology are evident in her portfolio. She has produced an impressive body of work, including garden design and construction, water features, furniture of all types, installations, site-specific sculpture, residencies and collaborations with other artists and designers.

Her work is featured in *Ecodesign* by Alastair Fuad-Luke (2001), *1000 Chairs* by Charlotte and Peter Fiel (1997) and *Green Design* by Dorothy Mackenzie (1991), and has been the subject of articles in *Blueprint*, *World of Interiors*, *Casa Vogue*, *The Face*, *Elle Decoration* (USA, UK, Spain and Japan), *Abitare*, *Ambiente* and *Spaziocasa*. Her work is represented in the Victoria and Albert Museum, London, and was included in *Hats Off*, an exhibition of one-off hats by applied artists, curated by Sharon Plant.

Profile of an Oak Tree
Oak
Floor piece 400 x 70 cm (157 x 27½ in.)

GILL WILSON

"Onetree presented an opportunity to work with oak leaves, although they were difficult to make paper with as the fibre content is poor. However, the pulp was very beautiful and imbued with a sensual quality. Handmade paper creates a surface that may appear flat at first viewing, but each piece reveals an intricacy of texture, fibre and tone. No colour is true or solid. Through dyeing or gentle bleaching areas come to be composed of an array of mixed coloured fibres, or a layering of different consistencies of the same pulp. The lines and textures are a way of indicating the place of contact, the marking of a moment with a line, a way of catching and recording the vibrancy of the process of touching.

After visiting Tatton Park in the summer of 2000 I received a delivery of leaves, and after producing several studies I had a clear sense of the work I wanted to produce. I focused my interest on the interrelationship of trees and particularly the spatial relationships within a copse or forest. I used the extensive forests of north Nottinghamshire as an inspirational resource. The pieces function in an interior space as punctuations in a busy and chaotic world. The work seems to look through apertures at trees and landscapes from interior to exterior space. This reflects the way landscape is often perceived as the monitoring of organic worlds through man-made spaces – the distancing we now find between our technological world and that of ecology and landscape." *Gill Wilson*

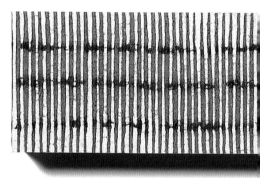

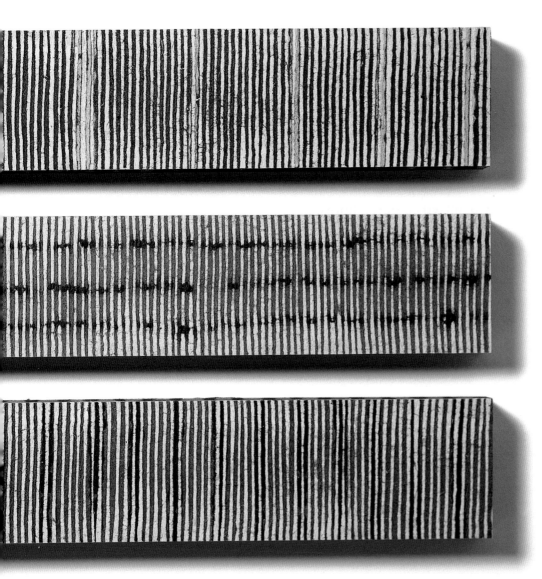

Gill Wilson was born in Burgess Hill, Sussex, in 1957. After a foundation course at Mansfield School of Art she completed a degree in constructed textiles at Winchester School of Art (1976–79). From 1986 to 1988 she studied education at Nottingham Trent University. She obtained a Postgraduate Certificate at Loughborough College of Art and Design in 1998.

Gill's career has always involved being in employment as well as running her practice as a paper-maker. She set up her first studio in Newark in 1980 after studying paper-making in Japan, and developed her craft along the lines of Japanese paper, or Washi. She then took a studio in Edwinstowe, Nottinghamshire, where her paper-making became integrated with weaving, and she started to produce work to commission and for exhibitions, developing specific techniques with plant fibre to refine and manipulate pulp. Gill's employment has enriched her own work: she was a lecturer in design for fifteen years before becoming craft officer for the East Midlands Arts Board. She moved to the Harley Gallery, Welbeck, near Worksop, Nottinghamshire, where she manages the retail area and exhibition programmes. She has a workshop at the Harley Foundation, where she is able to produce much larger works, mainly for contract art companies and for exhibition. Gill is passionate about interiors and about the way her work relates to interior space and architecture. Such artists and architects as Sol LeWitt, Luis Barragán, Donald Judd and Andy Goldsworthy have influenced her work.

Gill received the 1977 Hampshire Award for Textile Design and a Leverhulme Award for Industrial Design in 1979 to study paper-making in Japan.

Oak Tree Wall Box #1, #2, #3
Handmade paper
Each 18 x 108 x 6 cm (7 x 42½ x 2½ in.)

DAVID WOODROFFE

"I was living with my girlfriend, Sacha, in a one-bedroom flat, when I first heard about onetree. We needed a dining table, and as space was limited and we didn't have many chairs, we thought a table for six would be best. However, the move to a bigger home was literally around the corner, and we envisaged huge Friday-night dinners, entertaining our families and, one day, our own family.

I would describe my approach to design as 'quiet'; more and more I realize that it's taken from the maxim 'anything for a quiet life'. I would talk about simplicity, honesty, purity and the socialist ideals of mass-production. Normally preferring man-made materials, I become obsessed, striving for efficiency in manufacture. Both my idols, Jasper Morrison and Donald Judd, work(ed) reducing forms to the essential, without sacrificing wit.

Like all creative fields, designing furniture is both exciting and confusing, but only for those involved. Amazingly, it's also incredibly difficult. I wonder whether it is confidence, or the lack of it, that prevents me from writing just the five words I would usually utter when asked to describe this work: 'It is just a table'." *David Woodroffe*

David Woodroffe was born in Solihull, Birmingham, in 1969. He gained a degree in architecture from the University of Sheffield in 1990, followed by a City and Guilds course in cabinetmaking at Manchester College of Art and Technology (1991–92). He returned to complete his architecture studies at Manchester School of Architecture, graduating in 1998.

David had notable successes in the Ness/Blueprint Furniture Competition (1999), the Furniture Awards (1991 and 1992) and the British Toy and Hobby Manufacturers Association Design-a-Toy Competition (1988).

David is currently working at Ian Simpson Architects, Manchester, in a team responsible for producing feasibility studies, major planning applications and competition entries. Recent schemes include a forty-five-storey residential glass eco-tower at Holloway Circus, Birmingham, and the conversion of the former General Post Office building in Manchester into three hundred loft-style apartments. Before this period, David worked as an interior and exhibition designer in both the pharmaceutical and retail trade. Client accounts included ICI, SKB, Pfizer, Sharp, Nokia, Absolut and ITV.

David has worked in all fields of the industry but always returns to his first love – furniture design. Throughout the past ten years, he has undertaken furniture commissions and continued to produce speculative designs for mass production. He has sold privately and through such galleries as Artizana in Prestbury, Cheshire, while also building links with local manufacturers. Certain items have been batch-produced and self-marketed in collaboration with other designer–makers.

In 1995 David was invited to teach on the BA degree course at Manchester School of Architecture, helping on two furniture projects.

Two-size dining table
Oak, toughened glass, stainless steel and rubber
75 x 140 x 90 cm (29½ x 55 x 35½ in.) or 75 x 180 x 140 cm (29½ x 71 x 55 in.)

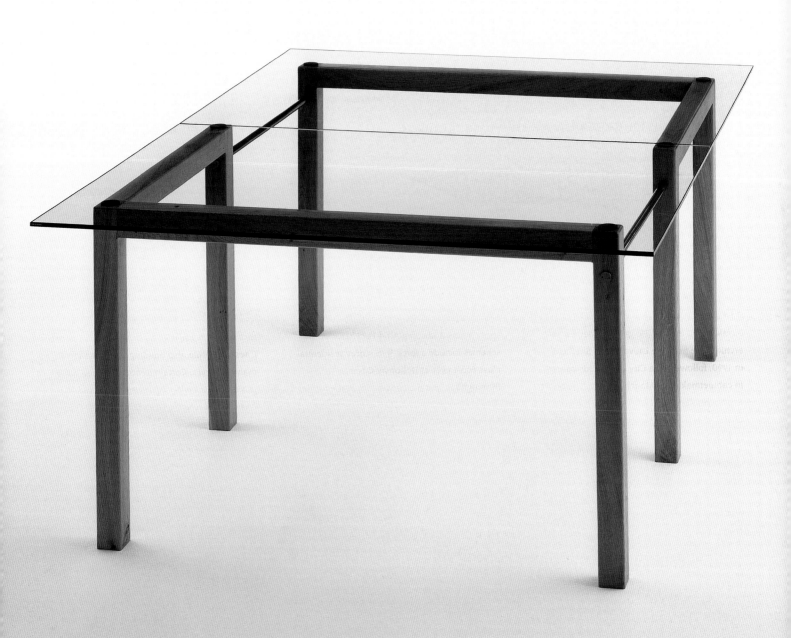

WES WOTRUBA

"I am Quercus robur, punk or punk?

We were a collective, I a leader,

In our dappled shadow the quarry grazed;

Then quarried were we, chainsaws raped, severed,

Limbs left strewn, what would our decay offer?

But plucked up was I, what: still more torture?

First ripped in two, then chipped and planed and scratched,

Worse still chasms right through my heart were chased.

I wept alone: pain to cause near rupture.

Time passed by, I woke immortal sovereign.

No! Wait. Where is my sap? How can this be?

Wounds remain unhealed where they severed limbs,

My naked chest and past for all to see.

Life: perception of my custodian.

I contemplate: punk as my destiny."

Wes Wotruba, 27 January 2001

Wes Wotruba was born in Southampton, Hampshire, in 1973. He studied design at Brunel University, graduating in 1995. In 1997 he took a course in ornamental woodcarving at the City and Guilds of London Art School.

After graduating from Brunel University, Wes fulfilled a long-standing ambition by immersing himself in the realms of wood-based craft. His business has many facets, ranging from the batch production of 'long boards' (cruising skateboards) to interior coachwork for limousines. The business is primarily supported, however, through the restoration of antique furniture. Freedom from the pressure of producing creative work as a sole source of income has allowed him to pursue contentment in the execution of his craft. It also gives him time to contemplate design and the ethics of design.

Quercus robur: a native English oak tree.

punk 1 n. (arch.) Prostitute.
[16th c., of unknown orig.]

punk 2 n. & a.
1. n. Rotten wood, fungus growing on wood, used as tinder.
2. (colloq.) Worthless stuff, nonsense: worthless person: novice: young ruffian.
3. a. (colloq.) Worthless, rotten. [18th c., of unknown orig.; cf. spunk]

Concise Oxford Dictionary, 10th impression, Oxford (Oxford University Press) 1980

Punk or punk?
Oak, Norway spruce, toughened glass
235 x 145 x 60 cm (93 x 57 x 24 in.)

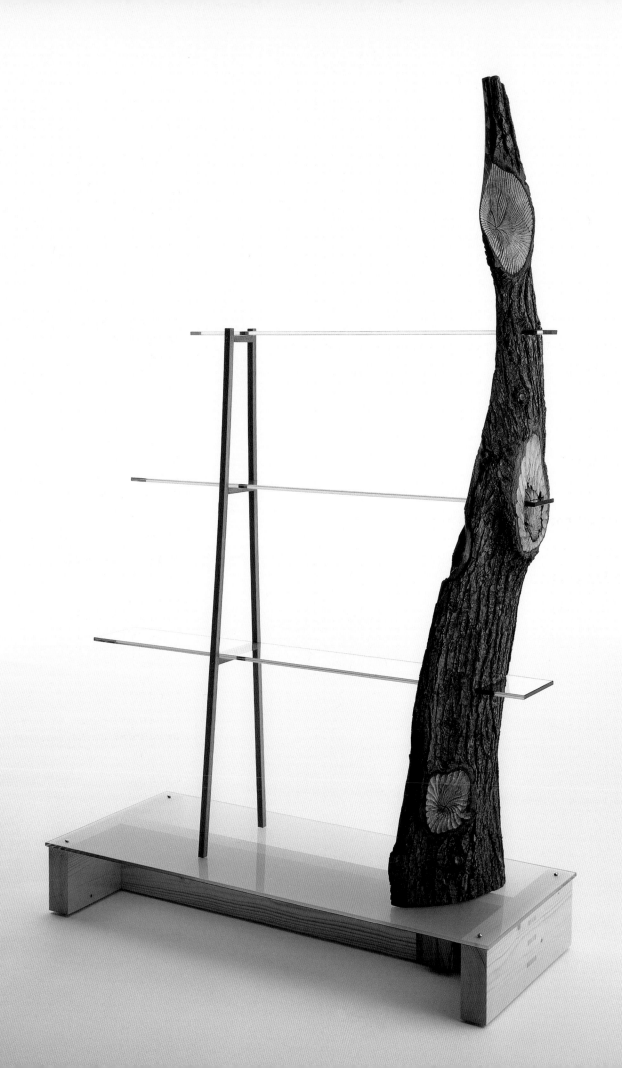

BOOKEND

In the autumn of 1995 I was invited to open an exhibition to celebrate the great trees of Shropshire. Standing among the great and the good of the Welsh Marches, I cast around for inspiration: a few words to add to the powerful images of ancient trees, and the wooden carvings, containers, toys and furniture that made up the display. We were standing in the offices of the local wildlife trust: a sixteenth-century riverside building with walls of wattle and daub, and huge low-slung oak beams supporting floors and ceilings. Here were blackened lumps of oak, felled five hundred years ago when they were already several centuries old. I suddenly realized that we were in the presence of trees that probably sprouted into life on the banks of the Severn as many as one thousand years ago.

A year later, on a tiny village green in Herefordshire, I was gathering acorns from beneath the branches of a great oak that was actually mentioned as a local landmark in the Domesday Book – a living link to the Norman Conquest, still shedding thousands of seeds year after year. How many local people must have been inspired by that one individual living legend?

In an age of mass production, uniformity and globalization, the local distinctiveness of trees is all the more appealing. In an age of instant results, the slow pace of tree-seed germination and sapling growth is somehow reassuring, and in a throw-away society, how refreshing to have trees that will grow for a thousand years and still be full of life.

I was first made aware of onetree as I was shaping my own response to the magic of the millennium. I am a gardener at heart, with hands like spades and a firm conviction that growing plants can help forge a closer personal bond with the Earth. The seed of my own particular

millennial idea grew quickly to become the Trees of Time and Place campaign, and by now hundreds of thousands of individuals have gathered seeds from their favourite tree and grown a personal seedling to plant for future generations.

During that same period Peter Toaig and Garry Olson's own idea was putting down roots and branching out in all directions. Being generous with the disarmingly simple concept of onetree has been the key to their astounding success. All those involved have been encouraged to play to their strengths, interpret their love of wood with all the skill they could muster and work together to celebrate the glorious potential of one very ordinary, very special tree.

We have at last begun to rediscover the remarkable qualities that trees possess. In the hurricanes at the end of the 1980s, when a great many trees were snapped off in their prime, the truly ancient veteran trees were left almost entirely unaffected. The hollowness that until then had been condemned as a weakness caused by life-threatening fungal rot, revealed itself as a central strength of those trees' survival. Old parkland pollards could survive the storm precisely because they were so hollow – a cylinder is stronger than a solid rod.

The frequent floods so often blamed on global climate change have now been linked in part to Britain's lack of trees. Pundits always quote third-world deforestation as a cause of flood disasters in developing countries such as Honduras and Mozambique. Until now we have chosen to overlook the fact that Britain is the least well-wooded country in Europe, and bare hillsides shed dramatically more water in a rainstorm than a landscape clad with trees and surfaced with a spongy woodland floor.

In towns, where almost all the British people live and work, the urban forest is at last being recognized as fundamental to the quality of life. We have a glorious heritage of avenues and leafy parks that help to foster nature in the city and add elegance to the street scene. Now those trees are also being recognized as air conditioners. Their leaves and twigs can filter out pollution, shade us from the sun, shelter us from winter winds and add cool moisture on the hot, dry days of summer. Trees are a fundamental part of the natural life-support system for urban dwellers, and the fact that they look so beautiful, change with the seasons, grow so big and live so long makes them all the more amazing.

The practical environmental benefits that come from trees may have particular appeal for politicians, planners, engineers and other practical decision makers – but it is the awesome splendour of trees and the beauty of natural wood that really capture hearts and minds. From the gnarled old-timers of childhood tree-climbing and bedtime fairy stories to the thin veneers that amplify the sound of a string quartet, and from the solid support of a trestle table to the comforting feel of a hand-turned bowl, wood holds a very special place in the heart of the nation. It is this unique quality that onetree has captured so superbly. No one could fail to be inspired by the ingenuity, the craftsmanship and the artistic talent that has turned this one extraordinary Tatton oak into such a glorious celebration.

All those involved in the onetree project have performed a miracle. Having chopped down and uprooted an oak tree in its prime, they have made quite sure that it will live forever. Clearly the individual works of art and craft will survive for generations as treasured reminders of the tree, while the newly planted seedlings could have several

centuries of life ahead of them. Most significantly, people down the generations will remember onetree for the way it helped to reconnect an urban generation with the power and beauty of the natural world, just as the new millennium was dawning.

Chris Baines, *14 February 2001*

onetree

...MENTS

The authors would like to acknowledge the generous help of:

All the artists, designers, makers and manufacturers involved in onetree

The Arts Council of England

Ben Cracknell Studios

Bristol City Museum and Art Gallery

C'ART – Art Transport Limited

Gloria Ceaming

the chase

Cheshire County Council

County Car and Van Hire, Stockport

Eno at OnoEno

Ercol Furniture Limited

The Ernest Cook Trust

Forestry Commission

The Geffrye Museum, London

Ramez Ghazoul and Jemila Topalian, Artizana Gallery, Prestbury

The Harley Gallery, Welbeck Estate, Nottinghamshire

The Harley Foundation

Simon Harrington at Mannequin World

Highlight Printers

Lesley Jackson

Maria Karamanoli

Peter Kenyon

Helen Littler at Elvis Jesus Co. Couture

Macclesfield Borough Council

Manchester Airport Community Trust Fund

The National Trust

North West Arts Board

Tonia D. Podmore

Gaby Porter

The Royal Botanic Garden Edinburgh

Smee Timber Limited

Julie Stuart

Tatton Park, Knutsford, Cheshire

Lynne Walker

Whitmore's Timber Limited

John Williams

Woodland Heritage

The Worshipful Company of Furniture Makers

The following individuals provided invaluable help with the dendrochronology of onetree (pp. 28–29):

Joe Buchdahl (Manchester Metropolitan University) for access to weather data from Manchester Ringway Meteorological Station (data supplied by: UK Meteorological Office; *World Climate Disc: Global Climatic Change Data*, Climatic Research Unit, University of East Anglia, Cambridge (Chadwyck-Healey) 1992.

Phil Carter of Manchester Metropolitan University for facilitating initial contact with the onetree project.

Brian Goulden, Head Forester, Tatton Park, Cheshire, for management information relating to Boat House Wood.

Mrs Pat Heath for access to a chronology of local historical events compiled by the Knutsford Heritage Centre, Cheshire.

Jonathan Howell of Manchester Metropolitan University for assistance in producing scan/digital images.

David Price of the Forestry Commission and Peter Thomas of Keele University for additional information.

Numerous other individuals have provided information, advice and enthusiastic moral support during the onetree project. We thank them all.

Published by Merrell Publishers Limited
42 Southwark Street
London SE1 1UN
www.merrellpublishers.com

First published 2001

Text copyright © Garry Olson and Peter Toaig 2001

Photographs copyright © Robert Walker 2001

Distributed in the USA and Canada by Rizzoli International Publications, Inc. through St Martin's Press, 175 Fifth Avenue, New York, New York 10010

British Library Cataloguing-in-Publication Data:

Olson, Garry
Onetree
1. Trees – Pictorial works 2. Trees in art
3. Wood products
4. Woodwork 5. Wood carving
I. Title II. Toaig, Peter
704.9'434

ISBN 1 85894 133 4

Produced by Merrell Publishers Limited
Designed by John and Orna Designs, London
Edited by Julian Honer and Charlotte Rundall

Printed and bound in Great Britain
by Butler & Tanner Ltd, Frome, Somerset